D0359857

FASHION
CLIMBING

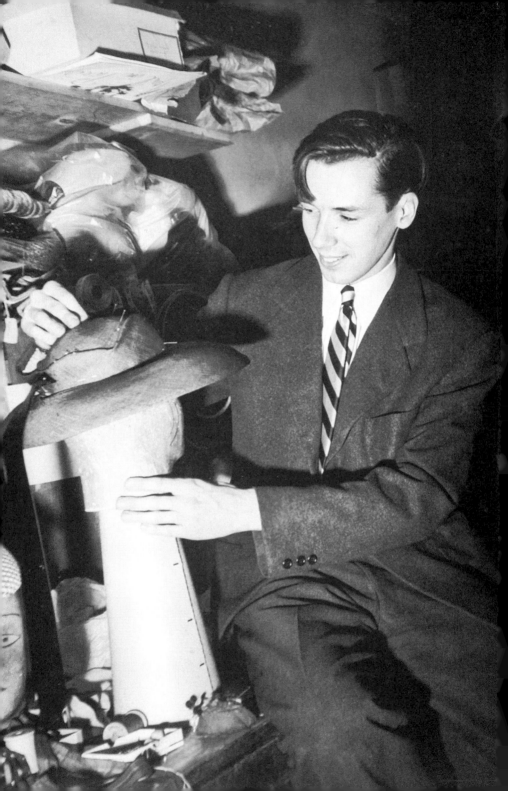

FASHION

CLIMBING

BILL CUNNINGHAM

Preface by Hilton Als

Penguin Press *New York* *2018*

PENGUIN PRESS
An imprint of Penguin Random House LLC
375 Hudson Street
New York, New York 10014
penguinrandomhouse.com

9780525558705 (hardcover)
9780525558712 (ebook)

Printed in the United States of America
1 3 5 7 9 10 8 6 4 2

DESIGNED BY LUCIA BERNARD

Penguin is committed to publishing works of quality and integrity.
In that spirit, we are proud to offer this book to our readers; however,
the story, the experiences, and the words are the author's alone.

CONTENTS

PREFACE

by Hilton Als

I loved him without knowing how to love him. If you think of love as an activity—a purposeful, shared exchange—what could anyone who was lucky enough to be acquainted with Bill Cunningham, the late, legendary *New York Times* On the Street and Evening Hours style photographer, writer, former milliner, and all-around genial fashion genius, really offer him but one's self? I don't mean the self we reserve for our deepest intimacies, the body and soul that goes into life with another person. No, the Cunningham exchange was based on something else, was profound in a different way, and I think it had to do with what he inspired in you, what you wanted to give him the minute you saw him on the street, or in a gilded hall: a certain faith and pride in one's public persona—"the face that I face the world with, baby" as the fugitive star, the princess

Kosmonopolis, has it in Tennessee Williams's *Sweet Bird of Youth*. Like the princess, Bill knew a great deal about surfaces; unlike the princess, though, he was never fatigued or undone by his search for that most elusive of sartorial qualities: style. You wanted to aid Bill in his quest for exceptional surfaces, to be beautifully dressed and interesting for him, because of the deep pleasure it gave him to notice something he had never seen before. Even if you were not the happy recipient of his interest—the subject of his camera's *click click click* and Bill's glorious toothy smile—there were very few things as pleasurable as watching his heart beat fast (you could see it behind his blue French worker's jacket!) as he saw another fascinating woman approach, making his day. That's just one of the things Bill Cunningham gave the world: his delight in the possibility of you. And you wanted to pull yourself together—to gather together the existential mess and bright spots called your "I"— the minute you saw Bill's skinny frame bent low near Bergdorf's on Fifth Avenue and Fifty-Seventh Street, his spot, capturing a heel, or chasing after a hemline, because here was your chance to show love to someone who lived to discover what you had made of yourself. His enthusiasm defined him from the first. It permeates this, his posthumous memoir, *Fashion Climbing*, which covers the years Bill worked in fashion before he picked up a camera. (He published only one book during his lifetime, 1978's *Facades*, which starred his old friend, portraitist Editta Sherman, dressed in a number of period costumes Bill had collected over the years. He was not happy with

the book but he was a perfectionist and anti-archival in his way of thinking, so how could a book satisfy his need to move forward, always? *Fashion Climbing* is, in many ways, his most unusual project. Of course at the end of his memoir he uses his story to help point the way toward fashion's future.)

As a preternaturally cheerful person, Bill seemed not to ever feel alone—after all, he had himself. Born to a middle-class Irish Catholic family in Depression-era Massachusetts, Bill was raised just outside Boston; as a little boy he loved fashion more than he longed for anything as unimaginative as social acceptance. He begins *Fashion Climbing* this way:

> My first remembrance of fashion was the day my mother caught me parading around our middle-class Catholic home. . . . There I was, four years old, decked out in my sister's prettiest dress. Women's clothes were always much more stimulating to my imagination. That summer day, in 1933, as my back was pinned to the dining room wall, my eyes spattering tears all over the pink organdy full-skirted dress, my mother beat the hell out of me, and threatened every bone in my uninhibited body if I wore girls' clothes again.

A familiar queer story: being attacked for one's interest in being one's self. Still, there is no rancor when Bill says: "My dear parents gathered all their Bostonian reserve and decided

the best cure was to hide me from any artistic or fashionable life." But this was not possible. He would be himself, despite the pain. After he found work as a youth in a high-end department store in Boston, there was no stopping him, really, and no turning back. After Boston, the move to Manhattan where he lives for a time with more disappointed relatives, secures a job at Bonwit's, and designs his first hats. The startling optimism of his outlook! In 1950, when he was twenty-one, he was inducted into the army. "At first I was heartbroken at the thought of giving up all the years of hard work," he writes, "but I never had a mind that dwelled on the bad. I always believed that good came from every situation." He would love despite the cruelty he had been given. It's like watching a movie—Bill post-Bonwit's, working as a janitor in a town house in exchange for a room to show his hats. The other residents are straight out of Truman Capote's *Breakfast at Tiffany's* and still, despite the mayhem—there's even a flood—Bill presses on, and presses against our hearts because of his acceptance of others while maintaining very strict standards for himself. Living on a scoop or two of Ovaltine a day when things just weren't happening financially, he fed on fashion and beauty; there was no shortage of it in all those glistening store windows advertising so much that's been forgotten. I don't think it's too much to compare Bill to the Catholic art collectors John and Dominique de Menil, who regarded their commitment to beauty and supporting artists as a spiritual practice, a form of attention that was a kind of loving discipline: you could love God through his creators and

their creations. There's a nearly unbearable moment in the 2010 documentary *Bill Cunningham New York* when Bill is asked about his faith—his Catholicism. It's the only time he turns away from the camera; his body folds in on itself. I turned away from the screen in that moment, just as, when Bill was the smiling recipient of the Council of Fashion Designers of America's Media Award in Honor of Eugenia Sheppard in 1993—he collected the award on his bicycle perch, of course—I turned away, too: How could such goodness be possible? In the world of *fashion?* Such tenderness—it would kill you and Bill if he didn't have an essential toughness, too, a way of looking at fashion's transformative value, its ability to make and remake the spirit, without being sentimental about it, any of it.

Fashion Climbing more or less closes with his realization that hats are going out of style and the originality he ultimately achieved as a milliner is to no end because by 1964 who wears a hat? "Constant change is the breath of fashion." Bill proves, in *Fashion Climbing,* that having a fashion personality is distinct from being a person who's interested in style, and how style grows out of the kind of self that turns the glass of fashion to the wall. (As writer Kennedy Fraser observed, style is fashion's "anarchic" cousin who refuses to play by the rules.) Toward the close of *Fashion Climbing,* Bill writes: "The wearing of clothes at the proper place and time is so important." That's because they tell a story—not only about the wearer, but also about her time. How dare one not pay attention to the world one lived in, a world filled with the gorgeous tragedy of what is happening

now, never to be repeated. For the fashionable minded (Bill never liked ladies in "borrowed dresses," he said) and other followers of the herd, Bill offers a kind of prayer:

> Let's hope the fashion world never stops creating for those few who stimulate the imaginations of creative designers, and on wearing their flights of fancy, bring fashion into a living art. There's only one rule in fashion that you should remember, whether you're a client or a designer: when you feel you know everything, and have captured the spirit of today's fashion, that's the very instant to stand everything you have learned upside down and discover new ways in using the old formulas for the spirit of today.

The light that lit Bill from within—his heart light—was that of a person who couldn't believe his good fortune: he was alive. And I'm sure Bill knew that part of the privilege of life is our ability to have hope, that which is the backbone of all days.

FASHION
CLIMBING

The Doors of Paradise

My first remembrance of fashion was the day my mother caught me parading around our middle-class Catholic home in a lace-curtain Irish suburb of Boston. There I was, four years old, decked out in my sister's prettiest dress. Women's clothes were always much more stimulating to my imagination. That summer day, in 1933, as my back was pinned to the dining room wall, my eyes spattering tears all over the pink organdy full-skirted dress, my mother beat the hell out of me, and threatened every bone in my uninhibited body if I wore girls' clothes again. My dear parents gathered all their Bostonian reserve and decided the best cure was to hide me from any artistic or fashionable life. This wasn't hard in suburban Boston; a drab puritanical life prevailed, brightened only by Christmas, Easter, the Thanksgiving Day parade, Halloween, Valentine's Day, and the maypole costume party in kindergarten. My life was lived for each of these special days when I

could express all the fancy thoughts in my head. Of course, Christmas was the blowout of the year, and I started wrapping the packages months before anyone dreamed of another Christmas. The tree ornaments were packed away in the attic, where I usually dusted them off with a trial run in midsummer and prepared a plan of decoration for the coming season.

When Christmas came, I must have redecorated the tree a half dozen times in the short week it was left to stand, and when New Year's Day arrived and the tree was to be thrown out on the street, a deep depression usually set upon me, as I tucked all the glamour, the shiny tinsel, away for another eternally long year, and only the thought of Valentine's Day with its lace-trimmed displays of love made life bearable.

Easter Sunday was always a high point. I can remember every one of Mother's hats, which were absolute knockouts to my eyes, but when I look back today, they were all very conservative. My two sisters and brother Jack (who was all sports-minded) and I were outfitted in new clothes for Easter Sunday. This was the dandy day of my life. I can't remember a thing the priest said during Mass, but I sure as hell could describe every interesting fashion worn by the two hundred or so ladies, and for the following few Sundays I kept an accurate record of which ladies wore their Easter Sunday flower corsages longest, emerging from the refrigerators for the Sunday airing.

The next excitement I can remember was the maypole costume party where I managed, much to my conservative family's embarrassment, to be a crepe paper pansy, violet, or daffodil. I always had a ball playing make-believe, and usually

got hell when my mother got her hands on me, as I'd play with the girls, mainly because their costumes were the most beautiful roses. The boys were bees and caterpillars, which didn't interest me a bit.

Summers were a fashion desert. Our small beach house on the south shore of Boston allowed nothing but bathing suits and T-shirts, and lots of horrible sunburn on the miles of salty beach. No one ever wore anything colorful or gay. Each Sunday's church was the only adventure as my brother and sisters

and I were wrapped in starched white clothes and chalk-white shoes. During the reading of the Gospel, I eyed every woman and decided who was the most elegant. It was a wonderful game, and by the end of each summer I would produce my list of the women at the beach whom I thought most exciting.

Going back to school was really the monster for me. I couldn't have cared less about reading, writing, and arithmetic—and they cared much less for me! It was only through the grace of God and the teachers, who didn't want to have me around another year, that I finished each school year. The only class I remember was a weekly one-hour art session where the most delightful, slightly eccentric teacher would read *Winnie-the-Pooh* and tell us about Mrs. Jack Gardner's Venetian palace, set in Boston's Back Bay. This was my hour of pure dream and fantasy. Of course, I immediately fell passionately in love with Mrs. Jack Gardner and her gilded palace, and to this very day she is my inspiration.

Life really began for me on my first visit to Mrs. Jack's. That marvelous art teacher took the class to view what she called a "Renaissance splendor." It was the opening of the doors of paradise for me, and there was no stopping my desire to create a world of exotic beauty. No matter how many times my mother caught me wearing my sister's first long party dress, which was peach satin—and I know I wore it more than she did—I knew my destiny was to create beautiful women and place them in fantastic surroundings.

After school was the most fun, as I would hide in my room and build model airplanes and theatrical stage sets. Each

month I would concoct a special display for the season, and I was forever talking the girls next door into putting on a dramatic play where I made all the crepe paper costumes and usually ended up wearing the highest crown or the longest train of purple, trimmed with my dad's notepaper ermine tails.

Mother's wedding gown, covered with embroidery and pearls and tiny satin roses, was the hidden treasure that I was constantly unpacking for another look. Actually, it was the only beautiful thing in the house.

Radio was a huge influence, to which I give credit for my strong imagination. Instead of doing school homework, I would be listening to *Stella Dallas*, *Helen Trent*, and my favorite, Helen Hayes, who led the glamorous New York life. In my imagination I dressed each of these soap opera ladies, designing for them all sorts of fancy clothes.

As kids we weren't allowed to go to the movies except on Saturday afternoons, when some rough-and-tumble cowboy affair would scramble across the screen. I couldn't have cared less; I was just itching to get back to the movies on a Saturday night instead and see Greta Garbo, Carole Lombard, and *Gone with the Wind*. Unfortunately, I never made it, and these movies remained totally unknown to me until the late 1950s, when I saw them in revival.

In later years, after-school jobs were part of my upbringing, which I enjoyed very much, as they paid me money that I promptly spent on something colorful and pretty at the local Woolworth's five-and-dime. Shoveling long driveways of snow allowed me to indulge in elaborate gifts for my mother and

sisters; I would shovel snow all day long just to get my frozen hands on some money to buy beautiful things. One time I bought the supplies to make a hat. It was a real dilly—a great big cabbage rose hung over the right eye, and all sorts of ribbons tied at the back of the neck. My mother nearly collapsed in shame when she saw it.

I was a newspaper delivery boy at twelve, and each morning got up at five thirty to pedal my bike around the neighborhood and collect five bucks at the end of a week. After the first month, I saved my money, slipped in to the city of Boston on my first trip, and bought a dress, which I thought was the most chic thing in town. It was black crepe and bias cut, and had three red hearts on the right shoulder. As usual, Mother nearly had a fit. Now I was buying her clothes. Her reply was, "Think what the neighbors will say!" These were famous last words with my mother and dad.

My family had a whispering thought that I'd be a priest. And all this attraction to feminine fashion didn't help their hope. But what Irish Catholic family didn't dream of its eldest son being a priest? I always knew I wasn't priesthood material as I was sewing away from some devilish fire, flaming inside the deepest corners of my soul.

The paper route made life worthwhile, giving me the loot to indulge in a little fashion fantasy, and as fast as I'd buy the newest styles, Mother would return them. I would counteract with another dress or fake diamond bracelet. My next job was delivering clothes for Mr. Kaplan, the local tailor. This was the beginning of my understanding what made beautiful clothes.

Here I learned all about the construction of coats and suits, the fine technique of pressing and shaping. I also earned more money, and my two sisters soon fell under my assault of buying clothes, always making secret trips to the city and visiting the fashionable stores. My favorite was Jays on Temple Place. The facade of the terra-cotta-colored building was decorated with silhouetted ladies sitting on French chairs, admiring themselves in the style of 1910. Inside, the smell of perfume and champagne and wall-to-wall carpet made me want to buy everything in sight. They had the best-looking shopping bags in Boston, with a silhouetted lady and the name Jays giving the carrier great distinction. Of course, I was proud as a peacock, carrying the package home to my middle-class neighborhood. (I was the worst snob in town.)

By the time I was twelve, the family was in a state of frenzy over how they could knock this artistic nature out of me. Finally, it was decided that a trade school, where my hands could be the learners, was the only solution for a safe future. I enrolled at Mechanic Arts High School, where I learned carpentry. My spindle-legged tables were a howling success and caused a great deal of hell-raising with the people who wanted plain, sturdy-legged tables. I just couldn't resist putting the wood on a lathe and making all the fanciest turns I knew how. The classes were anything but fashionable. They consisted of sheet-metal work and a blacksmith's shop where we had the best fun. What I couldn't do with the blowtorch and anvil! Everything I made had curlicues and twists . . . I suppose you might call it Irish baroque. Along with all those shop classes

came algebra, which I could never figure out, and history, which I was terrific at, from a costume point of view. I couldn't recite a word of Shakespeare, but I could sure draw a costume for every character in the plays.

What made these school years livable was an after-school job at Jordan Marsh Company, the city's largest department store. At two thirty I was out of the school prison, trotting down fashionable Boylston Street with more enthusiasm than I'd shown all day, observing all the windows of the most fashionable shops in Boston. A special delight was sizing up the august Beacon Hill dowagers who would be going to tea at the Ritz Hotel. I often dallied outside its doors just to get a glimpse of some fascinating women. Jordan Marsh was across the Boston Common, in the commercial section of town, surrounded by Filene's and the other big stores that just swallowed me up. At Jordan's I was a stock boy in the ready-to-wear departments, and had the time of my life pushing the big carts through the store. My favorite departments were better dresses, furs, and handbags. The store had an elegant quality that disappeared after my days there in the early 1940s. A grand stairway curved up through the central rotunda; mahogany showcases gave a proper Bostonian attitude to the high-ceilinged main floor.

I wasn't there but a few weeks before I knew the best merchandise from the plain, everyday stuff. I was always finagling a deal, until I got to push the racks with the best dresses down to their department, where I carefully scrutinized every one I took off.

I would unload the stock truck of the handbag department

like I was unveiling the emperor's jewels, making sure I set the bag on the counter so customers felt they had just discovered something they had never seen before. If the salesgirls didn't make a few sales during the performance, I was crushed. The store's glove department didn't interest me, but its buyer wore the most exciting hats. They were tall Lilly Daché turbans, the likes of which few Bostonian women had ever seen. They had a sense of drama. This buyer also wore the first silver foxes without legs, tails, and heads I had seen. It was a knockout when everyone else in Boston was cherishing all those legs, tails, and heads. As a matter of fact, for years they continued to wear it like that in Boston, and didn't think of cutting them off.

My first six months' salary went to buying a pair of these silver foxes for my mother. She hardly ever wore them, feeling they were too daring and showy.

At this time I started covering myself in outrageous bright shirts and ties. I bought the first fake-fur-lined trench coat with the biggest fur collar I could find, and nearly drove the family crazy with shame, wearing it on the first cool day of September. I just couldn't wait to get it on my back and parade into school—although I almost fainted from the heat in the rush-hour crowd in the trolley car. Clothes were everything to me, and I think I spent seven days a week deciding what I'd wear the next week.

Life at Jordan's was fabulous, and had they given diplomas, I would have graduated with honors. That said, I almost got canned at one point. It was during the parade at the end of the Second World War, and I felt the store should do something in

the way of a big display. Of course, they had already hung the world's largest American flag over the Washington Street facade of the building, which made Filene's flag look like a postage stamp. But I thought I should add some of my own flair, so I went through all the men's rooms in the store, taking the rolls of toilet tissue and stashing them up on the roof of the store, at the corner of Washington and Summer Streets, the busiest intersection in Boston, where the biggest crowd was sure to assemble. After collecting dozens and dozens of rolls, I began to unroll them over the heads of the marching soldiers. It was an instant success, as the white rolls whipped down in huge white streaks! The crowd below went wild with delight as the unrolled ends bounced off the heads of the cops. Within fifteen minutes the intersection was a blizzard of toilet paper, which became a spectacular tangled mess in all of Filene's flagpoles—it took them months to unwind it. In my enthusiasm in creating a living display, I had completely blocked the window view of the store's president, Mr. Mitton, which was right under where I was standing. I had hardly unrolled the last of the paper, when the hands of store detectives, executives, and Boston cops hauled me before the exasperated president.

After three years in the women's fashion department, I was sentenced—because of the toilet paper episode—to the home furnishings department. The only excitement there came from the fabrics and colors, especially in the towel and linen department, which generated gigantic sales from customers replacing the war years' drain on their linen closets. My stock cart would

be piled eight feet high with towels of brilliant color: flamingos, blues, greens, roses. Up to this time, toweling had always been pure white, and I must say I took real delight in mixing all the colors onto the counters—almost like painting. The department was a wonderful education in the rare laces and damasks used for table covers, and I was given great insight into the weaving of materials. The assistant buyer was a wonderful gal by the name of Nancy Peckham, who wore the best-looking hats, and introduced me to the *New Yorker*, which we would hide away in the stockroom and read like the Bible most of Friday afternoon. The buyer was a very quiet sort of man who could freeze you out quicker than any windstorm. But he was very nice to me, and gave me my first tuxedo to wear to the many school proms and debutante cotillions that were taking place.

These dances were social highlights, and I attended every one I could get an invitation to. They presented the delicious opportunity of bringing fresh flowers to all my favorite girls of the moment, and I definitely chose my girlfriends because of their chic. If they didn't wear just what I thought was the right gown, that ended the romance. I had two favorites in my first year of high school, Barbara, who looked like the traditional debutante and dressed with respectable taste, and Gloria, who was the Brenda Starr of my life. Gloria and I got going on glamorous Hollywood living. Her great ambition was a mink coat, and we made the most uninhibited entrances into the local ballrooms. The neighbors were talking for weeks. We were considered fast kids. Also, she drove her own convertible, and

dyed her hair to match it. She was fabulous and all the guys
wanted to date her, but after the first night they were scared to
death, because all Gloria would talk about were her dreams of
mink coats, vacations in Florida, new cars, and twenty-room
houses with five maids. As you can imagine, in a middle-class
neighborhood this went over with anything but a bang. But
Gloria and I were a pair; I remember a dance at the very con-
servative Vendome where Gloria, who was sixteen years old,
caused a sensation. All the girls wore birthday-party-pastel
gowns, but Gloria made her own from thirty yards of navy-
blue net, and jeweled stars sparkled across her strapless top and
the front of the skirt. It was really a ravishing affair, and we'd
have been tops at the party if it hadn't been for Gloria's sister,
who was by far the most entrancing girl in town. Her slithery
crepe dress, draped up on one side like you saw on the movie
queens, practically got us all expelled from school. I guess it
was what you'd call early vamp.

During my last year at the trade school a swanky Fifth Av-
enue New York store bought and started remodeling the old
Museum of Natural History. This was to be a new fashion
store. I passed it each afternoon on my way to work. The site
for the store was superb—the lovely old redbrick museum was
set in a block-wide park of trees and shrubs. All this right in the
center of the most exclusive shopping area. The store was to be
Bonwit Teller's first branch. The excitement over its opening
in Boston was terrific. For a whole year, every cup of tea
downed in Boston was followed by gossip about the extrava-
gance of the New York store spending a million dollars to

renovate and decorate this old museum. White sheets covered the building's windows, and all the work was directed from New York under great secrecy. As the September opening neared, everyone wondered what kind of store it would be. No display windows were installed in the mansion-like building. The word was out that it would remain like a private estate. William Pahlmann, New York's answer to Elsie de Wolfe, was the interior decorator. Huge crates arrived daily from the antiques shops of Europe and Third Avenue. The suspense was killing, as I would pass each day on my way from school to Jordan Marsh. When the first newspaper announcement appeared a month before the opening, all of Boston was shocked, as the extravagant New Yorkers bought an entirely blank newspaper page with a tiny Steinberg drawing of five superb Beacon Hill dowagers standing on a platform in an upper corner, all dripping in fur, frantically waving their lorgnettes at the empty page. For a month, this teaser advertising continued, with never a mention of Bonwit Teller. In the ad, a long pole from under the platform on which the ladies stood ran down the side of the page to the lower corner, where gears and wheels lowered the ladies further each day. On opening day, all the Boston newspapers showed two totally blank pages, with the Steinberg platform finally lowered to the bottom of the page, and the five ladies madly running across it toward a two-inch-high drawing of the new palatial Bonwit store. The ad campaign caught everyone's imagination, and really put the lorgnettes of Boston on its doings. I had passed the store each day during its construction, and I couldn't stand the suspense any longer. I had to

get right in the middle of all the excitement. Two days before Bonwit's opened, I quit my job at Jordan's against the better judgment of the vice president, Cameron Thompson, who told me that Bonwit's could never last, and they'd be dumping all the help within a year. But no one could stop me. All this glamour had really shaken me up. I had to be in the middle of the soup.

Bonwit's hired me the same afternoon I left Jordan's, as a stock boy for the designer clothes. I was to keep track of the Diors and Adrians. My head was in a swivel of excitement as I crawled around the gorgeous clothes. And when it came to the romantic ball gowns, I thought I'd die of happiness! The store opened on a bright Indian summer day. The gardens around the store were freshly planted in a rioting color of chrysanthemums and shrubs; the grass lawns were like velvet gowns. From the grand stairway, a red carpet flowed out to the street. Two striped metal tents with sides of glass flanked the huge stairway. These were set on pillars of marble. They were to be the display cases, and the only indication that this was a fashion store. The white sheets had been dropped from the windows, and the dazzle of beautiful crystal chandeliers blazed through every window. The first floor overwhelmed each visitor with sumptuous French decorations, made more extravagant by the daring use of pale pastel walls and carpets, and damask upholstery. (At that time, pastels were not used in decorating; instead dark greens and grays were dominant for interiors.) Off this large entrance room were four separate salons, each decorated

in a different French period, with not a hint of what was for sale, until a saleslady wearing the daring New Look of Dior—tight bodice, full skirt to the mid-calf—presented the handbags, shoes, lingerie, and gloves that occupied the four rooms. Most of the opening-day guests were still wearing war-length to-the-knee skirts. The whole effect of Bonwit's was as if Paris had been transplanted into twentieth-century Boston. The stuffed birds, bees, butterflies, and serpents that had once filled the rooms had disappeared, leaving only their plumage, rare skins, and delicate wings, which were turned into the most exquisite handbags of alligator, scarves of ostrich feathers, shoes of snakeskin, and silk stockings with the delicacy of butterfly wings. And the silkworm had turned its dark nest into a glittering salon where the most seductive lingerie in the world could be seen.

Great excitement centered on the forty-five-foot-ceilinged grand salon on the second floor. Here, a mammoth whale had once been suspended from the ceiling and delighted millions of Boston children. It was my favorite room in the museum; as I now stood in the middle of the huge salon, my eyes almost fell out of my head. A magic wand had turned the room into the most glorious ballroom imaginable, fit to please an empress. Three gigantic crystal chandeliers dangled and danced from the gilded ceiling, where the immense black whale had slept. The floor, which had held cases of sharks, flying fish, and other great beauties, now held the rarest French chairs, tables, and sofas covered in satins and velvets. The dark, dingy oak walls had

been transformed into mirrored and gilded underwater grottoes. Ruby-red drapes fringed in gold dripped from the thirty-foot-high French windows that opened onto a royal balcony.

The four rooms that led off the halls of the grand salon once housed lions, tigers, leopards, and dozens of precious jungle animals. They were now the fitting rooms and stockrooms for the top designer clothes of the world. Here the New Look of Dior brushed shoulders with thirty-thousand-dollar Russian sable coats. Three maids strutted through, spraying the rarest perfume from rock crystal flagons, which sat upon silver platters with pearl satin pillows. I often thought the jungle beasts that slept for so long in these rooms were still lurking in the shadows. Every now and then the frightening screams of hysterical women being fitted in the finest creations made me feel the jungle of wild beasts and that of the tame human were quite the same.

The next floor was a mezzanine between the second and third. These rooms had been a delight to Beantown kids as they squeezed their parents' hands and peeped at the ferocious gorillas and a hundred different monkeys that had played in the glass cases; now there was a splendid French Victorian millinery salon displaying the most frivolous hats in the world, which would have made the apes and monkeys shriek with laughter as proper Bostonian women admired their heads in Paris's latest whimsy.

The third floor was decorated in the manner of a country house, where sport clothes and young college girls replaced the seashells and other natural studies.

It was a sumptuous opening: famous New York designers lapped up the free champagne while rubbing shoulders with the Four Hundred of Boston. All the Yankee bluebloods were there, along with the cream of Beacon Hill and Commonwealth Avenue. Bonwit's had staffed the store with Social Register help, and it was all going to be just too swell for words, till the New Yorkers soon discovered that the proper Bostonians didn't spend lots of money on clothes. As a matter of fact, they hardly ever bought new clothes. I remember the first week; everything about the opening had been so ritzy and snobby that women were afraid to come into the store. One pedigreed dowager from Louisburg Square came in with a twenty-year-old gown that she thought Bonwit's would remake. I almost died laughing. Here the stockrooms were sagging under the weight of the newest clothes, and the favored blueblood customers were bringing in old dresses to be done over! About this time the big-shot New Yorkers started to sober up and wonder about business. They wanted this store to be so exclusive, invitations for the opening were not sent to the wealthy ladies of the Jewish community. As you can imagine, this slight was the underground talk in Boston for years, and many in the Jewish community totally ignored the Boston store. Bonwit's had had a hell of a long pull putting the store in the black since that opening day. The store eventually ended up in completely different hands, where no such ridiculously stupid clique could insult a group of the community. Of course feelings were outraged at the time because the atrocities committed by Hitler had scarcely stopped when an antiquated minority of social

snobs dared to pull so brazen a segregating stunt in a store that supposedly opened its doors to the public.

The upshot to the story was that, within a year, the whole bunch of society women who opened with the store in executive positions were all thrown out on their derrieres, and the long, hard task of rebuilding an integrated image was carried on by a Texan, Mrs. Rosalind DeHart.

As the store changed ownership, it came to scarcely resemble the original glamorous decor. Eventually, you could hardly see the floor or the walls for the clutter of counters and merchandise hung everywhere. The fine French furnishings were replaced by hidden racks of lingerie and dresses, which were probably much, much better for business.

But the first year was wonderfully exciting to me. Each morning I arrived early and helped unload the trucks from New York. I saw every piece of merchandise that came into the store, and learned a great deal about design and how to use materials, and at any time I could tell you what was in every department. There was a wonderful freedom, and I was allowed to work through every stockroom and alteration room. It was a big, happy family; everyone was pleasant to get along with, the salesgirls often letting me help them sell the clothes. I was only eighteen at the time. One salesgirl, Dolly, had a fabulous customer who bought dozens of things on each visit. The lady also had two beautiful daughters, whom Dolly let me show

clothes to when she was busy with the mother. One time I sold the eighteen-year-old girl my favorite coat of the season. It was a Ben Reig design of cuddly brown chinchilla cloth, tight bodice and full skirt, with the back vent slit to the waist, and then closed with a row of twelve half-dollar-size black buttons. It was $395. I had almost sold the other sister an $1,800 Dior ball gown, when their mother called a halt to the episode. It's such a wonderful feeling to sell someone something you love and that you know they will enjoy. Selling fine clothes is an art equal to designing them. Unfortunately, it's an art unappreciated today. Today's generation thinks of it as a lowly occupation. What a mistake! Just think of the great art dealers selling the canvases of famous painters. The art of selling fine clothes has been lost in big, overcrowded department stores where the intimate personal interest is not important. That's why fine clothes from the most important designers are now being sold in small, privately owned shops around America. No elegant lady spending hundreds of dollars for a dress wants to push her way through a mobbed department store.

Everyone worked together at Bonwit's. When those winter blizzards hit the city, all the men, from the top manager down, had to come in and help shovel the block-wide sidewalks. We didn't have motor shovels then, just lots of backbreaking hand shoveling. Each season the store would put on a big evening show and cocktail party for the employees. This was to introduce all the new clothes. I had a ball dressing and helping to accessorize the salesgirls who modeled the clothes, and during

the showing I would dash around with my five-dollar camera, taking pictures of everything I thought was newest. Mrs. Rosalind DeHart, the second manager of the store, taught me one of the most important lessons of my life. She showed me how to observe every woman I saw, seeing how she was dressed and accessorized, and then taking her apart in my mind's eye and putting the right kind of clothes on her. I never go down the street or enter a room without automatically deciding what the woman should wear. It's probably the reason for the heavy development of my eye toward fashion.

The summer of my first year, the president of the New York store gave me a two-week all-expenses-paid trip to New York so I could experience the workings of the Fifth Avenue store. I was beside myself with excitement. At long last I was going to see the most glamorous city in the world. The trip was planned for the first two weeks in August. I lay awake nights with imaginary visions of the fantastic city racing through my head. The day of my departure dawned. It was a hot Sunday. I was to take the five p.m. Merchants Limited train from Boston's Back Bay Station. Needless to say, I was dressed and packed at seven in the morning, all ready for my big trip to the unknown. Mother nearly called a halt to the whole trip, as she thought New York was the hellhole of the world; only foreign people lived there. Then Dad reminded her that her brother lived in New York in total respectability, and after all, I was to stay with him and his family. Mr. Harrington, my uncle, was president of a large advertising firm, and my two cousins were there for company. Plus, my aunt had been my mother's childhood friend. With

everyone satisfied and feeling I would be safe in the tall-building city, Dad drove the family and my one suitcase from the summerhouse. The Sunday beach traffic was so slow that the car engine boiled over on the way. We had to stop and wait for it to cool off, and I thought I'd have pups for fear of missing the train. But luckily Dad was always an hour early.

As I got on the train, neither Mother nor Dad shed a tear. I was so excited at my first long train trip, I only remember trying to be very sophisticated. As soon as I sat down, I promptly began eating the sandwiches Mother had packed, and then pulled out a copy of *Women's Wear Daily*, thinking I'd appear professional, as this was the train all the buyers took to the city.

The train seemed to take hours, and I was so nervous I visited the toilet a dozen times. When we finally arrived at Grand Central Station, I wasn't scared at all. As a matter of fact, I felt like a big shot. My aunt and uncle weren't there to meet me, as they were at their summer home until Monday. Bonwit's had arranged for me to stay the one night at the Hotel Fourteen on East Sixtieth Street. Everything seemed to be deserted as the taxi sped between the tall Madison Avenue buildings. I had never been in a hotel before, and I was impressed and sure that this one was chic, as it seemed to be decorated with French furniture.

The first place I wanted to see in New York was the Waldorf-Astoria hotel. I had listened to Helen Hayes on her radio program, where she was always trailing in and out of the Waldorf in her most spectacular gown. I had hardly unpacked my bag when I left the hotel at ten p.m. and told the taxi driver in my

most sophisticated high-pitched voice that I wanted the Waldorf on Park Avenue. When the cab pulled up, I didn't want to get out, as I thought the driver had misunderstood me. The building outside the cab window looked like an ugly insurance company. Surely this wasn't the glamorous Waldorf, where movie queens swept in and out. As I entered the lobby, a second disappointment: there wasn't an inch of old-world glamour. The whole immense place was seething in drab, flashy 1930s decor. All my imaginary dreams were smashed. There were no great crystal chandeliers, and the few people milling about certainly didn't look like Helen Hayes. I left brokenhearted and walked back to the hotel with the French furniture. As I rambled along Fifth Avenue, the bright lights and imaginative window displays gave me new hope and brought back the thrill of New York to my mind. There were Saks, Bonwit's, Bergdorf's, and all the others. The clothes in the window displays were eight inches off the ground. This was really the New Look we had all read about in Boston, but hardly anyone wore. As I passed Bergdorf's I remembered what a New York lady then living in Boston had told me about the fabulously chic women who passed through its doors, dressed to the teeth. The clothes in the windows were not the birthday pastels that women in Boston were wearing—these were midsummer dresses of black and brown, dark colors. I knew I was where chic people would be.

As I went back to my hotel, I noticed that a nightclub, the Copacabana, was located on the ground floor off the lobby in the same building. I peeked through the door, but a maître d' in

full dress promptly froze me out. In the lobby of the hotel, I bought a postcard showing the notoriously famous nightclub. This I sent off to Boston, advising my parents of my safe arrival. From what I heard later, Mother nearly fainted when she got the card showing the almost nude dancing girls prancing across the club's stage—to think her little boy was corrupted on his first night in the Big City! My parents thought the people at Bonwit's must be shady characters for arranging my stay in such a rowdy hotel. The truth of the matter was, it was a very respectable hotel, three blocks from the store.

The next morning I was at Bonwit's hours before the store opened. The president, Mr. Rudolph, received me in his office, which was decorated like something off the 20th Century Fox movie screen. I was introduced to all the buyers and enjoyed a two-week training program, where the inside workings of each department were shown and explained. The people I met were all so kind, and many are still my friends. I was surprised to find they were no different from Boston people, and I never saw any of the "creepy foreigners" my mother was so worried about—the only difference was that people dressed with lots of fashion flair. It was a wonderful trip. Every minute was filled with fashion. The suit buyer took me on my first adventure to Seventh Avenue. We went to the Davidow showroom. They made the suits that sold best in Boston, with their thin collars and lush tweeds. Mr. Davidow and his brother were very kind and normal—they weren't anything like the highfalutin designers Hollywood movies had shown, and their showroom wasn't glamorous at all. Neither were their models the exotic,

fascinating vamps that had floated across the screen and pre-pared me for outrageous glamour.

Meanwhile, the Bonwit's New York store was a big twelve-story affair with none of the charm the jewel-like Boston store had. The New York store was in the process of being redeco-rated, and many of the nine selling floors were in the old 1930s mood; although the street floor and the sixth-floor gown shop were decorated with some of the feeling of the Boston store, there was none of the friendly intimacy. The departments I loved best were the custom millinery and the private salon of Chez Ninon. It seems Mrs. Park and Mrs. Shonnard, the own-ers of Chez Ninon, were close friends of the Hovings, who owned Bonwit's at the time. Mr. Hoving wanted a prestige sa-lon, so he leased the ninth-floor space to the exclusive shop. I fell immediately and madly in love with Chez Ninon, for here they were actually designing and making the most ravishing clothes I had ever seen. I was put in a room with a huge pad of white paper and a fistful of pencils and given a chance to show my design ideas. The door was shut, and my big opportunity was at hand. I nearly died of fright, and couldn't think of one idea, so I made horrible funny sketches of everything I remem-bered from the stockrooms of the Boston store. After the day of drawing, I was taken into the plush sofa-ed inner sanctum of the high priestesses, Mrs. Park and Mrs. Shonnard. There they sat like Dresden duchesses. Mrs. Park's white hair had been blued and curled in a fuzzy halo around her head; she wore a simple black dress, and around her neck and wrist were ropes of pearls, which she kept taking off and on, and she topped this

off with brilliant blue sapphire pins and rings that matched the clear blue of her eyes. She perched on a low beige satin damask sofa, with her feet in the most comfortable shoes, a sort of bedroom mule. Mrs. Shonnard sat at the desk. She smiled warmly, where Mrs. Park was brisk and had a let's-get-right-to-the-point attitude. Mrs. Park was from a Philadelphia Main Line family; her father was William Gibbs McAdoo, secretary of the treasury under President Wilson. Mrs. Shonnard, a real beauty with a gentle voice full of Southern hospitality, put me at ease. She had golden hair softly falling around her face, and a large white organdy scarf draped about her shoulders; a gold seashell pin held it in front. The two ladies, who many people said had the finest taste in New York, looked through my sketches. Out of the bunch they chose one dress, which was the only one that was really my own idea. I admired them so much for being able to pick the creative thought. Although Mrs. Park thought I was hopeless as a designer, Mrs. Shonnard felt the boy should have a chance.

The two weeks dashed by like two days. I had stayed at the fifteen-room Park Avenue apartment of my cousins for the last week, although I didn't see them, as they were away for the summer. It was all very glamorous, and the New Haven railroad trains would vibrate the apartment as they glided down under the glittering swank of Park Avenue. I remember the first night I stayed in the apartment, high on the tenth floor, I went around and locked all the windows, being still slightly afraid of the Big City.

Becoming William J.

I arrived back in Boston, and nothing was the same after the razzle-dazzle of New York. Bonwit's gave me a scholarship to Harvard, where I started in September 1948. But let's face it, after the glamour of the big city, the dull life of Cambridge wasn't going to soothe me. Nothing could stop me; I wanted to live and work in New York City. The classes at Harvard were like being in prison; I nearly drove my family mad begging and pleading to be set free.

After a lot of letter writing, I convinced Bonwit's to offer me a training program at the New York store, and I was welcome to live with my aunt and uncle. After a month of hell-raising with Mother and Dad, they decided they would let me try it. For the week before I left, all I did was tell my parents how good I'd be and that I would write them every day. Mother and Dad had reached the conclusion that they couldn't live with me as I was and that I might as well go and get it out of my system.

Plus, they were absolutely positive that I would become lonely, missing all my friends, and be back in Boston before the month was up. Well, I'm almost ashamed to say I've never been lonely in my life. I took to New York life like a star shooting through the heavens. And my parents always regretted letting me go. They could never believe that I would fall so completely in love with the city. When I arrived, the family had one rule: that I must continue a general education at night, at New York University, after my Bonwit work each day. After a few nights of school, I found myself playing hooky, and I would be at the opera each Monday, watching the elderly ladies. On other nights I would go as an observer to the fashionable balls, where I would take notes on all the styles, new and old, watching the way the gowns moved on the wearers, how the jewels hung, and how the hair laid on each head. This was my education. I scarcely attended any of the classes the family paid for—although they never knew the difference. To this very day my favorite pastime is people watching. It's one of the great educations of life.

It's a crime families don't understand how their children are oriented, and point them along their natural way. My poor family was probably scared to death by all these crazy ideas I had, and so they fought my direction every inch of the way. American society has a lot to understand about the natural creative desires of children. Parents should stop feeling ashamed of the arts, and this trend of thinking men who are interested in ballet, opera, and fields of design are just a lot of sissies has caused more unhappy family breakups. The country would not

have half the trouble with mentally disturbed people it has if parents would accept each child's God-given personality and stop trying to force what they feel is more suitable for their offspring.

In November 1948 I arrived in New York to live, on the opening Monday night of the opera. That was the night Mrs. Florence Henderson, a rich society matron, put her feet up on a table at Louis Sherry's restaurant during intermission. The next morning the world press was full of her picture, and I knew my fashion-climbing days had really begun. This act of public defiance to the old order was something Mrs. Isabella Gardner might have shocked staid Boston with fifty years before, but no one has so much as wiggled a toe in Boston since. Now I was in the swing of life, the very night the opera opened and Mrs. Henderson's legs on the table caused a near riot.

New York wasn't to be so fabulous for me for a while, as the Harringtons were a very rich and a very conservative family, plus my uncle and my two cousins Dick and Donald were ashamed to tell their friends that I wanted to be a fashion designer, making women's clothes. My aunt, not wanting to get mixed up in a family fight, stayed neutral, explaining that each person has a right to do what they wish, so long as it pleased the eye of Almighty God.

Life at the Harringtons' was very grand—candlelight at the table each night as the maid and the cook served dinner. Weekends were spent at the lovely country house in Connecticut. This was a big change from Boston, where we lived a very quiet, unpretentious life of baked beans and hamburgers every

Saturday night. Occasionally, wealthy friends of my cousins would zoom us down Park Avenue in their chauffeured limousines to parties in magnificent apartments. I remember one where all the bathroom fixtures were made of gold.

AT BONWIT'S I SPENT A MONTH learning the way of each department. It was a fabulous training I'll be thankful for the rest of my life. Miss Ross, the head of stock, and Miss Dawson, the buyer, would explain the signatures of all the designers and what made their designs worth the money. I became enchanted with the millinery department, and spent all my free Saturdays in the workroom learning to make hats. The young milliners showed me the first steps in making millinery. I saw the ladies of Chez Ninon almost every day, and they became my guardian angels. The first Christmas I worked in the 721 Club, a gift shop for men on the store's second floor. It was wonderful excitement, going around to pick up from all over the store what you thought would be just the right gifts for men to give women. The men were given cocktails, and with a little encouragement from the beautiful salesgirls, the sales were phenomenal.

All during this holiday time, there were lots of fancy headdress balls, and masquerades being given by society for charity. There were small dances and supposedly only the best people attended. These were the beginning of the avalanche of charity parties that marked the main divertissement of New York swells during the 1950s. Of course, I never had tickets for any of these parties, and would gate-crash just to be an observer,

always peeking from behind some silk curtain or potted palm. The first ball I remember well was a headdress ball given at the old Ritz Hotel. Many of Chez Ninon's customers and friends were going. Nona Park and Sophie Shonnard suggested I make some fancy headdresses to go with the ball gowns. I was thrilled to my toes; this was my first real designing assignment, and the headdresses were going to be worn with the most original Paris gowns, by some of the leading New York society women. My aunt let me turn one of the maid's rooms at the apartment into a tiny workroom. This was my first shop, and I worked every night until the early morning hours. The feathers and flowers were really flying; birds' wings were my favorite form of expression, as their grace and movement were full of romance. The millinery supply houses on Thirty-Eighth Street soon became familiar to me, and I found huge black wings left over from the extravagant 1910 period. I made nearly twenty-nine headdresses, without my uncle or cousins ever knowing what I was doing, as they rarely set foot beyond the kitchen. But on the night of the ball, when I was frantically rushing to finish the work, my uncle wanted to know why I had not gone to Bonwit's and why I was missing from the dinner table. When my aunt broke down and told him, he stormed into the makeshift workroom and nearly killed me.

It was bad enough that I was working around women's clothes, but to be designing and making hats, right under his own roof, that was too much. For the following year, my uncle scarcely spoke to me, and everyone in the household was forbidden to speak about fashion. I'm sorry to say we lived like

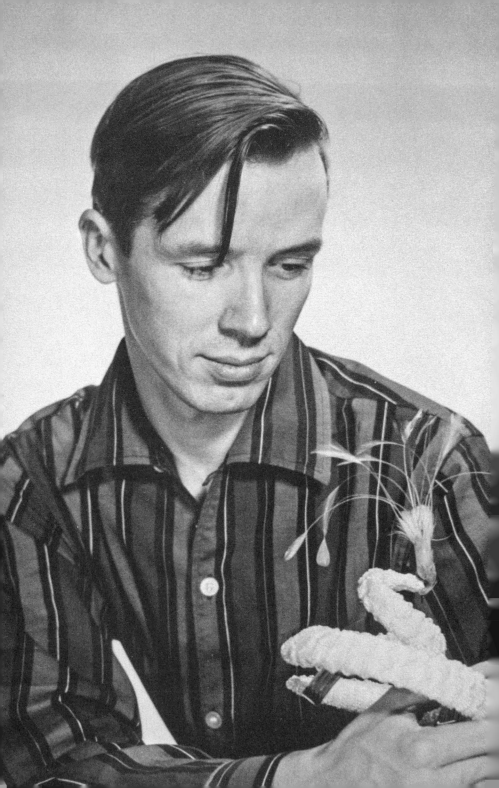

complete strangers, and it's a shame, as he was one of the kindest men on earth. I guess he was scared to death of all the homosexuals he had heard about in fashion. At any rate, my aunt was trying to keep peace, and my cousins, when they wanted to get me in trouble, would casually say I was making hats during dinner, and the whole situation would boil over again.

By the end of the first year in New York, I was working in the advertising and publicity and art department of the store, and making a few hats from the store's workroom, as continuing them at home was out of the question. One of Bonwit's artists, Miss Janet Kegg, liked my work and enjoyed wearing my creations out to lunch in hopes of getting me a customer. Often she did. Janet also designed my trademark—a lady with a dozen hats piled one on top of the other on her head. It was a great success all throughout my career.

One afternoon while we were dabbling around the art department, Janet and I decided to give a showing of my hats. We requested an appointment with Mr. Rudolph, the president, then took a big Bonwit's hatbox and pasted what we decided would be the designer's name over the label. So my family wouldn't get excited, I called myself "William J.," leaving off my last name. We borrowed a black crepe Traina-Norell dress from the designers' salon for Janet to wear, a slithery trumpet affair. From the fur department came a black fox scarf, which, combined with some long dangling jet earrings, made Janet the vampire model of all times. I wanted her to knock the president right off his chair. At the appointed hour we sashayed into his office, Janet swinging the borrowed fox and I the disguised

hatbox. Mr. Rudolph was quite shocked at the getup. Janet looked more like a tart than an elegant lady, as the dress was a size too small and stretched tight over the fanny. The long earrings never stopped swinging, and that damned black fox hit me in the face each time Janet swung around for me to help her try on another hat.

When the showing was over, Mr. Rudolph advised us to return the borrowed clothes and said the hatbox looked too familiar. As for the hats themselves, he gave me some of the best and kindest advice of my life: first, he said, to be an original creator, using only one's own ideas would be the true way to happiness. He gently told me I'd been influenced by everything in the store, and that this was not the makings of a true designer's signature. He advised me to make six new hats, using only my own thoughts, no matter how bad people might find them. He said they would represent a true "me." This was to be the hardest lesson, that of throwing off outside influences and making definite designs of my own.

The publicity department used one of the hats from this showing in some photographs they took for the *Christian Science Monitor.* I was really thrilled to see one of my hats in print, although no one ever asked to buy it. Soon after the showing, Mrs. Hoving, the wife of the owner, while at a party inquired about a friend's hat. The lady said, "That darling little boy in your store made it." Well, Mrs. Hoving didn't know of any darling little boy making hats in their store, so she got on her high horse and found out that I was designing on Saturdays and selling the hats to Chez Ninon customers. Mrs. Hoving raised holy

hell and had me fired from the store (a gesture for which I am eternally grateful, as it was the push I needed to start on my own). Nona and Sophie, who owned Chez Ninon, were so displeased at Mrs. Hoving's action that they forbade her from entering their salon. The truth of the matter was, Mrs. Hoving was such a nagging customer, driving their fitters and tailors mad demanding a dozen fittings on each garment, that Nona and Sophie were thrilled to get rid of her.

Just as I was thrown out of Bonwit's, a fabulous masked ball on December 5, 1949, put me in a frenzy of creating elaborate masks where my imagination could fly to the world of make-believe. I produced almost fifty masks. All this was done while the maid and the cook hid me in the back room of the apartment. The night of the ball nearly drove my aunt and uncle into a hysterical battle, as the secretary of the air force's wife, Mrs. Talbott, kept calling on the phone asking for more masks for her friends. Mrs. Talbott was a dear woman, and really helped me launch myself with all her society friends. She even took me to the ball and let me sit at her table as a guest. It was from this money made with the masks that I opened my own business the following day.

The principal reason for me to start my own business was to bring happiness to the world by making women an inspiration to themselves and everyone who saw them. I wanted fashion to be happy—but oh my God, what an idealist I was! The road I was to travel was full of thorns, where women wanted to use fashion for impressing friends, climbing the social ladder, and everything but sheer enjoyment. Social climbing had been the big

New York sport of the 1930s and '40s, when swanky nightclubs became playgrounds for a once-private society. I immediately felt the new game was to be fashion climbing. As we had no king and queen of America, and no Duchesses of Texas nor Dukes of Brooklyn, there was only one possible distinction: FASHION. I felt rich women would embellish their social images by wearing designers' fashion. The press, always looking for a new angle to report on Who's Who with Whom, and Who's Wearing What, gobbled up the new status of designer-label clothes. Fashion designers were to become raving celebrities equal to the past Hollywood queens. Jacques Fath and Christian Dior and most of the Paris designers became the prize property of every conquering social lioness. Fath was a sensation with all his parties, and his designs represented a spirit of joy that life had not known. In Paris, it mattered little who your ancestors were so long as you wore a Fath or Dior original. Fashion-climbing women were spiraling up the ladder at an alarming rate, to the dismay of the old names of the Social Register. Out of all this came what is known as the international society climbers, who weren't satisfied with New York, Paris, or Rome but who established their conquests all over the world. American designers were slow in climbing, and not until the late 1950s did Norman Norell become the great American status symbol.

Fashion designers who reach the top and slipcover the bodies of a generation must deeply feel the spirit of the times. It's not just a little effective outward trimming that produces real talent but an inner mystical revelation that a designer brightens the world with.

My First Shop

In November of 1948, without the slightest idea of how to rent a shop—I never knew a thing about the *Times* rental section, I just thought you went along the street looking for empty windows, which is exactly what I did—wrapped in my fur-lined school coat and looking like I just got out of college, I went in and out of every building I saw with empty windows, inquiring for space. I decided my shop should be no further downtown than Hattie Carnegie's on East Forty-Eighth Street, and no further uptown than Fifty-Seventh Street, somewhere between Park and Fifth Avenues. Oh, was I ever dumb and innocent! As I dashed into buildings, breathless with excitement, most of the people I met thought I was pulling a school prank. When I saw what appeared to be empty windows on the top floor of Hattie Carnegie's, I walked right into the grand salon, where a frosty-eyed salesgirl said Hattie would be delighted to rent me the top rooms. She went on to say Hattie would be thrilled to see me,

and she wrote down Hattie's address, where I expected to be greeted with open arms. I was so sure of myself, and the three hundred dollars I had in my pocket made me feel I owned the world. With great dignity I rushed over to the address the salesgirl had given me, which turned out to be the insane asylum at Bellevue Hospital. I was so mad I could hardly see straight. Who did I think I was to just rush into Hattie Carnegie's and rent the top floor?

The next day, with fresh enthusiasm, the first rays of honest hope came with a charming little town house, 62 East Fifty-Second Street, formerly the residence of the mayor of New York around 1820, and a notorious speakeasy during the 1920s. As I walked up the front steps and entered the quaint Renaissance revival reception room—which looked down on a huge Hollywood-type medieval banquet hall with six desks on either side of a giant fireplace—a kind of moon-shaped face covered with freckles asked me what I wanted. The young lady of about twenty-eight turned out to be secretary to the six men who held offices in the three-story building. Her name was Kathy Keene. When I asked her about the empty windows on the top floor and my plan to open a millinery business, she thought I was a little mixed-up, but invited me to stay awhile and warm myself from the ten-degree cold outside. As we talked, she became more believing, and finally said to come back the following day, as there was a tiny attic room on the top floor that was empty. The second day, I was sitting on the doorstep when Miss Keene arrived to open the house. We had an hour before her bosses would come, so she briefed me on how to impress them,

as they didn't want to speak to some crazy kid about renting a room. Kathy was terrific; she told me to tell her boss the names of the women for whom I had just made masks, as her boss was a desperate social climber. Finally he arrived and called me into his office, but when I started telling him about my plan to be the world's greatest milliner and began naming some of my customers, the guy nearly fainted. He thought he'd caught a real live one. He figured he'd use me to meet all the ladies, so I was given the room.

Up tiny, winding stairs, were the offices of a movie talent scout headed by the niece of David O. Selznick, and another office for TV productions where dozens of passé radio personalities from the 1920s and '30s were desperately trying to make a comeback. On the top floor, a man in the front room wrote murder mysteries; he was a real spooky character. There, in the back of the house, was my first salon, a nine-by-twelve room with two large windows looking down to what once was an enchanted garden of fountains and statuary, now lying in despair after twenty years of neglect. Finally, we got down to the discussion of rent, which I wasn't prepared to pay. The price was put at fifty dollars a month. I immediately said I couldn't afford it but that I'd clean the house each morning before eight, for the use of the room. The owner was stunned by my unorthodox terms but decided he needed a cleaning man, and the deal was made. (Miss Keene, knowing I had little money, told me they needed a house cleaner.) Within two days I had left the glamour and comfort of Park Avenue for my garret, with just three hundred dollars in capital. I was a ten-cent millionaire, and

immediately rushed out to the Salvation Army store, where I bought slightly moth-eaten Austrian drapes and Louis Bronx French furniture. I think the whole room was decorated for about thirty-five dollars. Wallowing in French chic, I started making my new hats.

Separated from my glamorous salon by a three-panel cardboard screen that hid the workroom, I designed hats inspired by nature. Life-size apples hung on profile hats of red felt; daisies were wrapped around plaid duckbills, and a pixie cap of straw was molded into fruit shapes. These were truly happy times, and I waited quietly for my first client to come rushing up the narrow little stairway. But I must honestly say, they didn't come breaking through the door, and my three hundred bucks disappeared. Finally, I took a job delivering lunches for a drugstore on the corner of Madison and Fifty-Second. For this I made tips and got a free lunch. Nothing was going to stop me; my happiest moments were spent making hats, and I was bound to succeed. At night I got a job as a barker on Broadway, at the Palace Vaudeville Theatre. After a few weeks in the freezing cold, I got myself moved inside, where the Saturday night audiences would give a few quarter tips for better seats. I stayed on this job for about four months and then moved on to the Howard Johnson's restaurant across from Radio City, where I had lots to fill my stomach, and generous tips from the soda counter. My hours there were from five in the afternoon until two in the morning. In between all this, I designed the hats. The millinery supply houses were all kept busy counting out my payments, the piles of nickels and dimes I had made the

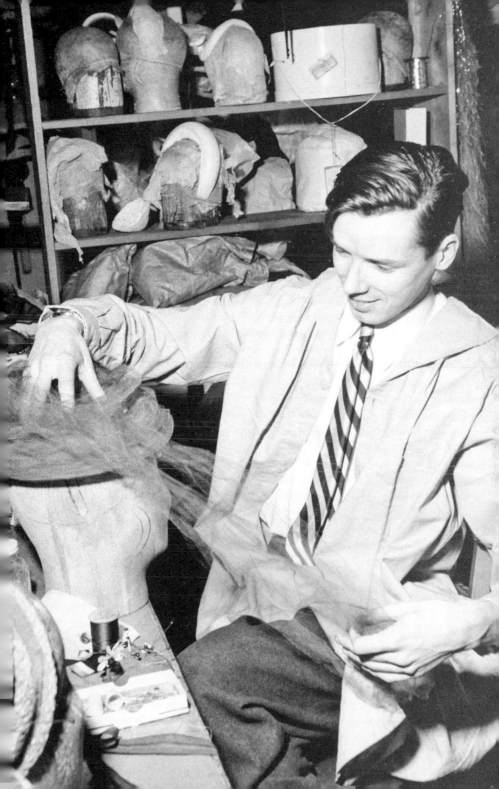

previous night. I never felt ashamed of any job, so long as I could pay my bills with honest money, although my poor family was embarrassed. I guess I caused them a lot of heartaches, but I just felt I had to do it on my own.

Each morning I was up at six o'clock cleaning the little brownstone mansion, then making hats, and occasionally having a customer sent by an old pal from Bonwit's. I think the entrance into the dark house and the climb up the narrow little stairway scared the hell out of most of the ladies. On Sundays, I would roam the streets of New York, after early church, feasting my eyes on the wonderful window displays, which are perhaps the best free show in New York, always winding up my tour at the public library on Fifth Avenue. There I would spend the evening looking through old *Vogue* and *Harper's* magazines, and their superb collection of costume books. I hadn't seen a fashion magazine until I was seventeen; my family didn't believe in such frivolities, and the closest thing to a fashion magazine was my sister's movie magazines.

I SHOWED MY FIRST PRESS collection in July 1949, working night and day to prepare fifty models, with the help of my first milliner, a darling quiet lady with an alcoholic sister who would arrive at the shop at the most unexpected moments, demanding money for whiskey. Wild scenes of screaming and fighting would often occur between the two sisters.

The day of the showing arrived, with the press and hopefully many of the ladies I had made masks and fancy party hats

for expected as guests. I was disappointed when the elegant ladies wouldn't buy my hats. I soon realized they wanted only fashions similar to the big names of Paris but made more cheaply by an unknown. My designs were too original, and they were afraid of criticism and being thought of as coming from the wrong side of the tracks. The road of a true creator is a long, hard trail, with little recompense at first. It's a bitter battle, but the promise of success in creating what you truly believe is so rewarding it makes the fashion ladder reach the gates of paradise.

Meanwhile, on earth, I had use of the kitchen in the basement, as the steam kettle could get up much more steam over a gas stove than my garret's hot plate. I needed the steam for hat making. One morning as I started the kettle huffing and puffing, to my surprise, baked beans came popping out of the spout. It seems one of the men in the house was on a bender and tried to cook lunch in my hat steamer. The people in the house were colorful, and anything could be expected. I was so naive I hardly knew what was going on between the bill collectors who were steadily filling the front office of the house, chasing most of the people who worked there, and the two men on the second floor who often displayed screaming tempers, scaring my sedate customers out of ever coming back. On one occasion, while I was fitting a deep cloche hat on a very timid Park Avenue woman, the cops raided the second floor, and the two men scrambled over the garden wall to adjoining Fifty-Third Street.

On another occasion, one of the movie producers, who was

being hotly pursued by the sheriff, came in late one night to gather all her belongings with the help of a now famous and respected movie actor. They were escaping to California, but before leaving decided to take what they thought was an antique. It was a bidet in the second-floor bathroom, and these two damned fools got ahold of the fire hatchet and began chopping the lead plumbing. In the midst of gushing of water, I woke up to see a waterfall flowing down the spiral stairway, pooling in several feet of water down below.

Despite all the wild carryings-on, my first show got off to a grand start. The old garden and the big Renaissance hall were lent to me for my showing, as all the people who worked in the room were hoping to meet my customers. I was also allowed to use the dirty garden, and found myself very happily cleaning it and arranging big bunches of peonies in glass light globes I had taken off the unused ceiling fixtures, which I planted in the sooty ground. The center fountain was cleaned out, and palms sprouted from its spout. The gals at Bonwit's modeled the hats. Of the seventy-five hoped-for guests, only six customers came, all hatted in my latest whims, and of the press, only one appeared, but she was the most influential and important in all New York: Virginia Pope of the *New York Times*. Most people would have thought the tiny audience a disaster, but I felt the queen herself was there, and no one else mattered. She graciously sat through the whole show, when I'm sure she could have used her time elsewhere. The next day a tiny paragraph appeared on the *Times* fashion page proclaiming a new de-

signer. This was the most important encouragement, and gave me reason to fight on—and what a fight it was!

One Fourth of July weekend, I remember having nothing to eat except a jar of Ovaltine, of which I rationed three spoonfuls a day. When I would feel the pangs of hunger, I would go out looking in store windows and feed myself on beautiful things. Particularly filling were the windows of decorator Rose Cumming, whose shop was on the corner of Fifty-Third and Madison. I would press my nose flat on the windowpane, looking at the most inspiring taste I had ever seen. Everything was different and unusual: I had never seen the likes of her materials, colors, and combinations. And then in the midst of all this exotic decor would be Rose Cumming herself, with her purple hair and a tiger-printed dress. I never met the lady until years later, but in those hungry days her shop would give me the burning desire to run home and create new hats. On weekends when the men who owned the house on Fifty-Second Street were away, Miss Keene would call me as soon as they left, and we would set up a millinery display in the first-floor window, removing their business signs. One weekend things got so desperate, I hung six hats on the city lamppost outside the house, and to everyone's surprise, sold several of them to a doctor's wife who was walking down the street in despair over her sad life. Seeing the hats on the lamppost seemed to give her a ray of sunshine, and she dashed into the house to inquire about them. She always claimed the hats saved her from committing suicide.

On other weekends, I would hock my bicycle in a Third

Avenue pawnshop so I could eat, or buy supplies for hats. The bicycle was my only way of delivering hats around the city, often pedaling up Park Avenue with the hatboxes dangling from the handlebars.

One Friday night I got an order for two hats but didn't have any money to buy material. The bicycle was already in hock, and the money had gone to save a bouncing check at the bank, so Miss Keene pawned her boss's typewriter and gave me the twenty dollars to complete the hats. Later, her boss made an unexpected return visit to the office, and Miss Keene very quickly threw two telephone books under the typewriter cover.

We couldn't afford labels for the hats, so I would spend my spare time gracefully painting the name William J. over three-inch squares of linen, clipped with pinking shears. In the fall of 1949 a miracle occurred: my star ascended, as one Miss Elizabeth Griffin, the daughter of Madame Shoumatoff (the lady who was painting Roosevelt's portrait when he died), came to my shop and liked the hats. The next day she returned with two other ladies. One was Mrs. William Hale Harkness, the multimillionairess of Standard Oil. The ladies decided they wanted to set me up in business, with three thousand dollars they had made on a small investment in the hit musical *Guys and Dolls*.

Within a month, Mrs. Harkness and I were partners and immediately opened a very grand shop on East Fifty-Seventh Street, all decorated in white and gold, with lots of crystal chandeliers. The rise to prosperity was so sudden that I spent

most of the three thousand dollars on decor. Mrs. Harkness, not having been in business before, never thought to ask if I had any business sense—which I definitely never had. At any rate, she had lots of Wall Street lawyers to protect her, as one of her friends had just lost a couple of hundred thousand dollars with a fashion designer who decided he didn't have to work and became a playboy with the lady's money.

At this point I found my second milliner while I was buying used mirrors in a shop that was closing. The ladies of the shop recommended their prize milliner, a lady by the name of Mrs. Nielsen. A date was set for me to meet Mrs. Nielsen, and I was a little afraid, as I thought the hats I'd seen in her shop were all for old ladies. When Mrs. Nielsen and I met, it was love at first sight. She says that when I told her I didn't have much money, but expected to make some, she couldn't resist and wanted to help me. Plus, I looked so young she could hardly believe it. My knees were showing through my pants, which were worn thin.

The first showing in the new salon was January 1950, and unlike my very first show, where only Virginia Pope came, now all the fashion world came knocking down the door. The excitement of the Harkness money was like honey to bees. Overnight I was discovered by the darlings and dearies of the fashion world who desperately climbed onto anything new with money.

The first store to buy my hats wholesale was Gunther Jaeckel. Their buyer, Miss LaGauche, bought from this first spring collection, and I can still feel the thrill of seeing my work in the Fifty-Seventh Street store window. It's always a

great compliment to designers to have their work exhibited. Erlebacher's, a store in Washington, DC, was the second to buy. They loved my wild hats, and especially a rather uninhibited number made of scouring pads from the five-and-dime store and stretched over a helmet of gold lamé, with big black feathers shooting out of it. But it was the conservative hats that paid

the bills; the hats that had excitement and fancy, however, were dearest to my heart. Birds and nature were always an inspiration. Graceful wings soaring through the air constantly gave rise to the best hats. Unfortunately, the cash-paying customers didn't think as I did, and I had to give away all the best hats so there would be room for more. I found, years later, that most of the fabulous trendsetting clothes of Paris and New York are lent to celebrities at no charge, so as to advertise the designers. All through history it's been this way. Seldom do the most fantastic clothes you see in the glossy high-style magazines sell. If you go into any top Fifth Avenue store at the end of the season, you'll be sure to find the most ravishing creations knocked down to a quarter of their original prices. The stores buy the clothes just to fill the dull, everyday stock with the thrills that make women buy.

I was really pretty dumb in those early days. I didn't even know the names of the famous Hollywood stars. One day Miss Keene rang me up from her desk on the ground floor to tell me that Dorothy Lamour was climbing up to see my hats. Kathy was all excited: this was our first celebrity, and she could have killed me when I said, "But who is Dorothy Lamour?"

I had another famous customer for whom I had been making hats for seven years before someone told me who she was; on my next visit, I asked my customer, whose name was Kay Francis, if she was a star. She laughed for weeks afterward, remembering how she had enjoyed our years of working together, as I had always treated her like a good friend, with none of the phony-baloney bowing and scraping. It wasn't that I wasn't

impressed by people; I always thought all people are equal. One day before I was fired from Bonwit's, Mr. Hoving said, "Bill, you're not afraid of anyone." And I looked at him with great surprise, and said, "No human being should be afraid of another, although we respect his high position."

During those first years of hat making, I went to my first Beaux-Arts costume ball in New York. On these fantasy nights, I would create the most fantastic costumes for my friends and myself. Never realizing there was a theme to each ball, I would create whatever was inspiring to me at the time. The first costume I made was Kathy Keene dressed as the most provocative ostrich you've ever laid eyes on. The base of her costume was an old Jantzen bathing suit, which we feathered and beaded; a huge court train of ostrich plumes gave it a Folies Bergère look, and a turban of peacock plumes made it like no other bird. The irreverent mixing of plumage didn't bother me a bit, and Kathy felt like a bird of paradise. She never fussed so long as I didn't cover her legs, as they were her great asset. As for myself, I was something right out of the ballet, with two live chickens, one black and the other white. I gilded each with glitter dust, by putting a little paste on the feathers. I tucked both birds under my arm, and off we went to the Waldorf, where the artists' ball was in full frenzy. I had planned to carry the two gilded birds into the ballroom before letting them loose on rhinestone leashes, but the big crowd of onlookers lining the hotel lobby, pushing and shoving to see the costumes, was just the right amount of encouragement to show off our complete entourage. As Kathy strutted across the lobby, I released the two chickens,

and all hell broke loose. The damned birds went wild, flying every which way. The rhinestone-studded leashes were snapping under the frantic strain. Our voluptuous entrance went haywire, giving the crowd a good laugh and severely damaging my dignity. As I jumped around the hotel trying to retrieve the gilded hens that were causing a real scene in the Peacock Alley restaurant, ladies were screaming, and waiters were running all over, trying to capture the birds. I never did get one bird back . . . it flew out the Park Avenue doors and caused a rush outside the hotel. Someone in the crowd subdued the bird and wouldn't give it back—seems they were bird lovers who wanted to turn us over to the police.

To make a long story short, we didn't win first prize, and the day after the ball, Kathy and I killed the bird, as we had no money for food for the weekend. (I had often chopped off birds' heads on my aunt's farm as a kid, and it didn't bother me a bit.) At another ball, I was still suffering from my bird obsession. This time, Kathy was dressed as a chicken coming out of a half-open egg. I then proceeded to make a huge six-foot sculptured wire cage to cover her. The poor thing had a miserable night trying to dance with the cage on, and I wouldn't let her take it off and spoil the costume. At the third costume ball, we finally won last prize, and caused the fire department to invade the Hotel Astor ballroom. Our costumed entourage consisted of five friends and me. We were a barnyard scene; over an enormous Marie Antoinette hoopskirt, I built a real haystack ten feet high, all covered with real hay. Underneath it we placed one of my shy friends. Kathy was again a bird, and I played the

big bad wolf with a grisly mask showing off a terrific set of uppers. We had to hire a moving van to get the haystack from the shop, where it had been hanging from the crystal chandelier, infuriating many of the customers who were trying to keep my mind on making serious hats. To get the haystack into the hotel, we covered it with muslin, as the firemen would have stopped any flammable costumes from going into the ballroom. As the grand march started, we uncovered our haystack and paraded out on the ballroom floor. The hotel officials and firemen nearly dropped dead of shock when they saw the haystack, and a terrible row started as they began to drag the haystack off the floor, fearing someone would throw a match in it. I kept pleading that it was fireproof, but I knew damn well it wasn't, and my shy friend who was underneath got mad as hell when they dragged him and the costume off the floor. When he was pulled out from underneath the mess, he threw a punch at the first person he saw, and then fists were flying. He ended up with a black eye. When the cops finally got the damned thing out onto Forty-Fourth Street, they took a match to it just to see if it was fireproof, as I had been claiming all the way out. Fireproof, nothing—it went up like the blazing neon lights of Broadway!

These costumes and nights of fantasy were wonderful for designers; they unlocked doors and let the inhibitions shoot off the built-up tensions of everyday designing. People need this chance to explode. There should be more costume parties. Every year I would create some fantastic costume, winning first prize on four occasions. One time a group of friends and I

went as Roman conquerors. I built a life-size papier-mâché elephant over a twelve-foot-high stepladder, mounted on a dolly that was manually moved by a man beneath it. Yards of chicken wire formed the frame, over which newspapers saturated in flour and water molded the shape of the huge beast. Kathy was to represent the queen of Rome, practically naked, riding on top of the elephant's head, while another friend was supposed to be a Christian slave, her limp body hung over the elephant's trunk. Another friend carried a sumptuous beach umbrella of white satin with golden tassels; yet another waved an eight-foot-wide peacock fan. The whole thing got out of hand and started to look like the circus, and we finally had to get a police permit to parade it up Fifth Avenue to the Plaza Hotel. The night of the ball arrived, and the cops came to escort us. Well, there was a two-hour delay while Kathy was being primped at the hairdresser, and I struggled to move the elephant. Naturally I had never thought about getting the damned thing out the door. We pinched and squeezed the poor animal until I was in a flood of tears, all my hours of work being ruined. When we finally got it out on the street, the spray paints were put into action, and the pearl-gray beast was mended. By this time the two cops and most of the entourage were beginning to weave under the many martinis they had been consuming. We started up Fifth Avenue hours late, with me beating a huge Chinese gong, and the friend carrying the umbrella stumbling and frantically waving the thing over the elephant's head. At the Plaza Hotel, we had to enter through the huge service elevator. We had only five tickets for seven people, so I slit open the belly of

the elephant, and two friends crawled in, and we pulled our Trojan elephant into the ballroom. Just before the grand march, the umbrella carrier passed out. It's a good thing I don't drink, as someone had to have his wits about him. I quickly wrapped a white tablecloth around a busboy as we marched out and caused a sensation. Unbelievably, we didn't win any prize, and I was in despair. Later that evening, an artist friend of mine told me that prizes were given only to members of the school that was hosting the ball. Very unfair. But the following year my artist friend bought the tickets for me, and sure enough we won first prize.

During all the hysteria before the blowout evening, Mrs. Nielsen carried on the business. The one year she went to the ball with us, she was so shocked by the naked people running around that she threatened to leave. But as she sat at the table, one young lady arrived fully costumed in the splendor of the French court of Marie Antoinette. Mrs. Nielsen was oohing and aahing over how lovely this girl looked, but when she turned around and her behind was stark naked and framed in a baroque gilt picture frame, Mrs. Nielsen almost fainted, and left the ballroom thinking the devil had taken hold of it. The orgies that took place under the tables never bothered me, and I rarely ever saw them, as I was always up dancing and not just sitting and watching the wild goings-on.

One of the best costumes I ever made was a very simple affair that won top prize: a model friend, Ellen, and I went as Greta Garbo and Maurice Chevalier, both wearing skinny black leotards with huge natural straw hats that covered half

our bodies. Ellen's hat was an enormous boater, the brim five feet wide with a crown to match. She was a darling Maurice Chevalier, with a white starched front and a bamboo cane. I went as a hidden Greta Garbo, under an enormous straw cloche. Other first prize winners I designed over the years were a pair of gigantic white seashells; and another time, a group of four mammoth fruits and vegetables made in huge straw shapes of carrots, tomatoes, watermelons, and oranges. But the most gorgeous costume we ever made, which won a thousand-dollar prize, was entitled "The Devil's Passion," where I used ten miles of red feathers and sequins to expose my beautiful girlfriend and cover myself. These parties always came in April, just before I started the new fall collection, and they were wonderful to get all the wildness out of my system and let me quietly and peacefully settle down to designing the new fall hats.

The shop on Fifty-Seventh Street was starting to build. The press were now recognizing my work, not with praise, exactly, but at least full coverage. Miss Claire Weil, the dean of the millinery world, had taken me under her wing. Store buyers were placing small trial orders. De Pinna's gave us our first newspaper advertisement, picturing a hat in the shape of a cherry pie with a slice out of the back where it fit over the fashionable chignon of the time. The ad had a good response, and for the first time Mrs. Nielsen and I were working until midnight every night, making cherry pie hats until we wished George Washington had never cut down that damned tree!

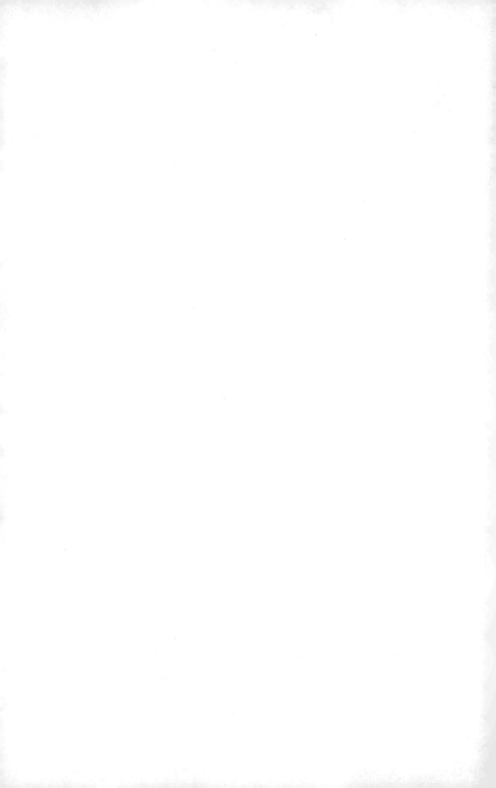

A Helmet Covered in Flowers

I n May of 1950, I had a notice from Uncle Sam requesting the pleasure of my company in the United States Army. At first I was heartbroken at the thought of having to give up all the years of hard work, but I never had a mind that dwelled on the bad. I always believed that good came from every situation, and immediately I thought: I might get stationed in France, and it would be a fabulous opportunity to see Europe. And the idea of looking in on the Paris designers was enough to set me in orbit. I got this thought in my head, and straightaway started studying French. Of course, my chances of being sent to France at a time when the Korean War was at its height were one in a million. But the idea of France never left my head. Mrs. Harkness and her lawyers were in a rage that I was drafted, just when their 60 percent share of the business was beginning to look rosy.

The Harkness lawyers got very nasty and claimed all sorts

of damages, and sued for the return of the three-thousand-dollar investment. They wrote my family arrogant letters and treated them like peasants, until my uncle got on his high horse and put them in their narrow-minded place. I must say my uncle couldn't have been nicer. After despising my fashion work for so long, he came to the rescue when I really needed him. He realized these people who had taken a 60 percent cut of the business when they formed the partnership figured that I had no business sense and they could do what they wanted. At any rate, my uncle prevented a lawsuit and reimbursed the Harkness lawyers half of the three thousand dollars, even though they weren't entitled to it. My uncle also paid the remaining debts when the Harkness lawyers walked out. Many years later, I repaid my uncle every cent, and learned a damned good lesson: never take financial help, as the investors are only interested in getting all they can out of the artist, giving little care for honest creativity. I never held Mrs. Harkness responsible, as she was under the influence of her coldhearted lawyers.

From the first day in army camp, I had two years of the most wonderfully broadening experience. During basic training I was the star of the camouflage maneuvers. My helmet was always covered with a dazzling garden of flowers and grass, as we advanced on the enemy, out on the deserted flats of Fort Dix, New Jersey. I can remember the exasperation of the sergeant as my spectacular headgear stood out like the Garden of Eden on a desert while the camouflaged company was to be sneaking up on the enemy. As a result, I was always on guard

duty, marching around some isolated water tower. Thank God it was summer. I circled the cursed thing a thousand times, holding my heavy rifle as if it were a bouquet of ostrich feathers, with ideas for fashion designs filling my head. All during this period I kept studying French and thinking of France, even though my company was being trained for duty in Korea.

When graduation from basic training came, they lined us up in long rows, and we were separated into two groups, one for Korea and one for European duty in Germany. I landed in the European group. The thrill was so great that I rushed down to the PX and bought every French language book I could get my hands on, even though my papers read "Germany." All I could think was, what's the difference? France is a neighboring country, and I could smell Paris in the wind. We boarded the army ship in Brooklyn, and I'm sure none of the Vanderbilts could have felt any more excited boarding a ship for Europe than I did at that moment. I had only been in the swan boats in Boston's Public Garden, but now, crossing the Atlantic seemed like the swellest thing, even though a hundred other soldiers would sleep in the same cabin. The chow line for lunch started around ten in the morning, and it was just one constant wait after another. I had purchased and studied a book on handwriting analysis, so each day while we waited in line I would sit on the deck, and a group of sad soldiers were waiting for me to read the handwriting of their girlfriends' love letters. It was a howl. The boys believed everything I told them, plus I got to read some of the most interesting letters. This tiny thirty-five-page

book made me an expert in one quick reading. It's a wonder some of the soldiers didn't throw me overboard for some of the scandalous things I told them.

The days flew by, and the crossing was sunny and cold, except for two days of storms that had half the three thousand soldiers on board hanging over the railing. I slept on deck a couple of nights, not from seasickness—as nothing seemed to bother me—but the perfume of the hallways and sleeping quarters was enough to make your hair stand on end. We landed in Germany on September 28, and the early fall landscape of the Bavarian countryside is enchantingly etched in my memory for life.

I wasn't in Germany two days when orders came that a hundred men were needed in the newly opened camps of France. The requirements were that you had to speak French (to be able to mix with people, as the French were in the throes of their "Go Home, Americans" demonstrations), and a college education was preferred. I made it only because my records had shown entrance to Harvard. Thank God it didn't say how long I'd stayed. I was able to speak French fairly well, from all the studying I had done. It seems the power of positive thought really works. I was so excited I couldn't sleep on the overnight train to Paris. I was to be stationed in the southwest of France, at La Rochelle, a small port town.

My enthusiasm on arriving in Paris just exploded. We had a six-hour stopover. I dashed out of the station, hailing one of those old puddle-hopping taxis with the holes in the roof. I stood up in the back of the cab with my head and shoulders

coming out of the roof, just breathing the air of Paris. The day was crisp and sunny, the trees lining the boulevard had been touched by frost, and the autumnal colorings seemed so right for a first look at the City of Fashion.

I didn't know the city, but I immediately told the driver to take me to the Place Vendôme, as that's where Schiaparelli and many of the fashionable designers had their shops. We drove through the city streets, past statues and fountains, the bridges, the imposing Louvre Museum, the cathedral of Notre-Dame, the rows of old houses like scenes from *La Bohème* My head was on a swivel, turning every which way on top of the taxi; as we drove along rue Saint-Honoré, women in delicious mid-calf-length tweed coats, billowing out in tent style, darted along in the autumn breezes. Heads were topped in elegant deep-profile hats, with long quills of pheasant tails piercing their felt. Everything was more French than I ever imagined. As we drove into the Place Vendôme, my eyes saw the signs of Schiaparelli, and a moment of triumph filled my body. I had finally reached the top of the fashion-climbing ladder as I eyed every-thing through Schiaparelli's window, a fantastic boutique full of imaginative shapes in shocking-pink colors. Most of all, I remember a satin sofa in the shape of lips.

I jumped back into the taxi, and we drove off to the pearl-gray stone mansion of the fashion king, Christian Dior. I re-member peeping in all the doors, afraid to go in. The smell of perfume was everywhere, and I longed for the day when I would climb the grand stairway to see a collection.

My six hours were over in what seemed like seconds, and

the train puffed out of the Paris station, weaving in and out of quaint old villages as we traveled through the central part of France.

What was to be home was an old broken-down French army building, left in despair since the war. The ceilings were falling down, and we had to put tents over our army cots for safety. There were no baths or toilets, and the twenty soldiers sent with me had a fit complaining. I didn't mind a bit, as we were given complete freedom. First, we weren't allowed to wear army uniforms, as the French civilians didn't like the idea of American soldiers coming back on French soil, and uniforms started trouble with the communists. Second, all regular army life was discontinued, and everyone had to shift for himself, as the few officers there were trying to find living quarters for themselves. Although the camp increased by nearly three hundred soldiers in a year, I never knew what it was to lead the army life.

Within two weeks of my arrival, when the boys and I were out digging a latrine ditch, a hundred additional soldiers arrived to help set up a headquarters. At night the boys would be seen drowning their sorrows in local barrooms, getting drunk to help forget their troubles. I don't drink alcohol, as I think it dulls the mind, and hate the taste of it. Seeing the fellows wasting their time and money sitting on bar stools really made me sad. So I boldly approached the post commander and told him something had to be done for the morale of the soldiers. He looked at me as if to ask how dare I be so blunt. At any rate, I presented my plan to him, which was to schedule weekend

tours to the local areas of interest, using an army bus. This, I felt, would get the men out of their self-pity, and orient their minds to enjoying their two years' stay. And of course I would guide the tours. When he asked about my experience, I looked him right in the eye and said, "Why, I've crossed the ocean and traveled through Europe, and know very well what would interest the men." I wasn't really lying, as I had just crossed the Atlantic, and I felt it would be a snap to run little trips to interesting parts of the country.

The following day, to my surprise, I got his okay to start a tour department. They gave me an old broken-down building to clean up into an office. The weekend tours developed so well that forty soldiers at a time were crowding onto the bus, if not for the benefit of my informative tours, at least to escape the dirt and boredom of their lives. I would read everything I could about the local areas during the week, and what I couldn't find out, or didn't sound interesting, I'd invent. No one ever questioned my stories, as no one ever really knew what was going on. The tours grew into two- and three-week vacations, taking the boys on their leaves. It allowed me to spend two years traveling all over Europe and North Africa, always guiding a caravan of forty thankful soldiers. I was very realistic about the trips. The three-day Paris tour was a sensation: instead of forcing the boys into the opera and the museums, I would have the bus pull up in front of the Folies Bergère, and as the fellows left the bus, they were given a white card with the address of our hotel and the departure time Sunday and granted complete freedom. I sat through so many performances

of the Folies I was just about able to tell the fellows how low she was going to drop it, and calm their whistles. During these weekends, I had arranged the hotel and tours to all the interesting spots, at prices soldiers could afford—my wholesale hat selling gave me the idea that a party could travel at a quarter of the cost for a solo traveler. On this theory, I bargained for theater tickets, restaurants, hotels, etc. all over Europe. Each fellow would pay just the cost of the trip, as these were considered army tours, and no extra money could be collected. On the trips to the French Riviera, we had a million laughs. I can remember getting the boys out of prostitutes' houses at the end of weekends, having the driver stop the bus at the houses of ill repute to collect the troops. On one of the first trips to the Riviera, we were riding along the main drag in Nice, and I was talking up a storm about all the hotels and fancy goings-on when we came to the famous war memorial that overlooks the beach. The forty soldiers had gotten out of the bus to get a better look and hear my long-winded spiel; when I turned around to ask if they had any questions, there wasn't one of them in sight—they had all run across the boulevard and were looking down at a beautiful nude woman sunbathing on the beach. Their cameras were snapping pictures like you never saw. Finally, the French cops came along and broke it up, chasing the curvaceous young lady from sight.

During the winter weekends, we took trips to the fashionable ski resorts in the Swiss Alps. They always gave me a chance to observe all the elegant women, and skiing is my favorite sport. I think I was the only one on the mountainside in

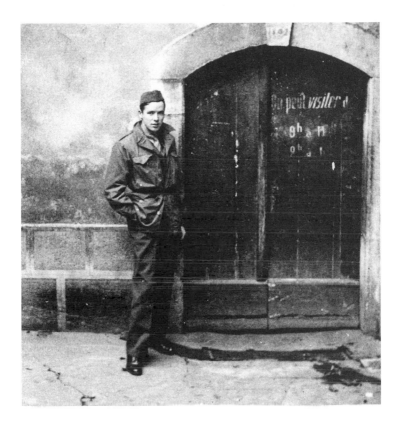

Saint-Moritz at seven thirty in the morning, as elegant life didn't begin to show its coiffured head until midday in that plush resort.

Zooming down the mountainside in freshly fallen snow, between the fir trees laden with fluffy white, I can't begin to tell you what a wonderful feeling it is when you feel all alone in the world, sliding down at terrific speed. I always felt it was the perfect place to commune with God.

These trips were certainly the chance of a lifetime for my

eyes to be exposed to different ways of life, and the true reasons for fashion; understanding the normal habits and working lives of women in all parts of the world gives a designer insight. Anyone can see a pretty dress and copy it in different fabrics, but a true designer will look deeper and understand the reason the garment was designed in the first place. A real spirit will be found. It's the same as looking at the art in international museums. You don't look at it to copy, but rather to see the essence that inspired the artist to create it. So often when people take these grand tours of Europe, they never find the essential meanings of art, and bring back a flighty surface impression.

The fashion magazines I had hidden in my locker were one of the big jokes around the camp. I had a subscription to *Women's Wear Daily*, along with the millinery magazine, *Hats*. And if you don't think that caused a lot of scandal! But after a while, most of the fellows wanted to peruse the fashion magazines, just to look at the beautiful girls. I remember one weekend when I was running around Paris with Stella Daufray—one of the most gorgeous models in all Paris—a group of the fellows from my camp were sitting at a sidewalk café when they spotted me skipping down the Champs-Élysées with this gorgeous creature tucked under my arm. The fellows were dumbfounded. They couldn't understand how a dope like me could have this fabulous gal, when they'd been sitting around all weekend without a chance for a date.

When I got back to camp that night, it was past midnight and most everyone was in bed. I quietly undressed and got into

my bunk, when all the lights went on and the fellows jumped out of their bunks, demanding to know where I'd picked up this beauty, as they were under the impression that I spent most of my time in museums.

THREE MONTHS AFTER my arrival at the camp, the commanding officer received a call from the head general at a neighboring camp. The caller left no message other than that the general wanted to meet Private Cunningham. This was truly unusual, and I couldn't imagine what the hell he wanted with me, an insignificant buck private. On my arrival at headquarters, I got the velvet treatment, as if I were a relation or something. I was ushered into the two-star general's office, and there stood the tall, lean, distinguished gent. He seemed slightly embarrassed and proceeded right to the meat of our meeting: it seems his wife had heard that I was working off-hours in a local millinery shop, which I was. I had made arrangements to use the workroom of the local milliner, and I was preparing a group of hats to take to Paris in hopes of selling them to the designers. Word had gotten all around camp that a soldier was making women's hats. I thought I'd drop dead when I realized my secret was out. All I could visualize was a concentration camp for the remainder of my two-year term. My mind drew a blank, until the general smiled a little and said that he would like to recruit my talent to open a school for the wives of the officers and enlisted men, as they needed a cheerful

diversion in our hard living conditions. Presto, a class and workroom was set up in the headquarters, and twice a week the general's star-plated limousine would arrive at our broken-down camp and pick me up with all my feathers and ribbons. It was a hilarious scene to see me trailing out of the army barracks, packing all this feminine fluff into the car. It sent the post's colonel into a state of shock.

The whole camp was afraid to look cross-eyed at me, thinking I must be some relation to the general. From that day on no one ever questioned a thing I did or didn't do. The army is hysterical on matters of rank, and here I was, a mere buck private, riding around the countryside in the general's car, designing hats for the officers' wives. And the millinery class was a great success. About forty-five of the wives feathered and beaded their headgear between bridge games, which was their number one sport.

One time the camp got in an uproar when a call came from headquarters stating that the general was coming to see Private Cunningham. All two hundred fellows of the camp were ordered into a frenzy of cleanup. Finally, the general's car pulled into the courtyard, and out stepped his wife. It seems the soldier who took the telephone message got it mixed up—it wasn't the general coming to see Cunningham, it was his wife. I didn't get in on any of the cleanup because I was downtown at one of the local auction houses bidding on an antique vase, and the colonel had to send sergeants out searching for me. When I got back I found my office so clean I couldn't believe it. They'd had six soldiers mopping and dusting the walls, in anticipation of

the inspection. There was no inspection at all, just a little friendly chat between the general's wife and me.

As you can see, I became untouchable.

IN FREE HOURS I completed a couple of dozen hats and headed for the two-week furlough in Paris, during the opening of the French fashions. I showed the hats to many designers. There weren't any takers, although Madame Schiaparelli peeped from behind a curtain while I was showing the models to her staff. And the following season, two of the models showed up in her collection!

On my furlough, I went to see the representative for Madcaps, an American mass producer who came to Paris each season to buy the most exclusive models. He was sitting in his plush hotel overlooking the Rond-Point, smoking and puffing a big cigar, which filled the room with so much smoke I could hardly find him. He took a quick look at the hats, and then said, "Listen, kid, if you don't have them tied to a big magazine promotion, I couldn't be interested even if they were gold bricks." This is so true of American fashion; the manufacturers and stores couldn't give a damn unless the dresses or hats are tied up with a big promotion. I think they could really sell a pot from under the bed to cover women's heads, so long as the magazines gave it a big play. It's no wonder the designers are so afraid of the press. Not for what the press know about clothes, but the influence they have on the buyers.

The hats were a failure, but my two weeks were spectacular,

as Nona and Sophie arrived from New York to buy new models for Chez Ninon. They had been coming to Paris for forty-five years and were able to take me to all the shows. I was to meet the girls at the first show, which was Jean Dessès, who was established in the sumptuous Paris town house of Monsieur Eiffel, the man who built the tower. I arrived a half hour early and had to wait at the bottom of the grand stairway, as the Duchess of Kent was in the salon, and no one was allowed in the same room as Her Royal Highness. This was my first Paris show, and I was so excited. After HRH had departed, the press mob were allowed into the salon to breathe the same stale air—as they never opened a window in Paris for fear some outsider would peep in and steal an idea. I was placed in the front row, next to the gray sofa, which was always reserved for Nona and Sophie. The sofa was the seat of honor in Paris, and reserved for the most pedigreed souls the designers wished to pamper that season. Many a battle has been fought over the sofas of Paris. I was disappointed that the audience didn't look anything like the kind of people who would wear the gorgeous clothes. As a matter of fact, I thought the audience generally looked pretty shabby, and I wondered where all the ladies were who would wear the clothes. I found out they came after the press hoodlums were gone.

Nona and Sophie were coming right from the airport, and when they arrived, Nona almost had a fit. She was so disappointed I wasn't wearing my uniform, as she had told everyone a soldier boy would be accompanying her at the showings, and she was so proud of the fact. After the show I was sent back to my hotel to change into the drab khaki uniform. Nona was

really delighted, and I think she was right, for at each collection we went to, I was treated like a VIP. They had a mania for men in uniform, as I sat through all the shows in front-row seats—which I've never got my derriere into since. I don't think anyone realized I was just a private. That same season the new house of Hubert de Givenchy opened, and all the buyers were overheard talking in the lobby of the Ritz Hotel that he was just going to be a flash in the pan. Nona and Sophie were quite conservative, and rarely went to a new house until after it was confirmed, but Miss Kay Silver, the fashion editor of *Mademoiselle*, took me along with her. After the showing, she was making photographs of the clothes, and they asked me to stand in some of the pictures. I had a wonderful time, and had a chance to see the inside workings of a new house. Often we had dinner with Carmel Snow, the editor of *Harper's Bazaar*, who was a personal friend of Nona and Sophie.

Each season while I was in the army, I arranged a two-week stay in Paris during the openings. Here I met all the designers and buyers, and sat through endless buying sessions, which were the best experience of all; as Nona and Sophie were ordering, I would be turning the clothes inside out, discovering how they were made. The behavior of the manufacturers was unbelievable. They were a riot, sneaking out their tape measures when the salesgirl was out of sight, frantically copying the measurements, hiding suit jackets under chairs, sneaking behind the potted palms and measuring the length of a skirt, measuring the sleeves from the ends of their noses out to their spread arms—every conceivable trick was employed.

The biggest free-for-all of swiping always took place at Dior, as the salons were always crowded with at least fifty buyers. The salesgirls needed ten sets of eyes to keep track of the shifty New York crowd. They worked in pairs: while one would be pulling the shoulder apart, a second would be swiping the buttons. And I almost died laughing when the salesgirls would float back into the room, and the manufacturers would relax and look so innocent that butter wouldn't melt in their mouths. Of course, the salesgirls are a pretty sharp crowd themselves. Dior's collections were always the most luxurious and the richest looking in Paris. Nona and Sophie loved the clothes and always bought heaviest there.

The collection I most wanted to see was that of Jacques Fath, but Nona, being quite conservative, always wanted to bypass the spirited Fath. But Sophie and I enjoyed his dashing flair. Fath was a big part of the show himself, always swishing into the salon in the middle of the show, often dressed in American western dungarees and a white shirt, the front slashed to the waist. He would kiss the hands of his favorite customers and cause half the women in the room to have palpitations, as he was so seductively good-looking. The whole thing was a great act that everyone loved.

But Nona would sit through the whole show moaning and groaning over how much money Fath was going to lose on the theatrical clothes. I must say Sophie enjoyed the vivacious flair, and I was spellbound by all the drama of fashion. After each showing, most of the buyers and press would meet in the lobby of the George V or the Ritz to discuss whether it was worth

paying the two-thousand-dollar entrance fee required of commercial buyers (even though this was deducted from their orders). The press got into the first showings free and would pass their judgment on to the buyers. I always thought this was a cart-before-the-horse idea on the part of the couture houses, as most of the press have no idea what refined, chic women wear, or the lives they lead. Yet the press hoodlums—as the couture houses called them—were handed the whip of destruction on a gilded platter.

Within a few hours after the showing, the buyers and some of the press people with photographic minds could draw in detail the whole collection of two hundred designs, which they then started selling to copycats. (Many people were caught carrying hidden miniature cameras, in canes, umbrellas, etc. Cloak-and-dagger stuff. One season a newspaper that was refused entrance hired a room across from the couture house and set up a special telescope, from which they saw the whole collection.) The Italian Mafia are like children compared to the boldness of what happens in Paris.

After these two weeks, I would go back to my army life of touring around Europe with forty soldiers. Oh my, I'm almost ashamed to tell people that!

I was filled with desire and ambition for the day when I would reopen my own business. The inspiration that Paris designers give the fashion world is total. Paris is the laboratory of fashion, where new ideas are discovered. The French take the time to mix and experiment. (It's a costly laboratory; that's why manufacturers were charged about $1,500 per garment, with

the right to copy.) American designers were 98 percent under the influence of Paris, even though few would have admitted that their ideas were confiscated from the French collections, then disguised in New York workrooms and called their own. Of course, it's not the fault of the American designers, as our big-business system didn't give them time to be really creative. The time is coming when the big giants of American fashion will have to set up their own laboratories. The tottering dowager of Paris couture can no longer afford to indulge in its old-age customs.

The army days were full of fun and excitement. In the spring, the fabulous Beaux-Arts ball of Paris was thrilling, as everyone poured their ingenuity into extraordinary costumes. I recall riding through the streets of Paris with the top half of my body coming out of a taxi roof, because I was done up like a huge lobster, with a giant head and claws that wouldn't fit inside the cab. I was staying at the Hôtel de Vendôme, where Nona and Sophie had been guests. Their rooms were still in the style of the empress Eugenie. Sophie charmed the owners of the hotel into giving me the attic room overlooking the city, for two dollars a night. The august clientele were quite upset as I paraded down the hotel stairway, dressed as this nightmare-size lobster. But the French are quick to relish fantasy, and the whole city seemed to enjoy the art students' ball. I remember we were free to run through the city streets and caused havoc as we danced a conga line through the sidewalk cafés of the Champs-Élysées. Some of us were almost nude.

The Luxury of Freedom

After the army years, I was desperate to get back to New York and sew up a storm of new hats. I had been released in June 1954 and spent the summer at the Long Island home of an army buddy, Jack Burkard. His mother let me set up a small millinery workroom in the basement of their home, from which I made a small collection.

By December I had found a tiny brownstone on West Fifty-Fourth Street. This was to be the home of William J. for the next eight years. It was a narrow slice of a house sandwiched between the Dorset Hotel and the athletic club. I rented the parlor floor for 140 bucks a month—a real bargain for that location, and my head was just bursting with ideas to remodel it. The owner, Mr. Kay, was a renowned restorer of Asian art who worked exclusively for Mrs. Doris Duke. Doris often sat in my shop discussing the garden of her New Jersey estate, as Mr. Kay was a superb creator of Japanese gardens.

The brownstone was an ugly boardinghouse that needed lots of imagination to bring back its high-ceilinged charm. The parlor floor consisted of a small front reception room and a large rear salon, separated by a hall with a stairway going to the upstairs apartments. It was a typical brownstone, with all that dark mahogany wood so fashionable at the turn of the century. I couldn't stand it, and immediately painted it off-white. The owners nearly had a stroke when they saw their lovely wood masked like the face of a geisha. To hide the effect, they allowed me to put up a partition in the hall connecting my two rooms, thus giving me a full sweep of the narrow house. There was some crazy New York law that stated the hall couldn't be cut off from the rest of the house, so I left a six-foot-wide opening as a doorway and closed it with a venetian blind. Everyone I knew was shocked at the idea of using a venetian blind as a door in New York City. I trusted everyone, and in all those years had only one robbery, and that was by one of my own customers, who stole a Russian sable scarf by putting it under her full-skirted dress. The owners of the house couldn't have been nicer; they let me canopy the front entrance and decorate with topiary trees that I made into the shape of women's heads. I must say they caused a lot of attention and stayed out in all the rain and snow, with long plastic drop earrings, which I had taken off a phony chandelier.

At Christmas and Easter the front of the shop was my pride and joy, and I indulged in elaborate decoration. On Easter, the eight steps were laden with tulips and lilies, while the topiary trees got a new spray of green paint and flowers shooting out of

their heads. At Christmas I usually got carried away. One year hundreds of white branches were arranged like a forest along the steps and sprouting out of the display windows. These were six to eight feet tall, and from them I hung thousands of tiny mirrors. In the cold winter wind they seemed to set the house dancing with their reflections.

In the middle of all this, at the top of the stairs, replacing the topiary trees, were two bigger-than-life red sequin peacocks. The effect was sensational, drawing almost as many tourists as the Rockefeller Center tree. I must in all truthfulness say that these arty displays never brought in customers. People are afraid of shops that are too chichi; they're scared to come in. But no matter, it was a wonderful relief for my flights of fancy—and besides, not many people bought hats around Christmastime.

On the second floor of the house lived a renowned fashion model. She was a raving beauty who used to model my hats, often bringing her famous boyfriends as guests—such as Aly Khan and too many movie stars to begin mentioning. On the back of the second floor was a French dress designer who was like a bottle of champagne just opened. She was full of life, and often after she had finished a new design, which she would completely make herself, out she'd trot, dressed to the nines, giving the new fashion a breath of El Morocco air. Madame's salon was dark and mysterious, like a French boudoir. Incense was always smoldering its exotic perfume, often filling the apartment above, which belonged to our landlady, a Prussian frau who was of the dowdy, practical German school. The

French dressmaker was a constant revelation to Frau Landlady. In the coldest days of winter, the dressmaker would be bitching up a storm over the lack of heat when the landlady would come tramping down the stairs lit by a fifteen-watt bulb, her body covered with heavy wooly underwear and layers of sweaters, bearing a huge thermometer in her fist to prove to the French madame that there was ample heat. When the landlady would tap at the door, she always got the shock of her life to find the French madame running around on ten-degree-cold days with just a bra and panties. She couldn't design fully clothed; she found inspiration only flowed to her fingers when she was almost naked. Of course, the landlady would hit the ceiling, wildly screaming, scaring my customers out of their wits.

I BELIEVED IN STARTING each week doing the thing you love most. Luckily, my love was flowers. At five thirty each Monday, I'd go down to the New York flower market, where all the colors of nature brightened the early morning. I would buy armfuls of fresh flowers to perfume my salon for the week. This is a practicing luxury I still indulge in, and one that makes all my weeks happy.

Monday shouldn't be drudgery. More people should start off doing what they enjoy most.

Flowers aside, I never believed in fixing a place up and then opening; I wanted business right away. Once I had found the brownstone, I immediately moved all my creations and millinery supplies out of the Burkards' on Long Island, and within

ten minutes I had washed the front window and had hats on display. I had very little money to begin with, and I wouldn't accept any financial help after the Harkness episode. From the second I crossed the threshold of the new shop, it was a case of sewing like hell and finding customers. I was too filled with false pride to ever ask my Boston family for help. I never borrowed a dime from them since the day I came to New York in '48.

I remember Bergdorf's custom millinery department ordered a couple of models from me at twenty dollars a hat, with a promise to reorder. I didn't have a cent to buy the necessary straw, and so I went to my uncle's office and asked for twenty dollars to fill the order. This took a lot of nerve; my uncle hadn't been speaking to me. He was a kind man, but the idea of a nephew in fashion was a total disgrace to him. After putting me through the third degree, I ended up in a flood of tears, feeling that the Bergdorf order meant the life or death of my shop. Finally, he gave me the twenty dollars against his better judgment, as he felt by giving me the money for millinery he was encouraging the thing he hated most. If I had wanted money for anything outside of fashion, the sky would have been the limit. When I finally got the dough in my hot little hand and ran down Fifth Avenue to the supply house, Bergdorf's buyers had been there that morning and bought every inch of the straw. I later learned from a customer that they were making my design and selling it themselves for sixty-five bucks. It was hard to take, but this was to be the typical transaction with retailers. I found with few exceptions that stores and

manufacturers had minimal ethics in business, even when it meant developing a new talent so they could reap the benefit in later years. The practice was to wait and watch a designer struggle to a position of influence and success, and then the buyers would descend on the designer like a pack of vultures, stripping the tree bare of fruit and leaving the raped tree to survive on its own.

Altogether, though, my new shop with a humble beginning

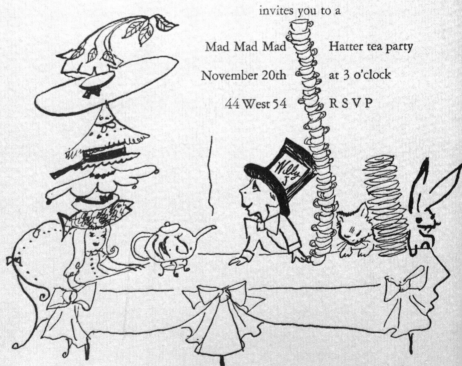

Mad Mad Hatter, William J.

invites you to a

Mad Mad Mad Hatter tea party

November 20th at 3 o'clock

44 West 54 R S V P

You simply must come, my dear, The new beach hats are too mad for words.

was happiness immediately. I used the small front room as a salon, and for decorations I went to the liquidation sale of a top fashion house. For just a few dollars I bought tables, chairs, and all kinds of millinery supplies. When I was leaving, I saw a huge trash can filled with hundreds of yards of nylon curtain. I salvaged it, and washed the yardage in my bathtub. It came out beautifully, and with it I draped every inch of my new salon, including the ceiling. The effect was of a seductive harem, which pleased me since the walls and ceilings were in terrible condition.

Nona and Sophie of Chez Ninon sent all their customers over to my West Side shop. For many it was a new experience, for these swanky ladies hardly ever crossed Fifth Avenue to the West Side except on the way to the opera on Monday nights. I remember Mrs. William Woodward Jr. pulling up in her sleek town car and climbing the stoop. She explained that had she realized it was on the West Side, she wouldn't have come, and immediately pulled a Paris hat out of a bag and asked me to copy it. I told her we *created* hats on the West Side, advising her to go back to the East Side where she could get a good copy. Mrs. Nielsen, who could hear everything as she sewed in the workroom, nearly killed me for tossing out such an influential lady, especially when we needed all the money we could get. But I felt we'd make ends meet by selling our own designs.

Another lady who found the West Side scary was Mrs. Mellon Bruce, one of the world's richest women. Chez Ninon sent her, and I'll never forget the frightened look on her face as she stepped out of her limousine and into my harem tent. She was

so unsettled by the decor that she bought two hats just to get out of the place, never to return.

When movie stars came into the shop, at first I was excited to see them, but after the first few, I never wanted to meet another one offscreen, as they are totally different people, and too often it's a depressing letdown. When Leslie Caron came, I couldn't believe my eyes, having just seen her film *Lili* where her adorable, charming personality caught everyone's imagination. When she arrived in my shop in the flesh, she had an extraordinary shyness and no visible personality. A great disappointment. It's best not to meet these famous people, as their mythical bubble of illusion bursts.

One time early in my career I was a super at the Met Opera, where you carry a spear in *Aida* and get paid two bucks. I got paid four dollars, as I let them paint me black, and I helped carry the throne of Aida onstage. A customer, opera singer Mildred Miller, got me the job, but after a few performances I had to quit, as all the magical enjoyment I had had while in the audience was stripped away while I was backstage, where the queen of the Nile could be seen reading a mystery, and on her musical cue, would turn herself into the century-old seductress. It really spoiled all my illusions, and it's definitely wrong to let the public see the inside of any industry, for immediately all the make-believe is gone. This is what's happened in fashion since the war. Customers have been fed a steady diet of behind-the-scenes goings-on. Now they know almost as much as the pros, and once having seen behind the gold-and-white salons,

they lose interest. In the future, I think fashion is going underground, to regain its breath of mystery.

THE FIRST FORMAL collection in the new shop was spring 1954. A dozen of the press attended, and lots of friends. There wasn't enough room in the tiny salon for more than twelve chairs, so we opened the workroom, where all my friends sat applauding like they were relatives. My family never came to one of the shows until many years later. It took them so long to get over being ashamed of my work, and they never really did accept it. The first collection showed seventy-five hats, and although I thought each hat was a spectacular original, the truth of the matter was that outside influence, and Paris, could be traced through most of the designs. It's funny, though; the press almost always chose the designs that showed my own personality. The most difficult thing in designing is the long, hard years it takes designers to free themselves of others' influences. Of course, the general public most often can't see the influence, but each designer in his own heart knows when he's taken someone else's idea, no matter how cleverly it's disguised. And whenever the coat, suit, or hat is shown, he is reminded that it is not really his own. Luckily for the business world, buyers couldn't give a damn, encouraging designers to take what they want from other people's work, so long as the finished product is salable. And this is the very reason there are so many unhappy designers. Their lives are continual frustration, as

inwardly they know they haven't freed themselves from copying, and their own personal signature is never born. This is why at any given time you have so few real creators. Most designers are stylists or good editors.

It wasn't until the fall collection of 1955 that I was able to free my inner self from outside influence. It happened to me in a rather embarrassing way, but one I shall always be grateful for. The *New York Times* took a picture of a sawtooth-brimmed cloche and placed it in a prominent spot on its fashion page, along with the work of Adolfo, one of the true creators. The sawtooth brim was an idea I had taken from one of his hats of the previous season. At any rate, when I saw the picture of the hat with my name under it, I felt so ashamed and disgraced that I vowed never to be influenced again, no matter how unsuccessful my own ideas might be. In the future they were going to be only what I felt and thought, deep inside me. From that moment on, I was freed, and ever since that day I have enjoyed a happiness in my designing that no hell on earth could destroy. I created the best hats, often setting trends years in advance of Paris. It's only when designers make this escape that they can express fully from inside things that they themselves aren't aware of until they've been put into design.

Preparing the new collection each spring and fall was the real reward for me. For two months before the showing, I would not make a date or see anyone, except a few customers during the day. But as soon as Mrs. Nielsen put down her needle and went home, I would close the door, turn off the telephone, and be alone with my thoughts to create throughout the night. It

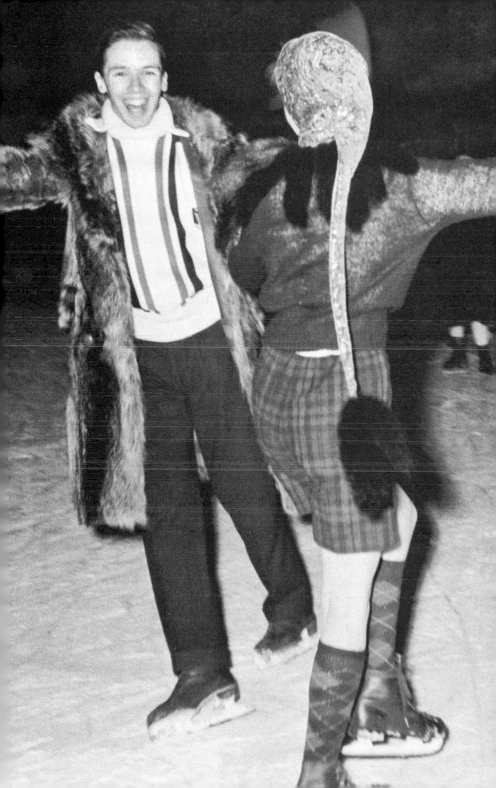

was the most wonderful time, to take the felts, draping and pulling them, as my imagination spilled through my hands. Some nights when the feeling was strong in my fingers, I could drape thirty hats, one after the other. Other nights, try as I might, nothing would come to my hands. At times like these, I would lace up my ice skates and race around the rink at Radio City, my body swerving and dashing through the cold wind. There was something inside me that needed to be released, and after an hour or two I could go back to the shop and start new hats all over.

Another time I stopped designing on a snowy night around midnight and went for a walk with my dog. The snow had blown itself into deep, beautiful drifts. At the Plaza I saw a horse-drawn sleigh, which I hired and rode through Central Park, filling myself with inspiration.

I didn't have many friends during these times, as the hats took up day and night. Besides, the designing was so rewarding I didn't feel the need for people, but the few friends that I had were always mad as hell when these two months came around. They couldn't understand why I had to shut myself off from everyone, but I felt that people might influence me, and I wasn't going to take the chance. I never told anyone about my new collection, or let them see it, before the showing. My reason for all this secrecy wasn't temperament or fear of copyists, it was simply that I found people too eager to give their advice, and especially in my case, where the designs weren't like everyone else's. I was widely criticized, and criticism is deadly harm for a designer and could prove discouraging in the crucial time

when the designing is taking place. The day I stopped creating, and the collection was shown, I felt the press, buyers, and friends could say whatever they wanted; it didn't bother me a bit. I had made a sincere statement with each new collection that I knew was my own, and anything they had to say had little meaning.

Although, I was often ripping mad at the inaccuracies of the press. Many times I couldn't figure out what they were trying to describe, and what really got my dander up were the big spreads they would give to their favorites, who often showed the same old thing year after year. After each showing I would feel a deep depression, a sort of wrung-through-the-wringer feeling, and the harsh reality of the buyers demanding changes, and never buying the most creative designs, didn't help. Of course Mrs. Nielsen was always there to cheer me up and give encouragement. Each morning Mrs. Nielsen would stop at Saint Patrick's on her way to work and say a few prayers. Sometimes she'd filch some holy water and sprinkle it around the shop. I'm sure this helped us through a lot of tough spots.

I LIVED IN THE BACK ROOM, where we sewed and designed the hats. Each night before going to sleep I had the task of trying to find the bed buried beneath the piles of hats. Business grew, and any money made went right back into the shop. I never believed in spending any money on myself, until all the bills were paid. In my first four years, I was thrown out of seven banks for passing checks without money to cover them. I would

issue the checks, always figuring that I could cover the amount in time, but the workings of banks and my bad business sense were a tragedy, which luckily never bothered me, so long as everyone got paid in the end. (One of the first people I hired, when I could afford it, was an accountant, who kept me out of trouble ever since.)

Summers are the worst time for the millinery business, as in May, June, July, and August you don't see a customer for weeks on end. I was always working in a restaurant trying to make ends meet and get free dinners. Mrs. Nielsen was often putting cardboard soles in my shoes to block up the big holes. She would cut out the heavy cardboard that the fragile veilings came wrapped on.

The summer of 1955 saw a good change, though. A pleated veil hat design saved the season and made the shop enough money to create the fall collection. My girlfriend at the time, Estelle Naughton, who worked at *Glamour*, showed her editors the new hat idea, and they put it prominently in the May issue and sent lots of advertising to all their accounts. It was a real invention, and it continually made money for eight years. The fabric was twenty-eight-cents-a-yard black nylon net from Macy's, which we pleated. It was totally collapsible and opened up to the size of a big-brimmed Asian hat. It sold for $10.95, which was a staggering profit, and we sold hundreds of them. If I'd been a shrewd businessman, I would have started manufacturing them.

The second year I didn't want to make it, as I thought it was dishonest to repeat, but my friend Mrs. Mack threatened to

have it copied elsewhere if I wouldn't remake it for her. Thus we repeated it every season.

The next commercial—and artistic—successes were the amusing beach hats. I could let my mind go when I made them, as I didn't have to worry about a bunch of stuffy old ladies

EDITORIALLY FEATURED IN MAY GLAMOUR, for the girl with a job

the travel-perfect

William J.

AN HAT

olds like-a-fan

or little-space packing

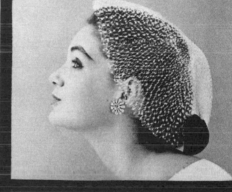

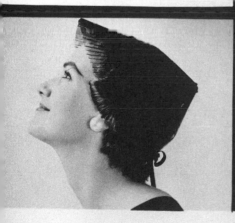

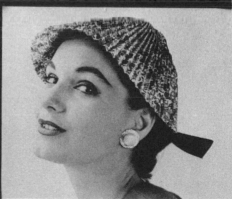

complaining about matching their coats and suits. One beach hat that brought the shop great publicity was a huge umbrella-size straw brim with long celluloid fringe sewn around the brim edge, hanging to the floor. The idea came because I can't stand the sun, and I thought it would make a wonderful portable beach cabana. At any rate, *Look* magazine gave it three full pages in color. I doubt if many people ever wore it on the beach except for a gag, but it was the hottest-selling party hat. People wore it to costume parties, always winning first prize. One year, two friends and I wore it in all black, to the Beaux-Arts ball. We were supposed to be the three witches from *Macbeth*. Much to our surprise we won the five-hundred-dollar first prize. Each year my beach hats became more successful. To design these was sheer pleasure. One year they were in the shape and colors of apples, oranges, pears, and carrots, and a slice of watermelon. Another year, they caused a riot of fun on the beaches of America and Europe in the shape of fish. And another time they were all in the shape of seashells—one got so big that I had to fill the bathtub with water to soak the straw, and then mold and twist it into the shape of a conch shell, and another into a giant head-covering clam. Unfortunately, they didn't sell widely, as they were twenty-five to thirty-five dollars, and even at that price there wasn't much profit in them. So copy houses that were able to make bad imitations by the thousands reaped all the profits. (One time a famous Italian designer used my fish hat a year later calling it his own, and I must say I was very flattered to see my influence coming back from Europe.)

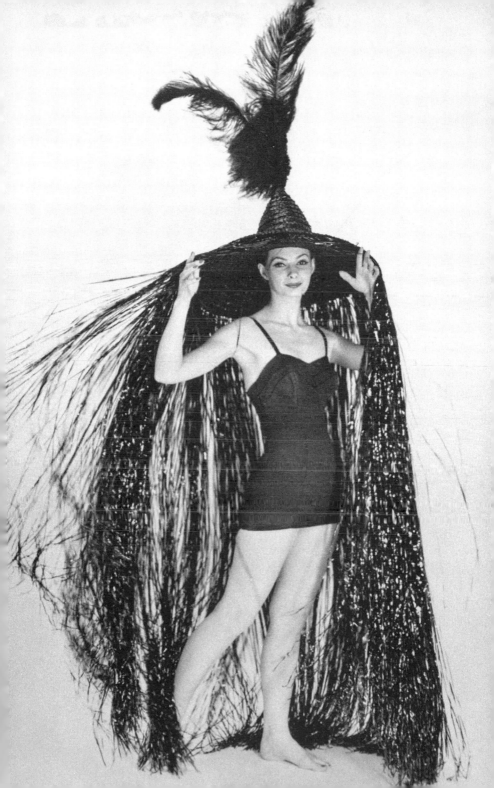

In the winter I made snow hats for the skiers and ice skaters. One collection was a sensation, and made lots of money and was widely copied. The hats were in the shape of animals, with darling felt faces pasted on the back: lions with manes of wool yarn, owls looking very wise with pearl monocles, and elephants and poodles. But the best of all was a simple little pussycat hat in white fur-like material with feathered whiskers and the most seductive blue eyes you've ever seen. I'll bet we sold five hundred the first year at sixteen dollars each. The magazines gave them wide coverage, and the following year the children's market adorned the heads of tiny tots from coast to coast with copies. I remember showing them to the Macy's buyer, who threw me out of the office, saying the idea was ridiculous. This is why I never trusted the opinions of the so-called pros, as most of them don't know a good idea until it sells.

Another time I showed spring hats with flowers growing right up out of the head. The buyers screamed, "Ridiculous! Prostituting your talent!" and walked out of the shop. A month later they saw the same idea at the top house in Paris. I still have their frantic telegrams, telling me to rush a dozen of my so-called ridiculous ideas to their stores. This has been one of the difficulties in designing in America. Buyers and press often won't recognize a new idea at a smaller house; they'll label it a freak—until they see it copied by a big-name designer. Then they go into their swooning act over how marvelous it all is, seldom remembering the unknown originator. This is quite heartbreaking, especially the fickleness of the press.

Commercial design yielded terrific business. My first big

order came from an advertising firm. They wanted 150 identical beach hats, which they sent to their clients to promote one of their products. The hat was an uninhibited affair, a deep cone of straw painted blush pink, with a glamorous face of felt decorating the front that had a real cigarette glued onto the lips, a long crystal drop earring, and a mop of pink feathers for hair, which flipped open and formed a carryall. It was a much-publicized hat, and caused a sensation for the advertising company. American Cyanamid was the next big account. Its chemical division had developed a paper that they wanted to use in fashion. I was chosen to create hats with their new paper fabric. It seems Lilly Daché was first given the commission but wanted five hundred dollars a hat, and the conservative Cyanamid Company balked, and someone mentioned William J. We consummated a deal for seventy-five bucks a hat. They ordered several hundred hats over a three-year period. It was terrific— no fitting, just make 'em and ship 'em out—better than blue-chip stocks!

American Airlines used one of my most fabulous feather hats in a national ad, but after taking the photo and printing it in full-page newspaper ads all over the country, they refused to pay. They said the deal was with the photographer, who had borrowed the hat from me under the pretext of using it for test shots of a model friend of mine. At any rate, they wouldn't even pay for the hat that they used in the full-page ad. I thought it was a dirty way to do business, and I was surprised. But that's business—you have to take the good with the bad. Luckily the ethical businesspeople far outnumber the cheats—at least

that's what I keep telling myself. This is why every designer should have a hardheaded business associate on hand the second the doors to the business are opened. The downfall of most designers is bad management. Designing is only 30 percent of the job, no matter what your aesthetic friends might tell you.

My first big retail account was Macy's, who sold hats by the gross. I wish I could have worked with them, but the price had to be around $25 retail, and that meant $12.50 for me. It was impossible for a handmade hat to stay at this price. You needed a factory where machines turned out hats by the dozens. Wholesale is a competitive business, never meant for hand labor. The whole way of American life is based on wholesale, and small custom operations are a true luxury. How they survive is a testimony to the hard work and determination of their owners. Of course, small shops give human nature freedom to express a personal message, which is rare in a big wholesale operation. It's even getting rarer to find customers who understand the individual statements of fashion put out in the form of two collections a year by the custom houses; but a new cycle is starting, and the status will be the great individualism. Fashion is in for an era of self-expression.

During the 1950s my business increased, and by 1956 five sewers were stitching up a storm in the workroom. Of course they didn't work year-round. For all practical purposes, it's a six-month business: September, October, November . . . February, March, and April. With all the increase of business, my serious hats were never really widely accepted. The trouble seemed to be that they were two or three years in advance of

their time, and people just weren't ready for the ideas. Often customers who knew me well would buy the new designs, putting them away for a year or so and then wearing them. Timing is one of the most important ingredients of design. It's exactly like the Wall Street stock market. Dress designer Norman Norell had the most perfect timing of all. He knew just when the public was ready to accept a new idea. I observed him for a long period of time, and this is one of his main contributions to fashion. To me, I never gave a damn for timing, or really understood what it meant. As a matter of fact, I delighted in shocking people with advanced ideas. This definitely wasn't good for business.

In July '56 I was about to give my fall showing, and I had the feeling it was going to be one of my best. The out-of-town press were going to be in New York at the same time, and they had never seen my work. I tried to schedule a showing with the leader of their group, Eleanor Lambert, a New York publicity woman who incidentally wrote a newspaper column on the side. At any rate, Eleanor informed me that there was no room for my showing, that only the big houses were allowed time. This made me so mad I decided somehow I was going to show. After all, this was America, and freedom prevails. It's funny how you get so patriotic when someone steps on you.

Two weeks before the showing, I looked over the fashion calendar, and every single hour of the day was taken; only from midnight until seven the following morning was free. I saw where the two hundred out-of-town press ladies would be guests at the new play *My Fair Lady*, hosted by one of the rich

manufacturers, so I decided that was the hour—I set my show for midnight, after the theater. Well, it caused a storm of protest, and if you've ever imagined throwing a monkey wrench into the grinding gears, this was it. Eleanor Lambert had a fit, as I also announced that the cast of *My Fair Lady* would be present, and the out-of-town press would have a chance to meet the stars. There was hysteria over the musical those first few months, so you can imagine the industry's fury. They just didn't know what the hell to do. This nobody William J. was causing a sensation; everyone wanted to come. Donna Cannon, who helped me with my showings by making pictures and releases, nearly died. Everyone had feared Miss Lambert, and I had taken the bull by the horns in going ahead with my elaborate plans. Five hundred people requested invitations, for a shop that held 125 people not too comfortably. As for the cast of *My Fair Lady*, three or four of the cast were my closest friends, and they had asked Rex Harrison and Julie Andrews and the other stars if they'd like to come to the show. They all accepted. I had finished designing the collection, and I could feel it was one of my best, so I invited all five hundred people to the show.

Two days before the showing, I started clearing all the rooms. The landlady wouldn't let me put anything in her back garden, and there were no storage rooms, so I brought yards and yards of heavy clothesline rope and hung all the furniture—worktables, chairs, and my bed—out the back windows of the house. The Museum of Modern Art was only two doors away, and for all anyone knew, this was just another mobile—pop art ahead of its time.

When the rooms were empty, I saw how ugly the walls really were, so I decorated using the theme of my collection, the Enchanted Forest, and rushed down to the big flower market and bought huge crates of smilax, the stuff I remembered hanging all over the ballrooms of the debutante weddings and parties. I also bought all kinds of exotic tropical foliage, which sprouted out of the walls from cardboard florist containers we had nailed high on the door arches. We then bought hundreds of live orchids and hung them among the greens that covered every inch of the walls and ceilings. I then went to the Museum of Natural History and rented a dozen stuffed rare birds, which I suspended on invisible wires and perched in the chandelier. In the front entrance room, I placed a stone fountain with a plump cherub holding a dolphin that spit water. Outside the house, on the eight steps of the stoop, were massed tall palm branches. The two six-foot-tall red peacocks from the Christmas decor and a gold-sprinkled red carpet that ran from the street curb up the stairs and through the rooms added to the glitter. A friend stood at the door dressed as a maharaja in a huge turban of draped lamé. I had been able to fit two hundred red-and-gold folding chairs into the empty rooms, and I built a temporary models' room in the hallway of the house.

I did all this in two days, without sleeping. Everything I couldn't hang out the back windows, I stashed away in the fourteen-foot-tall bathroom, but left room around the bathtub—which I had painted gold and filled with champagne—from which two rented butlers served the mob. Tiny sandwiches were piled four feet high on top of the john. There just wasn't room left

anywhere. By eleven on the night of the showing, my photographer friend Mr. Mack got out of a taxi and, not seeing a soul around, thought it was going to be a bust. I told him not to worry, that the show was set for midnight, and I was sure everyone would be there. I remember Mr. Mack quietly got on the telephone and called his wife to get ahold of all their friends to help fill the place up. When Mrs. Mack and her friends arrived they could hardly open their cab door, for the crowd.

By eleven forty-five the cops were out and cars were jamming Fifty-Fourth Street. The neighbors were all hanging out their windows, and well over five hundred people were trying to get through my door. All of the two hundred out-of-town press members came, if not out of spite then surely curiosity, as their leader Eleanor Lambert had warned, from the stage of the Hotel Pierre, that I was a fraud, and the cast of *My Fair Lady* wouldn't be at my show. She advised them not to waste their time. Eleanor soon discovered you don't tell the press what to do.

Poor Rex Harrison was nearly mauled. As he reached the door every female in hailing distance went wild. Some people say Julie Andrews made it; I never saw her. I did see Jayne Mansfield in a pink mink stole and white string gloves. Her husband carried her, and *Look* Magazine snapped lots of pictures. All of the two hundred press got in, but many of them became panicky over fire, etc. and started a hell of a rush back out. It reminded me of the Pacific meeting the Atlantic. I remember making a speech, that the mannequins would show the hats as soon as they could wiggle their way through the

crowd—and this took twenty minutes of wiggling! When there wasn't another inch of space inside the rooms, friends and I desperately set up little gold chairs on the sidewalk of Fifty-Fourth Street, and I promised that the models would march right out the door and show the hats. Several of President Kennedy's sisters sat in the front row on Fifty-Fourth Street—they never got up the stairway—as my more fragile society customers stood in astonishment in the street. The neighbors across the way had the best seats of all, sitting in their shirtsleeves and summer shorts, drinking beer and eating sandwiches. The show finally got on after I broke down in tears over the excitement of the hats. It was a glamorous show, and everyone who survived the ninety-degree heat to see it still talks about it.

After the show was over, the lucky ones dipped their cups into the gold bathtub filled with champagne, but no one was hungry. I ate those little sandwiches for a week after.

The show was not for the New York press, as theirs was set for the less sophisticated hour of eleven the following morning, but the *New York Times* was there on the spot and managed to report the midnight doings. They felt that what the hats lacked in wearability they made up for in the best show in town. The out-of-town press wrote rave reviews; they said it was the unique show of their lives, and they felt they had discovered a new talent. They were really the first ones to appreciate my hats. They seemed to have no inhibitions about exciting fashions.

The whole thing cost about $2,200 and was certainly worth every cent; although it was a very hungry summer after that, I never regretted it for a second. From that moment on, the

House of William J. was on the map, not with a refined dignity, but with an angry howl. The conservatives who ran the New York fashion world in the 1950s fought my imagination every inch of the way. The *New York Times*, the *World-Telegram*, *Look*, *This Week*, *Hats*, the *Journal-American*, the *New York Post*, and especially the *New Yorker* were solidly behind me. The *Herald Tribune's* Eugenia Sheppard was definitely against me. In my fifteen years of showing, she never came to see one of the collections. *Life*, *Vogue*, *Harper's Bazaar*, and all the so-called chichi clique magazines were the opposition, ignoring my work and sometimes calling it freakish. At this point money started to come into the house, and the furniture hanging out the window never resettled in the same rooms. As the French madame had moved from the second floor, I turned this into the new workroom, rearranging the first floor into salons. Jack Burkard, my interior decorator friend, transformed the drab floor into a sumptuous Venetian palace, with walls completely draped in pure white silk, palms in every corner of the room, French furniture covered in apricot silk French velvet, three huge crystal chandeliers dazzling in the gilt baroque mirrors, and gold carpets from wall to wall. The bay window held a huge mahogany statue of two cherubs tossing a seashell into the air, which was filled with live flowers. There was nothing in Paris or New York to equal the ritzy goings-on! I had climbed another rung or two on the fashion ladder.

On the opening of all this grandeur, I remember overhearing some of the sophisticated guests saying everything was so elegant, but Bill doesn't belong in it. How right they were!

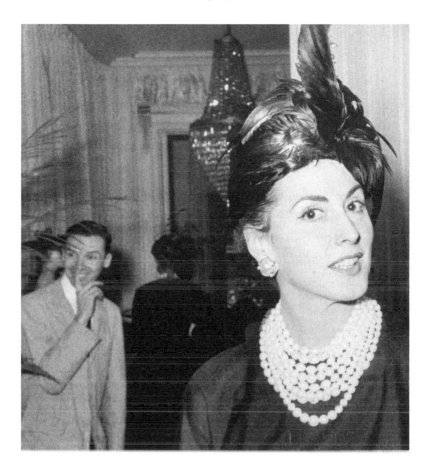

Within a few months I had converted the big bathroom into a bedroom, building a balcony over the bathtub, where I put my bed. I found I couldn't stand living in all the splendor. But it was tremendous for business, the customers were really eating it up, and they paid sixty-five dollars for a hat without blinking an eye, whereas before the new decor, they would fight over thirty-five for the same hat. There was only one other person who felt uncomfortable in all the pseudo-French grandeur, and

that was Mrs. Laurance Rockefeller, a charming lady who believed in simplicity. She said she was sorry I had spent so much money on decor. Her feeling was that women came just to buy the hats and they didn't need all the fancy trappings. Of course, we know this isn't true. Most women who indulge in high fashion expect all the trimmings.

The international society ladies are the most fashionable, and the rich ones of this group spend the most money on new clothes. Often they beg for the big impact designs from famous designers, fully knowing that the world press will spot them easily and put their name and photograph in print. Around the moneyed international group are the hangers-on: titled ex-royalty with little money, and famous celebrities who finagle deals so that they get all their clothes for nothing. Many designers give these ladies free wardrobes each season to promote the look of the fashion house. You'd be shocked at the number of fashionable society women who are constantly in the columns, yet never pay a cent for the glamorous wardrobes they strut around in. Lesser-known celebrities don't get the clothes given to them, but often have free access to borrow sensational clothes from top designers for the night.

After observing parties for so many years, I can spot the borrowed fashions. They don't fit the way a gown that cost thousands should. Often the women themselves find it amusing to tell the press it's on loan from the designer. Furriers are notorious for this practice, as are the famed jewelers. They all stand on their heads denying it, and frankly it's too bad that they do it in the first place, as the designer most often gets back

a soiled hem and perspiration stains, and hardly ever a customer. What really gets my goat is that fashion houses then sell these same used clothes to cash-paying customers, after the phonies have paraded around in them. This happens mostly with high-fashion trend clothes that rarely sell, and the designer is so eager to have it seen that he lends it, hoping to attract interest. All it really accomplishes is boosting the status of the wearer with her friends, who think she buys every gown.

The best-paying customers are the huge number of wealthy and unsocial. They tend to be slightly conservative, but these ladies form a backbone for a solid business, as their faithful patronage can be counted on year after year. They don't change designers from season to season, swayed by the press clippings of the current favorite. Besides being loyal, these ladies pay their bills on time. Social climbers are excellent customers for designers who specialize in the current status uniform. You can never sell these women anything the Duchess of Windsor hasn't already worn. These ladies have no opinions of their own; they merely use fashion to fit in with the accepted look of the old guard. These women are a locked box to a real designer's imagination.

Like with any business, there are the small groups of lovely, well-mannered customers who make life worth living. Unfortunately, 65 percent of the women buying high fashion act like star-spangled bitches, never satisfied, and full of conniving tricks to get the price as low as possible, demanding the best quality and three times more service. One of the snags of high fashion is that it attracts the most ambitious social climbers:

show-offs, snobs, bigots, and egoists. These women consider themselves as "social"—I think of them as miles of phony society fringe. They are the number one snake pit of the high-fashion business. By contrast, the customers who gave me the most pleasure were the out-of-towners, especially the westerners. These women have no ax to grind and indulge in fashion purely for personal expression and the joy it brings their families. The true cream of the crop of New York society are wonderful customers, but they don't usually indulge in high fashion. They prefer the best fabric and workmanship, with the quietest styling possible.

I have a book full of Fifth Avenue and Park Avenue hot-air artists who have never paid. And are these dames brazen! They almost dare you to get them into court. If I made lists of the names, you'd drop your teeth. I remember one lady, when I first started in business. She came in putting on the dog and belittling Mrs. Nielsen. I would have thrown the lady out, but she came recommended by one of my best clients. After she was done putting on airs, she left the store with four hats. This was in October. The winter and spring passed, and I couldn't get a nickel out of her. Even the small claims court was unable to make her pay. By midsummer, when there was no business and I was looking for money to eat, I passed by her apartment on Park Avenue and saw the second-floor windows open. I folded my *New York Times*—as I had done during my newspaper delivering days—attached a note, and threw it in the window. The note said that as a last resort I was going to get help from the woman who recommended her. The lady ran to the window

and threatened to call the cops, and I yelled back for her to read the note. As she was a desperate social climber, I evidently hit the nail on the head, and the idea of informing her friend just threw the woman into a tizzy. Within seconds $165 came flying back out through the window. (All this took place at the northeast corner of Park Avenue and Seventy-Ninth Street. How many times I've gone past that house since and burst into laughter!)

SINCE CHILDHOOD, an extra-sensitive sense has unlocked the door to my subconscious at least ten years in advance of everyone else. I'm able to feel and know what will be the general mood of fashion. During my school days, family and friends were always laughing and calling my ideas in fashion "weird," but sure enough, within seven to ten years, the very people who condemned my thoughts would themselves be parading around in the clothes they had judged. It wasn't just fashion, but the arts in general, that stimulated my conscious mind, which has total freedom to reach the very depths of my subconscious. Sometimes even I myself am afraid to submit to my subconscious inspiration, for fear of being ridiculous, but no matter how wild or vulgar an idea seems at its conception, within five years someone is sure to come up with it. My suggestion to anyone who is creative is: never hold back.

Designing a fashion collection is like growing antennas that reach high into the unknown and hopefully higher than any other designer's. It's a long time growing them till inspiration

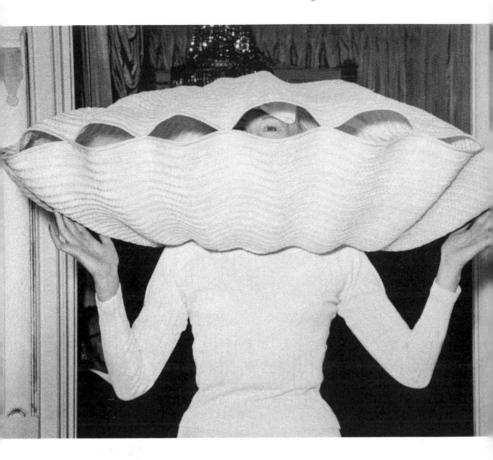

begins to tickle and outrates that of your competitors. With each new collection my antennas grew longer, starting in 1948, and reaching their highest by 1960. The day after each new hat collection, when the letdown from creating makes the body feel as if it's been through the wringer, my mind would spring back to life with the first thoughts of searching for inspiration for the next collection. Every designer has, deep inside his personality, his own unmistakable signature; and if the designer is

really creative, the doorway between his conscious and sub-
conscious minds swings open and shut at will.

I allowed my designs the greatest luxury of all: total free-
dom. In 1957, the apple, pear, and vegetable gardens were
spreading all over the hats. Huge, lush organza cabbage leaves
formed the cloches, while straws were soaked in a basin of wa-
ter and molded into overgrown apples and oranges. Sailor
shapes became platters of leaves and assorted fruits. There
wasn't an inhibition left in my body. I remember one summer
doing a special collection of straw hats that had to be soaked in
water before I could drape them into the seashell shapes I
wanted. The temperature in the shop was near one hundred, so
I filled the bathtub with water, put on my bathing suit, and
spent the afternoon in the tub shaping the hats. Each time the
phone rang or someone came to the door, I'd have to jump out
of the tub soaking wet.

By July, the feathers-and-bird inspiration, which had taken
a firm hold on my thoughts two years earlier, now looked like
it really hit the fan. Feathers were everywhere. The foremost
fashion writer on millinery for *Women's Wear Daily* raved that
"such inventive use of feathers hadn't been seen in many a gen-
eration, and midway through the collection the large audience
was fully aware that it was viewing one of the most creative
millinery shows seen in ten years."

I had a lot of fun doing this show. I took ostrich feathers and
stripped the plumes off the quill, then burnt the soft fluffy
white in acid, which left just a delicate lace feather, which then
was massed over a simple head-hugging shape, casting an aura

around the wearer's head. Whole birds sprang out of draped velvet; red-combed roosters' heads rested on live-looking bodies with yard-long tails fluttering down the wearer's back. The birds looked so real that many viewers thought they must be laying an egg! One bit of amusement was a parrot jumping through a velvet hoop, which caused eyebrows to rise and Garry Moore to quip, "Don't forget to line the bottom of the hatbox!"

During all these collections, many of the country's big-shot store buyers would come and sit through my shows and never so much as buy a hat to encourage our work. By 1958 I was so mad that I decided to charge a "caution fee," obligating the professional buyers to buy six hats or pay two hundred dollars for viewing the collection. This was nothing new, as Paris has always protected itself by the pay-first system. Unfortunately, no one in New York had ever followed this practice, and I didn't get any payers. But I caused lots of hard feelings with the phonies who did the heavy looking-on each season. Unfortunately the idea of the "caution" is antiquated in a field where it's a buyer's market.

With the fall collection of 1958, my antennas, which were reaching higher than ever, told me to hide all the hair with deep hats. A Paris designer had just launched the wig, and I felt certain the future of millinery would be only to cover dirty hair. These deep hats were all of fur, and in their most extreme depth covered the eyebrow. Their look was wicked and naughty, an act of real defiance in the face of all the tiny shell hats women had been wearing. Mrs. Nielsen, who knew how to

work fur, taught me all the secrets of stretching, cutting, and sewing furs, and the sables and chinchillas we shaped together formed the most exciting hats I'd ever made. I must say they scared the wits out of the conservatives.

Certainly, with this collection my antennas had gone much further than I had anticipated. Most of the buyers, even the venturesome ones, said I had flipped. They felt the proportions were outrageous, and no one would ever wear the look. Well, the season passed, and I sold most of the best fur hats off for five and ten dollars apiece, but with a lot of faith and patience

William J.

invites you

to his

1958 Spring Millinery Collection

in

His Salon — 44 West 54th Street

January 7 — 11:30 A.M.

Press — RSVP CI 5-8991

Invitation Not Transferable

Buyer's Caution Fee $200.00

Manufacturer's Caution Fee $450.00

on my part, after four years my 1958 hats were considered high fashion. Thank God I didn't give a damn about money. I just wanted to create the most trendsetting hats. That same season I designed a few fur accessories to be worn with the hats: round boas of fox and chinchilla, three yards long. And one item that I think was a definite innovation was a fur pillow, where I sewed the furs into a large collar and then stuffed it with feather down. This gave the fur a living appearance, and made the hairs bristle up and snuggle around the wearer's neck almost as if the animal were alive and breathing.

By 1960, abstract futuristic shapes began to tickle the tips of my antennas, sending them in a new direction. Origami, the centuries-old Japanese art of folding paper, set me off on squares and angles that were clean and free of curly nineteenth-century Romanticism.

By the fall of 1960, my feelers had stretched so high that people who had believed in me from the beginning were starting to feel that I was destined for Bellevue. The inspiration for the collection was Africa. The head shapes of the Zulu, along with the reptiles of Africa, inspired me to do a collection completely of snakeskin and leather hats. All the cobras and pythons were a thrill to sew. The hats were free of stiff foundations, relying on the snakeskin for shape. Monkey furs were lacquered and married to black leather brims. It was a wonderful collection, but unfortunately they were too new, and hardly sold. But three years later, everyone in the fashion world was wearing or making snakeskin hats, coats, suits, and bracelets.

My final collection in 1962 was space helmets, sleek and

naked of trimming, just pure shape, molded like the cones of rockets and racing headgear. This collection was speeding into a new era of fashion.

With each season I gave my critics something to talk about, and talk they did. Too bad they didn't shut their mouths long enough to buy something new and different. Some of my critics eventually apologized for trying to bully me out of my own ideas. Of course, it's always easier to see the light ten years after the explosion—but that's fashion: an idea that is elegant at its time is an outrageous disgrace ten years earlier, daring five years before its height, and boring five years later. There's no set way of becoming a designer except steady hard work, with an eye and a will bordering on pure stubbornness for what you truly believe in. Only the people who are willing to sacrifice the security and comforts of the establishment, and fight for their individual beliefs, cause the developing changes of the world.

THE YEARS 1956, 1957, and 1958 were excellent for millinery, but I knew there was a very dark cloud on the horizon. The wearing of hats was soon to be unfashionable. In 1954, when I made those first veil hats, I suspected then that hats were on their last legs, as the veils had extraordinary acceptance, although not with the milliners. The stores that bought them couldn't put them in the millinery department, as the buyers didn't want them, so they landed in the street-floor neckwear departments. After that season I stopped making the veils

because I felt they would ruin the hat business. Like all the milliners, I put my hatted head in the proverbial ostrich hole, trying not to see the coming threat of bareheaded women. This was a mistake. My friend Mrs. Mack was always yelling at me to be a realist and give people what they wanted. At any rate, the milliners wouldn't make veils. Consequently, by 1960, hats were becoming extinct, and the veiled head was the supreme victor. And a whole new millinery industry was developed by people who knew nothing about hats. This is really one of the most important lessons in fashion: you can't fight a trend. Designers must give full play to their innermost ideas, no matter how crazy it seems. I knew very well that hats had no future, yet I thought I could fight the trend.

The final blow to milliners came when Givenchy showed wigs on his models in Paris. Their hair was being ruined each time they changed clothes during his shows, and they didn't have time to redo their hair, so he put wigs on them. All the newspapers reported it as a big joke; no one took it seriously. But I knew that instant that the wig or the coiffured head would replace the hat for the next generation.

DURING ALL THOSE years I continued my hobby of gate-crashing to observe fashionable women. I was always lurking behind some potted palm, eagle-eyeing the clothes of elegant ladies. I remember one year Givenchy and Balenciaga, who wouldn't show the press until a month after the buyers, decided to bring their entire collections to New York two months after

the showing in Paris. This was really an innovation, but the buyers had, only two months before, spent all their money on a trip to Paris and paid two thousand dollars each to get into these top shows, and now for a hundred dollars a head, anyone in New York could go to the ballroom of the Hotel Ambassador. The plan was to show Givenchy first, and after a champagne intermission, show Balenciaga. I didn't have the hundred dollars, so I impersonated a waiter, with a towel over my arm, and walked right through the front door, where Carmel Snow, the editor of *Harper's Bazaar*, was handing over her one-hundred-dollar ticket. Once inside, I ditched the towel and watched the inspiring show from behind the huge damask draperies. Givenchy's show was spilling over with creative ideas, and the Watteau back was his big message. During intermission, my eyes were filled with the dresses of the audience. (At all the parties I've crashed, I've never once taken anything to eat or drink, or joined the guests. Perhaps too heavy a guilty conscience. At any rate, I felt better just being an observer.)

The Balenciaga show was act two of this double-barreled fashion parade, and seeing one after the other, you knew who was the master. Balenciaga's clothes had depth and interesting cuts that the younger Givenchy was yet to learn. The contrast of real couture and surface ideas was vividly portrayed to me that night. In all my many years of being associated with the finest clothes of the world at Chez Ninon, it was this particular night that brought me understanding—why Balenciaga or Dior reached the top. Three years later I dined with Givenchy on one of his New York visits. I wanted very much to meet him, so

I just picked up the telephone and called him at his hotel. He was as warm as a best friend. I told him I wanted to discuss fashion with him, and he invited me to dinner at the Sherry-Netherland hotel, where we talked for two hours. In his broken English and my torn French, we talked about that showing of his in New York; I was amazed at how fully aware he was of all the copying of his designs. He mentioned many prominent Paris designers who had swiped ideas from him. I could have named many of these myself. It's too bad designers don't remember the same principle when they themselves use someone else's formula. Givenchy had often paraded designs that were seen in the show of Balenciaga the year before. But I still feel Givenchy was one of the most creative people in fashion. He told me that night that Norman Norell, then America's most respected designer, saw both his and Balenciaga's showing each season. I must say this shocked me, but he produced a telegram he had received from Paris that afternoon telling of the dresses Norell had bought. Givenchy said Norell came two months after the professional buyers, so no one would see him. Of course, later, when I was to go back to Paris as a reporter, I saw just about every name American designer sitting in the front rows of the Paris showings. But Norell, unlike all the other designers who openly copied Paris and brazenly called it their own, claimed only to be interested in the construction, not the obvious effects. That same night Givenchy, the disciple of Balenciaga, said Balenciaga always encouraged him to design what he liked and believed in, and women would feel the

honesty and personal message in the clothes, and buy. This is just what I had found out for myself, five years before.

Each morning when I opened the New York papers, I turned first to the obituary page to see if any of my rich elderly customers had passed away. After all, my millinery business was made up mostly of the elderly matrons, as the young people weren't wearing hats, and there were few enough of my customers left. Secondly, I turned to the society pages, where I followed the goings-on of fashionable women. Five nights a week I spent observing elegant women from the balconies of the ballrooms, my opera glasses trained on their chic clothes as I mentally rearranged them to what I thought best for the women's individual types. Of course, I never had a ticket to any of these parties, but I soon learned all the back doors to the fashionable theaters, hotels, and restaurants. Today I can hardly find my way through the legitimate entrance of the Waldorf, but I could take you blindfolded through all the fire exits and kitchens leading to the ballroom. I remember when Queen Elizabeth was at the Waldorf, hundreds of cops were guarding the place, and I just had to get in to see all the glorious women. I was quite nervous about crashing, but by using all my secret doors, I made it to the projection room near the ballroom ceiling, where the spotlights threw shafts of light on the queen's diamond tiara. I lay on the suspended catwalk seventy feet above the three hundred elegant guests, with my binoculars glued to my eyes.

Another time I wanted to see the most exclusive debutante presentation of the city, where no press or public were allowed. It was one of the August Assemblies. I arrived at the Plaza two hours before, and after glancing around the ballroom and seeing dozens of private cops stationed at the entrance door, I knew I'd never get back in, so I crawled under a table in the main dining room and sat for two hours. When feet started to surround the table, I figured I could emerge and blend in with the guests. I got a wonderful exclusive story for the newspaper.

Gate-crashing was part of my self-education in fashion. When there were three parties each night and I couldn't see the elegant women on arrival—which is the best time to study all the clothes—I would take up the second best viewing point, which is outside the ladies' lounge, and as soon as the cocktails were over, every girl in the room would start a fashion parade in and out, giving me a marvelous display of the clothes. This observing has been a full-time hobby, which has turned out to be the finest education in fashion I could ever have. I am seen so often at the hotels that many people think I work there.

One of the most memorable nights was a masked ball a year earlier, in 1949, at the Waldorf, when the most chic woman in New York, Mrs. Byron Foy, made her grand entrance sweeping across the ballroom floor. She wore the first beaded gown I remember. It was from Dior, and was called "Junon." The huge crinoline skirt was petaled into dozens of scallops, covered with sequin fish scales of celluloid; the colors were blue, green, and aqua, and the foot-long train swerved like the fin of a mermaid. It made every other gown in the room look like a rag.

The Metropolitan Museum acquired the dress and many more of Mrs. Foy's fabulous clothes for its collection.

Seeing all these clothes being worn by live women was quite an experience. So many fashions look effective in stiff photographs, but the second they begin to move you really see the difference between a good dress and a cheap one. A fashion design is only perfection when it comes alive on a woman's body as a graceful sculpture. Whenever I was depressed and needed a lift, I could cure myself by running out to a fashionable restaurant or party and observing beautiful women. This

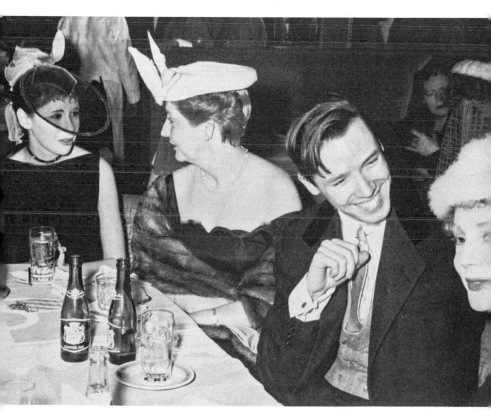

was quite easy to do in New York when three to five big public parties were held each night.

I never missed the April in Paris Ball, the opening of the opera, or Easter Sunday, as the trio were real fashion-climbing occasions. Often I took a girlfriend and dressed her in some outlandish flight of fancy that got her photo in the paper and pepped up my ego. One Metropolitan Opera opening stands out in my mind. It was in my poor days, when we could just afford standing room. After standing in line all day outside the opera house, we reached the box office, and there was only one ground-floor standing room ticket left; the other two were in the top balcony, which had its own drab entrance. There the music was the best in the house—but we definitely were not there for the music, we were there to see the audience, and had intended to make a splashy entrance on the ground floor at Thirty-Ninth Street where all the celebrities gathered. After buying the tickets at six o'clock, we ran home to doll ourselves up. I left my friends Ellen and Mary, all dressed to kill, in a taxi outside the opera, while I dashed up to the balcony, went out the fire escape, down the side of the opera house, and through the kitchen windows of Louis Sherry's restaurant, where all the elegant swells were seeing and being seen while they nibbled on their partridge. This put me on the lower floor, where I could get passes for the main entrance, which I did, and then climbed back into the taxi, drove around the block with Ellen and Mary, and made a smashing entrance through the Thirty-Ninth Street doors.

Three days before, my friend Jack Edwards had designed

and made Mary a fabulous empire-style gown, from his pearl-gray moiré shower curtain. The day after the opening, Mary, in Jack's creation, was on the front page of *Women's Wear Daily*, reported as the newest gown to be seen opening night. We almost died howling when we thought of the seven-dollar shower curtain upstaging all those expensive creations. Ellen made several New York papers, in a hysterical feather hat—crafted with white egret feathers that a customer had left with me to mount on a hat. We added a gold jeweled veil that completely covered her $8.95 lamé dress. These were wonderful wild days, when fashion was all we ate and drank. Ellen was the queen of Greenwich Village, always wearing black tights and the latest William J. hats. Easter Sunday we were the same show-offs, parading around. Although many of the press thought these displays were in the worst taste, I must say that for young designers, this kind of exhibitionism relieves the inhibitions you have to get rid of. Sadly, these days are gone now. The television camera caused the death of the opera opening, Easter Sunday parades, and the Paris ball, scaring away the real elegant people and bringing out far too many peacocks and rubbernecking farmers.

New Year's Eve was always an explosion, with twenty friends, all rigged up in the most unrestrained William J. hats. Lüchow's was usually the setting for our big party, with their German oompah band that set the tone. Our table always looked like something out of a Hollywood movie. At one of these parties, Clovine, a hostess friend from the army service club, put on a huge black hat, which I had draped only a few

hours before, and there wasn't a stitch in it. Fifty yards of transparent net were wound around and around into the shape of a bull's-eye. It all rested on a huge horsehair platter. Clovine got high on German beer and started to dance with a drummer; she was holding on to his suspenders, which were keeping his Alpine shorts up over his little potbelly. As they danced through the room, a branch of the famous Christmas tree caught the netting of the hat, and without her realizing it the net started to unwind with alarming speed. The restaurant was in an uproar of laughter as she retraced her steps, winding herself up again.

We'd make telephone calls during dinner, asking for the Duke or Duchess of So-and-So, and if you had visited Lüchow's, you'd remember seeing a page carrying through the rooms a huge three-foot-square blackboard, with the name of a person being paged chalked on it. Naturally, everyone would want to see who the duchess was, and of course one of our behatted girlfriends would sashay her way to the telephone. Upon her return, there would always be some inquiring woman coming over to ask about her hat. It was all nonsense, and I doubt that we ever snagged a customer from it, but everyone had a good laugh, and those trendsetting fashions had an airing.

Many women who never buy a hat any other time of the year will think nothing of spending a hundred bucks on a hat for Easter Sunday. I had a large crowd of these one-hat-a-year ladies. I think the motivation was always the hope of getting themselves into the newspapers. Years ago, during the Easter parade, really elegant women hardly ever came to Fifth Avenue unless they were going to a party at one of the hotels, and

most of those lunches were filled with ambitious women want-
ing to be photographed, or fashion designers showing off their
wares.

The Plaza Hotel was still the most voluptuous setting for
Easter. The ravishing elegance of the Palm Court, with its glit-
tering light and women dripping in the latest looks, that ex-
traordinary crystal terrace ballroom, whose thirty-foot-tall
mirrored French doors are thrown open for the day, allowing a
vista of dazzling splendor as you enter the hotel's lobby. Cer-
tainly nowhere else in the world could you see such old-world
elegance as at the Plaza on Easter Sunday. Monday night at the
opera still had this same atmosphere of gilded women, drip-
ping in chinchilla, jewels, and feathers. Outside the Thirty-
Ninth Street door was a sight few places in the world could
match—akin to a royal affair in London—as nearly four hun-
dred long shiny black chauffeured limousines waited to carry
the cream of capitalistic society to their French-decorated
apartments on the gold coast of Fifth Avenue. Events like these
kept the fashion wheels of New York spinning at a dizzy pace
and the pockets of the merchants filled with green.

But these events at the height of their splendor frightened
me. Wallowing in luxury gives me shame of overindulgence,
and as much as I am drawn to all of it, I have the strongest de-
sire to escape to the discomforts of the poor.

The kind of custom wholesale businesses that blossomed
all over New York between 1947 and 1960 never really made
money; although they had excellent press coverage, the cost of
rent and labor barely let them pay the bills. Occasionally a

good year would bolster spirits and faith. For me, the true creative road of design is one of continual struggle, both financially and morally. America is a commercial marketplace, and very few people are educated to understand artists or appreciate originality. A small following of private customers allows a designer to feel the pulse of life, but it cannot sustain a business. Designers in America must be geared to mass production. The big question now is where are creative people going to express themselves? One age-old formula is to lead the life of starvation while enjoying the freedom of creative life. Artists have tried desperately to blend creative life with modern comfortable living. I don't think they go together.

No matter which way you turn the problem, high fashion will always have to start on a personal level, being worn by a few daring women. The style cycle must always be a marriage of compromise between classic periods and creative periods. But fashion, like all art, mirrors the spirit of our times.

I can still hear the ladies at *Vogue*: "If we could only corral William's enthusiasm, and make him like everyone else." Oh, how I thank God they never did corral my thoughts—although I have many scars from the barbed wire traps set for me.

Nona and Sophie

All during my fashion career, my life has been involved with Nona Park and Sophie Shonnard, two elegant members of real New York society. The girls started their business because Nona had just been divorced and thought it might be just the thing to get her out of her depression. They opened their first shop in 1929, after they couldn't find the kind of clothes their lives and those of their friends called for. It seems no designer really knew how elegant women lived. Most designers sat in their workrooms and dreamed of a past that had nothing to do with reality. So Nona and Sophie opened Chez Ninon, buying most of their designs in Paris and bringing them back to New York, where their superb workroom made reproductions. From time to time they hired designers of their own, but always the Paris clothes were the backbone of their collection. The shop was an exclusive club where everyone knew each other. Nona's sister-in-law, Molly McAdoo, directed the

salon, and a few elegant friends down on their luck sold the clothes to more friends. The shop was an immediate success, as their formula for dressing their friends in clothes that fit their way of life was correct. Their families, though, were horrified that they had opened their shop. Their view was that young women from fine families just didn't go into business; they weren't educated for anything but the niceties of home and card games.

Chez Ninon was a name very few Seventh Avenue people had ever heard of until thirty years later, when Jackie Kennedy came into prominence. At that time, all Nona and Sophie's friends kidded them about being discovered, as the press mobs waited outside the Park Avenue shop, trying to find out what Jackie was wearing. Chez Ninon was like the Social Register of fashion; there were always as many women trying to get through its doors as there were trying to get their names pressed between the covers of the Social Register. Chez Ninon was a small business where clothes were sold not for their flashy appearance, but rather for their quiet whisper. Many people would have just fallen on their heads if they could have seen Nona, Sophie, Mr. Anthony (their superb tailor), Miss Sophie (their head dressmaker, who had the patience of a saint), and me at work, putting our two cents into designing a new model. We'd all be pulling the fabric every which way, looking through magazines for ideas. Nona and Sophie sat on the French sofa proclaiming what ladies would and would not wear. My suggestions were usually too flamboyant, although occasionally a dash of my spirit might stay with the dress. But it was Nona and

Sophie who really shaped these collections; they had fantastic instincts for what elegant women would wear. They would make all kinds of suggestions on the design, as Mr. Anthony and Miss Sophie reset the sleeves, repinning the skirts a hundred times, until the ladies felt it was just right. A fraction of an inch makes such a difference in fine custom-made clothes. This was also true in hats. These hours and hours of painstaking development gave me an insight into fashion that is rarely available. After these agonizing fittings I often wondered who would appreciate all the effort, but the customers instinctively admired all the details. Nona and Sophie would admit that they didn't know a thing about sewing, but few people in the fashion world could match their knowledge of what makes truly elegant clothes.

In Paris we would sit for a whole afternoon or morning while the girls discussed the designs they were buying. Nona and Sophie were the only buyers I know for whom Dior would allow changes to the designs to suit their taste. It was just a riot the way they took the jacket of one suit and added the fabric of another, the skirt of a third, and the buttons of a fourth. This was unheard of in the couture of Paris, where the House of Dior insisted that manufacturers take the designs exactly as they were shown. But they realized the exquisite taste of the girls and knew that Chez Ninon was one of the last truly custom salons in America, with a following of some of the most chic women of the world.

Nona's famous phrase—which I heard a million times when I'd show her an interesting dress—was "It's too much of an

effort." She appreciated clothes that didn't overpower the wearer yet had charm for the viewer and were a pleasure for the woman to put on. The girls didn't believe in that deadpan simple-as-sin look either, where the rich try to appear like their maids.

During the showings, Sophie sat near the door leading to the ecru-colored salon, where her sensitive eye adjusted each jacket and skirt so they hung at precisely the right angle. She then chose the proper gloves and scarves, tying them herself. Her chair was set into the closet, to keep her from the running

pace of the models. Mrs. Park would get very nervous and sit on her damask sofa in the office, like a frightened bird hiding in its gilded cage, constantly chirping, "Oh my God, do you think they'll like it?" and occasionally getting up to peep out the door and watch the reaction of her audience and friends. After so many years of showings, the girls were still full of anticipation with each new collection. They were past their thirty-ninth birthdays, and their families advised them, when redecorating their new shop, that perhaps they should be thinking of the old-age home—but Nona and Sophie wouldn't have it. They were like two debutantes at their first big party during each of these shows.

Many women have been known to exert all kinds of pressure to have themselves seated at the prestige showings, as the press who cover the showings have their eagle eyes trained on the audience as well as the clothes. Social climbers who are lucky enough to get invitations have been overheard saying, "It's like getting through the gates of paradise!" Nona and Sophie had a wonderful philosophy on the press. They simply couldn't understand why the press would want to come to see the clothes, as they answered each press request with the same story: "We have nothing sensational, just quiet, elegant clothes." Of course, this throws the press into a tizzy and they wish to come all the more. I remember one time in Paris, a leading New York editor asked Nona and Sophie to pose for a picture at Lanvin's. Nona's remark was, "Well, we really don't want to, but if you're desperate, call us back . . ." Of course, if you understand the puffed-up

egos of some members of the press, you can imagine what a whack on the head this was. Nona never meant it that way; she was merely being her truthful, blunt self.

Just before the war, Nona and Sophie were negotiating with Mainbocher, who had fled Paris before the German invasion. They were in negotiation to have him as designer for Chez Ninon. While the discussions were in progress, he got to know all about the workrooms and the people in them, which are the most valuable part of any fashion house. He stalled on signing the contract, and then fled with all the best workroom help and opened his own fashion house. It was a dirty trick, and contrary to the gentlemanly quality one associates with Mainbocher. Several of the salespeople fled with him, plus their customers. As you know, salesgirls and customers move around together, as the customers get such trust and loyalty in their vendeuses. But eventually one of Mainbocher's top salesladies who had been with him for years came back to roost at Chez Ninon, bringing with her many fabulous customers. It's funny how the score evens out if you wait long enough.

In big retailing stores, competitors are always raiding the best employees from others—it's all part of the retailing game. One afternoon when I stopped into Chez Ninon, Molly Mc-Adoo was sending Mrs. Kennedy ideas for designing an evening gown to be made from the exquisite saris Prime Minister Nehru had given Mrs. Kennedy on her trip to India. They were extraordinarily beautiful, but absolutely hell to design into a dress, as the huge gold and brocade designs made them more suitable for wall hangings. We draped them on the models for

days trying to figure out an elegant solution. Finally, sketches were made and sent to Mrs. Kennedy. On the spur of the moment I made a few rough sketches that went down to Washington and came back with Jackie's notes, stating, "Definitely not!"—my ideas were too full of drama. My ego was deflated for days, but soon recovered when Nona and Sophie decided not to make the dress, and advised Mrs. Kennedy against it. We read later that another designer had cut up the saris and made a gown, which *Women's Wear Daily* described as looking like it had been made by "loving hands at home"—a reference to shoddy workmanship. Several years later, when I went to interview this same designer, I was astonished to see the remains of the fabulous sari hanging as a window curtain in the designer's salon. All I could think was, what would Prime Minister Nehru think of the final resting place of his beautiful gift?

I never officially worked for Nona and Sophie, as my taste and theirs was at opposite ends of the fashion poles. I scarcely ever made hats for them, as they rarely wore them, and Nona thought most of my designs were freaks. The girls had the belief that anything extreme is considered bad taste, although Sophie often found merit in the designs but wanted me to give it all up and go into my uncle's advertising business. All the years that I had known the girls, our businesses had been miles apart. On rare occasions, I loaned hats for their openings, but seldom did the models wear them. Our association was always more of a private friendship, as our fashion philosophies were in constant conflict. The only thing in common was that we each dressed women.

The Southampton Shop

Each year, after the millinery collection opened the first week of July and I had shown the fall collection to the buyers and press, there would be those horrible two months of midsummer when there is absolutely no business. These were always penniless days, and all the money made on the spring hats was spent creating the fall collection. The cost of making a new collection is extraordinary, the labor alone is lost time, as you can only ask a legitimate price for each hat, no matter how long you worked on the original model, which often takes days to develop. On top of the cost of the collection was the cost of a big opening for the press. During the late 1950s when I was really fashion climbing, I had this idea in my head that it had to be a glamorous champagne opening, and of course this would put the shop in the red for about two thousand dollars. So each September we started by paying old debts. My friend Claire Weil, the editor of *Hats* magazine, was forever telling me it was

ridiculous to spend all that money, but I was at the impressionable age and thought a big splash was good for business.

I can tell you now that it definitely didn't mean a damn thing for business—as a matter of fact, all it did was attract the freeloaders. The serious press and the busy buyers couldn't give a damn about the fancy hors d'oeuvres and champagne. They find it time-consuming and annoying. At any rate, the day after the showing, the pocketbook of the shop would be empty. The flowers filling the rooms were dying, and the buyers had bought only a handful of hats that would scarcely bring any profit. In high-fashion wholesale buying, they tend to buy only one or two of a model, and in wholesale you need orders by the dozen to make money.

Those early summer days without a customer in sight were rather miserable, and even to this day I get the willies when I think of the summer months. I can remember searching the trash baskets along Seventh Avenue for the *Times* and *Tribune* so I could read the fashion reports from Europe. I was too proud to tell anyone I didn't have money, so I would go from day to day wondering where the next meal was coming from. At times like these I moved out of the Automat into Nedick's, where fifteen cents would buy breakfast and twenty-five cents a hot dog lunch. By the mid-1950s, I got the idea of taking my beach hats that hadn't sold in New York and going to the customers at the beach resorts. The first year I got on the Long Island Railroad, stopping at resorts in the Hamptons, and I found quite a bit of interest. The second year, Nona and Sophie, who had summer homes in Southampton, a very swanky

village, had been asking me to come out and stay with them. While I was there I decided to look for a tiny shop. Nona thought I was mad, as she said my hats were freaks and she couldn't imagine who would buy them, and besides, she felt Southampton was just a private little family beach. Of course, this was the understatement of the year. Southampton was the watering spot of the New York Social Register.

But Nona proved to be 100 percent right, as I found out during my summers there. I found a shop that same weekend and rented it on the spot. It hadn't been taken for the season, so the owner let me have it for the remainder of the summer for a modest two hundred dollars. I borrowed my friends' tiny station wagon, rushed back to New York, and loaded the car with all the leftover spring and summer hats, and, of course, my wild beach hats. I also packed a few workroom supplies, so I could design in my spare time. Worktables, mirrors, hatboxes, the whole works, were piled on top of the little car, which nearly collapsed under the bulging load. Ostrich feathers were hanging out the windows. My bed was tied to the roof—as I was determined to sleep in the back of the shop—and Ollie, my large black beatnik French poodle, had to sit on the floor under the brakes and gas pedal, as there wasn't an inch of space. It was to be the first time I had been away in five years, and the thought of escaping the penniless summer in New York filled me with renewed strength. I can still smell the fresh-cut grass as we drove through the farms and villages of Long Island. I didn't have a care in the world.

On arriving in Southampton, the lady who owned the shop

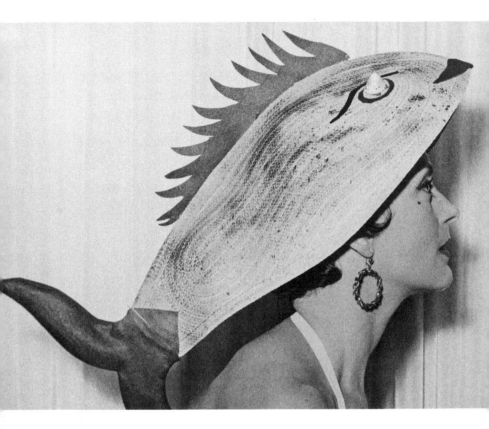

next to the place I had rented couldn't believe her eyes when the car stopped in front of her shop. She thought some refugee fleeing Greenwich Village had just broken down. Within a few hours, the shop was set up for business. Once all the whimsical beach hats filled the display window and I had hung a wonderful art nouveau sign of purple panne velvet with shocking-pink letters spelling "William J," my hastily arranged shop was opened.

For the first day, no customers came in. People gawked at the window as if they didn't believe it. Occasionally someone

would ask if it was a costume shop, and when I tried to convince them that it was a legitimate hat shop, their eyes almost fell out of their heads. I suppose it was the hats in the shapes of fish and vegetables, and one huge octopus hat, that scared the hell out of everyone. Southampton might be the most conservative fashion resort in America. At the time, they never thought of anything as being a hat except for the beret, which I've always hated with a vengeance. I'd never make the darned things, even if it killed me. I felt they weren't fashion, and

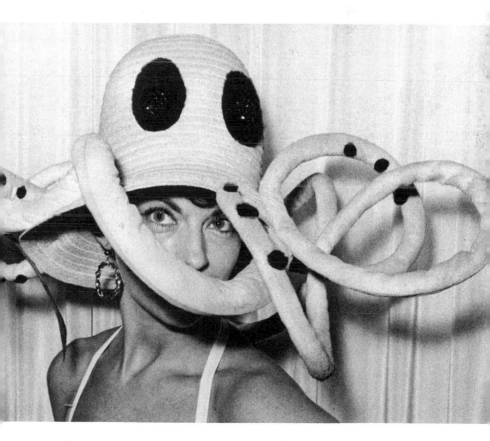

besides Woolworth's carried them for $1.98. At any rate, I lived with my aesthetic values, and it was eighteen days before anyone came in and bought a hat.

The first woman with the daring to come in was an elderly matron who drove up in a chauffeured car. I thought she'd have a heart attack when she saw the hats. Instead, she loved them, and said she hadn't seen such wonderful, imaginative hats since the days of the famous New York designer Herman Patrick Tappé, one of the most talented and fascinating designers around the time of the First World War. The lady turned out to be a Miss Ruth Woodward, a millionairess who lived at the Irving Hotel, Southampton's equivalent to the Plaza. It was a rocking chair hotel for pampered dowagers. Sometime I'd like to do a marvelous picture book on all the distinguished dowagers in their dog collars and elegant but passé fashions, rocking themselves on the veranda.

Each summer the reigning dowagers of Southampton would tell me about the fascinating Mr. Tappé. Besides being a truly original designer, he possessed a sense of showmanship and flair that made him the gossip of every fashionable salon of New York. His costume parties were notorious soirées. He went through a half dozen fortunes, indulging in luxuries. One time he married the mistress of one of New York's wealthiest telegraph tycoons. The gossip had it that the gent paid Mr. Tappé $100,000 to relieve him of his romantic duties. Once, an august dowager who had financed Mr. Tappé was miffed because he had spent a huge sum of her money on a group of glass elephants, which was to have been used on dress materials from

Paris. At any rate, the lady, while sitting in her box at the opera one night, saw Mr. Tappé sitting below in the orchestra. When the lights went on at intermission she leaned over the red plush balustrade, her pearls and diamonds spilling over the nude cupids that festooned the box, and hollered down: "You're a thief, Mr. Tappé!" With that, Tappé, who was a handsome six-footer, always fabulously dressed in swirling black capes and carrying a gold-handled walking stick, looked up at the box and, in the most triumphant voice, said, "Madam, you've made a mistake, I'm not Mr. Tappé." With that he strutted to the opera bar and toasted the lady's health and wealth in champagne.

Tappé's admirer, Miss Woodward, bought six hats right off the bat on her visit to my shop and paid me in cash. She said she'd be back the next day with friends. I was absolutely delighted with joy, as I'd run out of money four days before. As soon as the lady had left the shop, I locked the door and dashed to the nearest restaurant, where I proceeded to stuff my shrunken stomach. I could have gone to the beautiful summer home of Mrs. Park, where the best French cook was always preparing delicious meals, but I was full of that damned false pride and didn't want to admit to Nona that I hadn't sold any hats. Sure enough, the next day Miss Woodward arrived with two more elderly dowagers, both pillars of Southampton society. The ladies were a Mrs. Preston and a Mrs. Fox. They were both much more conservative than Miss Woodward but absolutely darling and bought about six hats between them. Unfortunately, they loved berets, and I must say it wasn't soon after their visit that I indulged in the foundation of the millinery

world—making berets. And I think when I stopped fighting it all, my troubles ended. Anyone who is interested in millinery, for God's sake, make berets—you will never have to worry about eating—they're the equivalent of the basic black suit or dress.

Mrs. Preston and Mrs. Fox knew everyone in Southampton, and they sent all their friends into my shop. At last, I was established, but it was with the dowagers, and not the young fun people for whom I was interested in designing. At any rate, I was paying my bills and was now designing winter hats for the ladies. The darling dowagers from the hotel had told me that Bergdorf's came once a year and put on a big millinery show, doing jaw-dropping business, so I dashed into the city and bought out all the fall materials. The velvet and feathers were flying around in the ninety-degree heat of Southampton.

There is a wonderful business opportunity if a designer can gear himself to the conservative rich. But all those imaginative crazy beach hats that I loved so much just rested on their hat stands, causing lots of laughter but no sales. The younger people seemed to be afraid of imagination. Their conservative upbringing kept them from enjoying creative fashion, especially in Southampton, where it was considered chic to look like the maid. Well, this was just the opposite of what I believed in, and I soon found my most exciting customers came from the surrounding communities. They wore the wild beach hats over their pink pants and brilliant printed Pucci blouses. The other group that admired my chicest and most amusing beach hats were the weekend international society, who visited the old

guard residents. These ladies gave Southampton its glamour. Their parties were elaborate costume affairs, or elegant dinners, where long Paris gowns were worn.

On weekends, the famed artist Larry Rivers would appear in the shop with his lady friends. He had bought an old leghorn hat, with a dented brim and crown, right off my head—my dog had often slept on it, giving it a well-used effect. This was the quality the artist loved. He wore it for years, and his friends had been begging him to give them his hat, but no doing; Larry wouldn't give it up. So I would have my dog sleeping on leghorn hats all week, getting them fashionably out of shape for his girlfriends. Sometimes Larry would take a paintbrush and sign his name inside the hat so the girls would feel authentic.

For me, Southampton was a wonderful, let-your-hair-down place. Weekends were a hoot. These summers were the time when I succeeded in showing people how to enjoy fashion. The shop must still be vibrating from the howls of laughter. By the end of the first summer, I had paid back all my debts, and the new customers were following me back to the city.

The next summer I rented the same shop at the going price of one thousand dollars for the season. The long-dreaded summer months were now full of excitement. The shop was the talk of Southampton. Many people thought it was a disgrace. The year-round residents were amused, as if they were at a circus, and the old guard at the restricted beach club on one occasion sent three arrogant ladies to tell me my shop and its vulgar, uninhibited designs were the cause of an influx of prostitutes. I was absolutely astonished, and nearly died laughing. What a

reputation! Oh well, what did I care? I was paying the rent, and lots of people enjoyed my designs—but I'm sure it wasn't my hats that brought the influx of the ladies of the night.

The shop was a stage, with one funny episode after another. The customers were on vacation and wanted a laugh, a sense of freedom. I always wore the most outrageous hats around the shop, and often out around the village. On dull days, a young lady who took care of the shop while I was in the city would dress as a beatnik, and I, unshaven for a week, wearing the dustiest clothes I could find, would sit on the shop floor reading poetry, to the astonishment of the sightseers. It really was good for business, as people came in and they usually bought something. One time a rather prim-looking tourist stuck her head in the door and asked what we sold. I yelled out, "Marijuana!" and invited her in for a jab of the needle. The woman fled the shop, and a few minutes later showed up with the local police, whom I knew very well, and who knew I was playing pranks on the tourists—whom, incidentally, they couldn't stand. Their automobiles were always blocking up the village streets as herds of the city sightseers made their summer pilgrimage to Southampton so they could rub shoulders with the swells, whom they rarely saw, as the famous inhabitants remained concealed behind the twelve-foot privet hedges that hid all of chic Southampton.

I was always giving advice to the unhappy social climbers who were trying to crash Southampton society. One day a couple of these ladies were in my shop trying to find out which hats the local swells had bought—I guess they wanted the

same status. The two girls were crying up a storm over how dull life was—it seems they hadn't been invited to any of the parties. I advised them to go back where they had friends, and to stop trying to crash society. I must say, though, the climbers sure bought a lot of hats. I was always giving them a big song and dance about how many famous people had the hats I was selling, but of course they didn't, as these famous people never wore hats.

Lots of the gay boys from neighboring communities were my best customers, always buying fancy hats for parties. At first they would say they wanted a hat for their sister. Of course, I knew damned well they wanted them for themselves, so I'd tell them to try them on, as they could better tell how it would look on their sisters. I always felt it was none of my business who buys what for whom—it was more important to humor people and make them feel good. Everyone seemed to enjoy coming into the shop. Lots of people just came in and sat down to laugh. I went out of my way to make everyone feel wanted and at home. Sometimes they bought, and sometimes they just took up my time, but usually they came back. The great trouble with private shops is this feeling of unfriendliness that freezes customers out. Unless the salesgirls know who is coming through the door, they usually give the stranger the unwelcome eye. I let customers browse around without breathing down their backs. I've always felt this is why department stores are so popular, as it allows freedom to look around without being belittled by some snobbish saleslady.

One Saturday afternoon the Gabor sisters came in with

their mother. They wanted something simple for Mama, as she was invited to be a guest at the restricted beach club, and they wanted Mama not to "stick out." Well, one look at Mama and I knew darned well she was going to stick out like a Folies Bergère girl! Mama already had on gold wedgie shoes, shocking-pink pants, a screaming print blouse, and a turquoise chiffon scarf around her waist, plus lots of family jewels. Magda said she wanted Mama to fit in with the other ladies, so I promptly told her to go home and exchange clothes with the maid. The answer was, "None of your nonsense, William, just make Mama a nice simple hat." All I could think of was, how could a nice simple straw hat quiet this explosion? After much haggling over an untrimmed straw hat, Mama and the girls left the shop. They got outside, looked in the reflection of the shop window, turned around, came back in, and asked for a little trimming—it seems the hat was too naked for Mama's taste. We ended up with a big ribbon bow on the hat, and I never did find out if her conquest succeeded in a return invitation to the beach club. But I remember it took me two months to collect the ten dollars, after all the fuss.

Another time Countess Cassini came in on her way to a big cocktail party. She always had an entourage of friends. The countess, who had a marvelous sense of humor, decided all the ladies should have amusing hats. One of the ladies, who shall remain nameless, insisted on having a white turban under her beach hat to protect her coiffure. I hunted all over the joint, and there wasn't a scrap of white jersey in the shop. I stood there looking at the woman, and thought for a minute, and I don't

know what ever made me say it, but out of the clear sky I asked her what color her panties were, as they were the only thing I could think of that would be jersey. Everyone howled, but a couple of conservative Southamptonites who were buying veils to wear to church almost passed out. I must say the countess's friends were full of fun, and within a second the lady dropped her white panties, right in the middle of the salon, and just as quick I picked them up, slashed them with the scissors, and proceeded to drape them around her head. The countess loaned her a diamond brooch to hold the turban, and they left for the cocktail party amid gales of laughter. As a matter of fact, there was so much laughter, a crowd had gathered outside the shop. But this was not unusual.

I would often put on one of the wildest beach hats and parade around the village, like those guys you see going up and down Broadway with the sandwich signs over their shoulders. Sometimes a few customers would follow me back into the shop, but generally they only had money for an ice cream soda, not a hat. At the end of each season, on the same Friday night that the Southampton ladies had a town fair across the street from my shop at the Parrish Art Museum, I would hold a midnight sale of all the hats. And what a kooky event that was! Everyone in town would manage to come into the shop sometime during the evening and have a ball trying on and buying everything in the shop. In one night I would make the whole summer's business: three thousand dollars. It was a real carnivalesque sale. I made huge foot-long color price tags, which I tied on each hat with long bright ribbons, and with a dark crayon I'd

make all sorts of outrageous prices, like $700 reduced to $5, or $2.95 increased to $35. The whole affair was a riot, and by the morning there wouldn't be a hat left in the shop, and I'd close the door and head back to New York with only a few empty boxes and the mattress I slept on.

In Southampton, shops open and close faster than car doors. The only reason my shop survived was that I never got discouraged—if one approach didn't work, I tried a dozen others, until it succeeded. A lot of people thought I was crazy, but I wasn't out to please, and after all, I was paying my rent, not my critics'. The darling Miss Woodward came almost every day, always buying a hat. She had more hats than anyone. On her trips from New York for the summer vacation, she would rent a separate truck to move all her hats, and in the hotel an extra room was reserved to keep the piles of hatboxes. She absolutely adored hats. I think she bought a new hat every day of her life. There wasn't a milliner in New York who hadn't sold to her and enjoyed her keen sense of humor. One summer, after sitting in my shop for an hour or so each day, she would rush back to her hotel without my realizing it and record all the wild goings-on. She was planning to produce a play around the shop—it was in production when she unexpectedly passed away. A lot of people in Southampton breathed a great deal easier.

One time while she was sitting in the shop, a friend of hers returned a hat she had bought the day before. The night before, the lady and her maid sat up trying to improve on the design. They made a mess of the hat and were now asking me to take it

back. This was a regular habit of hers. I said I'd take it back but that she couldn't come in the shop again. Miss Woodward never said a word as she sat through this whole episode. Two months later, Miss Woodward was again sitting in the shop when the ladies from the church bazaar came in for donations. When I brought out an armload of hats, which included the cut-up model belonging to Miss Woodward's friend, she said nothing but got up into her chauffeured car and followed the ladies to the church bazaar, where she promptly bought her friend's old cut-up hat for twenty-five cents. All so she could present it to the original lady as a birthday gift!

The second summer, I made a deal with a friend of Kathy Keene to take care of the shop three days a week while I was in New York working on the wholesale orders. In exchange, the young lady could have a rack of clothes and operate a small business of her own in my shop. It seems one of her miles of boyfriends manufactured sports clothes, so she could have her clothes made without cost. It was a good deal for her and for me, as I didn't have to pay her a salary, and she desperately wanted to be in Southampton so she could meet her life's ambition, a millionaire boyfriend. It was a delightful summer. Her life was one continual screening of *Stella Dallas*. From the first weekend on, she was constantly invited on board the swanky yachts of the rich. Each Monday I was filled in about the size of the boat, whom it belonged to, and how rich they were. Frankly, I thought it was a lot of baloney until one weekend I heard so much about the 145-foot yacht she was going to spend the

weekend on that I bicycled over to the docks to have a look for myself. Sure enough, there was my ambitious salesgirl playing Mrs. Richbitch.

When she arrived back to work the Monday following her big weekend cruise, she seemed very unhappy. After much probing, I found that the millionaire boyfriend just sat there and read murder mysteries all weekend, completely ignoring her charms.

On another Monday, she arrived in a tizzy after a weekend at the estate of some millionaire whom she said she wasn't able to meet. She went on to tell me about a man dressed like a farmer, who fell madly in love with her. He told her that he worked on the farmland of the estate, and she wasn't having anything to do with any unattractive farmer. After getting his description, I knew right away that this was the multimillionaire oil scion. Sure, he worked on the farms—he owned them all, and this was his hobby. When I told her, she almost killed herself—to think she had moved on to a flashy, penniless phony whom she met the same night. This girl was really a hoot. When it came to selling her clothes, God help the poor customer—many times I had to leave the shop, as I couldn't stop laughing, when she'd pull them into her snake-pit fitting room, where they didn't stand a chance of escape. One woman, whom I remember vividly, had been thrust into a floral jacket about five sizes too big. This never bothered the salesgirl. She saw it as a challenge, and she'd give the customer a song and dance about the new dropped shoulders that reached the elbow, and how smart it was to have the cuffs a foot deep. I was

often astounded at the gullibility of many women in dress shops. I don't know whether they bought the things to get out, or they really believed the story. The salesgirl and I soon parted company, as her night life became so active that she couldn't get to the shop until late in the afternoon, just in time for cocktails. During the first month of the girl's stay in Southampton she succeeded in gate-crashing the wrong beach club. I didn't have the heart to tell her she wasn't in the right one, which is named the Bathing Corporation, but referred to by its members as "the beach club." This club was quite unimposing from the outside, but the one my girlfriend joined was a huge white elephant mansion some declassé people turned into a club. When I'd be in New York, she'd quickly take down the sign "William J.," swap it with her own, and then empty the window of hats, replacing it with all her clothes. Then she'd invite her rich boyfriends, trying to impress them with her big business. I think she told them I was the stock boy or something.

Oftentimes when I'd return to Southampton, customers would tell me they couldn't find the shop; it seems the salesgirl did such a complete change of the display that many people thought I had only a weekend rental, until I finally tossed her and her rack of clothes out the door and paid a legitimate saleslady to run the shop in my absence.

The third summer, Jack Edwards, a friend who was studying theater and costume design, came out and decorated the shop. He also designed some fantasy beach clothes, which we sold with moderate success. I remember a wonderful beach

shirt he designed, with five different-colored stripes that ended in points from which hung colored tassels. It was only thirty-five dollars, and a real creative idea. The Seventh Avenue manufacturers were always shopping the store to see what ideas they could swipe. One afternoon the Seventh Avenue boys had their wives trying on the shirt as they sized it up. I just knew they were stealing the idea, but I figured they'd buy it. After pulling it on and off, they decided they wouldn't buy it, and I really got mad as hell and told them the least they could do was to pay thirty-five dollars for the design to encourage the creator to do more work for them to copy on return visits. Well, they weren't having any of that, and the reply was, "We don't need to buy it." And I guess they were right—just so long as they got the basic idea, they could copy anything they saw. As you can imagine, selling the general public creative ideas can be very disheartening. But this is what Paris has lived with for so long.

Although the shop was paying expenses and giving me a good change of scenery during the summer, I decided to close it and concentrate on my wholesale orders for fall hats, which were making it impossible for me to spend much time in Southampton.

On the close of my third season in Southampton, I arrived back in New York to find a new landlord had bought the Fifty-Fourth Street house, and he wanted $250 more for rent. He had been looking around my salon during the summer when I wasn't there, saw all the glamorous decorations, and figured it was worth much more rent. Well, I wasn't going to be taken for

any sucker, and there was nothing I could legally do to avoid the increase. So I up and moved the whole business in two weeks. I'll never forget the look on the new landlord's face when I had stripped the salons of all their fancy slipcovers. All that was left were the broken walls and tenement atmosphere. Only the white ceiling with its gilding remained from the elegant decor. I took a temporary place at 56 West Fifty-Sixth Street with the French dressmaker from the second floor, and we quickly set up our businesses, with her taking the back room and me taking the front room with the northern light. I couldn't afford an apartment, so I just camped there, without a bathtub.

I spent many an evening with Mr. and Mrs. Mack, whom I always referred to as Aunt May and Uncle Mack. They were so kind and considerate over the years, and during this time it was their bathtub that kept me clean. Mrs. Mack was a wonderful influence. She was always knocking the butterflies out of my head. She was a "black is black and white is white" person, and none of this arty carrying on impressed her. I have her to thank for giving me the realistic outlook that I now enjoy, along with my natural imaginative powers. She saved me from the exaggerated views I gave life. Her influence was the reason for my success as a reporter, as I am now able to look facts right in the eye without turning away, whereas before I was always beating around the bush, trying to dodge the truth of the matter.

The shop on Fifty-Sixth Street was a terrible place. Madame was always cooking her French recipes on the electric stove, which we hid from the fire department since it was

against the law to live there. Madame's cooking attracted a large following of the fattest cockroaches. One morning I was about to try a hat on a very distinguished customer, and just as I was about to pull it down on her head, one of the overfed cockroaches fell out of the hat and onto the floor. It had been sleeping off its dinner on the crown. Thank God the customer didn't see it—with one motion I pulled the hat down on the lady's head and slammed my foot on the cockroach as it ran across the room. Mrs. Nielsen, who was standing near me, turned sick and almost fainted—she had to flee the room. I must say I never blinked an eyelash but went right on chatting about the hat. (I never put another hat on a customer without first looking inside the crown.)

Within a year the fire department had caught up with us and tossed us out. I was kind of glad, although we had had a lot of laughs, and I created two of my most successful collections in this atmosphere; one was the fall collection, when I made all the hats of leather and snakeskin—one of my best, and like most successful collections, it didn't sell well at all. It was too new. But that collection set the mood for everything that was to follow.

I MOVED TO a seven-room duplex on the roof of Carnegie Hall. It was a marvelously grand place, with sixteen-foot ceilings in the huge studio, which was to become the salon. The kitchen was turned into a workroom; the refrigerator used to store the furs. Upstairs were two bedrooms and a bath.

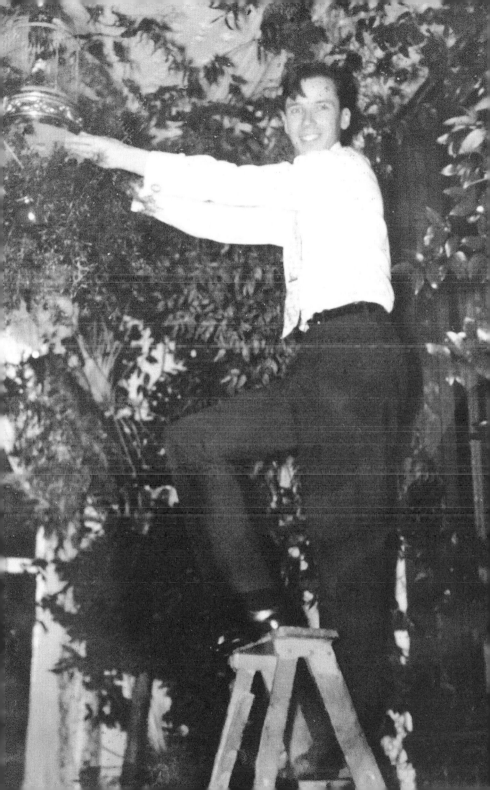

Imagine, the first bedroom I ever had in New York! It took me twelve years. One bedroom had French doors that opened onto a balcony that went around the huge studio. Southern-exposure windows ran from the floor to the ceiling. I decorated the space around a conservatory theme: 104 huge plants filled the room. The main room needed a stairway, and I had remembered seeing one being torn out of an old meat market on Madison Avenue. It was a darling circular iron stairway, which I bought for one hundred dollars. This gave the studio a wonderful air, and the jungle atmosphere was turned more fanciful with a fifty-candle crystal chandelier. (I really got carried away!) From the ceiling, hanging ferns dangled in midair, along with five cages, each housing a singing bird: a Japanese nightingale, a handsome wood thrush, a South American cardinal, and two female parakeets the French dressmaker had given me. One of her amours gave them to her as a gift, but when madame found out they were both girls, nothing doing—she wanted only mixed love affairs.

The sun streamed in the big room all day, and customers thought this was the most wonderful place I'd ever had. Carnegie Hall was a fantastic place in which to live and work. The air was full of creative people singing their brains out twenty-four hours a day—you felt creation taking place all around. I'm very thankful they saved it for so long, and the people that lived in its 133 studios were certainly colorful. On my floor, a middle-aged photographer with long black hair down to her waist danced the ballet of the Dying Swan as her hobby. She performed only on nights of the full moon, and she turned out

all the lights in her huge studio, which once belonged to Andrew Carnegie, with only the beams of the moon dancing across the Persian carpet. She would put on her *Swan Lake* costume, a feathered affair that looked rather molted when I arrived, but which I later refeathered—which made me a charter member to the dance nights. The whole performance was private, although occasionally she let in a few friends to watch her go into the mystical trance and glide through the moonlit room.

A memorable guest was ninety-year-old Mrs. Lila Tiffany, who lived on our floor and was a notable character who played the accordion on the street outside Carnegie Hall—you may have seen her when you came out of the concerts, she used to be there all through the heat of summer and the cold of winter. She's one of those marvelous eccentric treasures that make New York the most super place in the world. On the coldest nights, she could be seen sitting on an old egg crate, wearing three or four coats, her feet wrapped in newspaper and hidden inside a cardboard carton, her fantastic face with its long drawn lines and yellowish appearance, with those darting eyes piercing out from under the mass of silver-gray hair, which was crowned with an old red felt hat decorated with faded roses and ostrich plumes. I made her a new hat once, but she couldn't wear it because it looked too rich, so I told her to sleep on it for a couple of weeks. She was mad for dogs, and at one time had thirty-three. Often when I was walking my dog on cold winter nights, I took him over to her, where she warmed her hands in his fur. On one night of the full moon, Mrs. Tiffany wasn't feeling well, so the ballet dancer invited her in to rest and watch

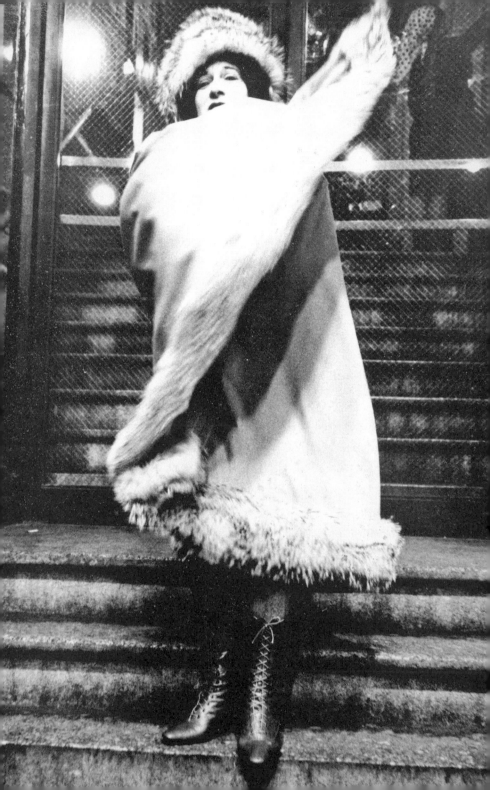

"The Dying Swan." Poor Mrs. Tiffany could hardly make it to the Empress Eugenie sofa; as she sat down, she put a brown paper bag under her. The dance of the swan began; the lights were out, and Mrs. Tiffany soon fell fast asleep. After the swan had died, Mrs. Tiffany awoke to find her paper bag—which she claimed was filled with $1,800—gone. Well, all hell broke loose, but the bag of money was never found.

Several days later, two gorgeous white damask sofas were moved into the dancer's studio (the dancer had been crying poverty) and Mrs. Tiffany, seeing the new furniture, threw a curse on the place, and in particular on a beautiful white Carrara marble statue of Venus. It was a prize possession of the dancer, but that night old Mrs. Tiffany had a vision of snakes crawling under her door and wrapping themselves around the cold statue. At this point, she jumped up out of her bed and threw another curse on it. Now, let's face it, I'm a good Irish Catholic, and I don't believe in a lot of hocus-pocus, but I'll be damned if the statue didn't topple over and break into a thousand pieces the following day! Of course, no one really knew if she had money in that paper bag, and there were other people in the room at the time. The following day, Mrs. Tiffany enlisted my help in carrying some bags of pennies to the bank, as she needed rent money. I didn't mind carrying a few bags of pennies, but piled up outside her door were five years' worth of pennies collected from playing on the street. Mrs. Tiffany was full of superstitions, and on Friday the Thirteenth she entertained us all with her good- and bad-luck songs.

My customers loved the shop in Carnegie Hall; it was a new experience for them. They'd been to the concerts on Friday afternoons, but this was their first time to come up into the bohemian living quarters. My work there flourished, and I presented four collections. During this period, I opened an experimental branch on Madison Avenue, but found it to be just like Southampton—loads of people looking who didn't understand designers' fashion. I think this is the reason you seldom saw high-fashion shops on the street level, as customers rarely just walk in from nowhere and plunk down hundreds of dollars for fashion. Most business was done by word of mouth and recommendation, where personal confidence exists. The granddaughter of one of my rich customers worked with us on this venture. She was a romantic fashion type who dressed each day to suit her mood. I couldn't wait until she arrived each day, as the changes in her appearance were astonishing—a complete transformation of hair and facial makeup. Some days she was a champagne bubble; others she was a stern New England schoolmistress. She was pure theater, with a gift of gab that could have sold the whole street. The boys at the local delicatessen were her slaves—I'd have to wait hours for my coffee, while Gay would hardly have the receiver down on the phone, and the delivery boy would be panting at her office door. During the Christmas season, when the shop was a little slow, Gay would get herself conspicuously into the shop window, and when she'd collected an audience outside, she would rush out to admire her window dressing. Of course, this was all bait to attract men into the shop, and sure enough they followed her

like bees after honey. As a matter of fact, one of the men who
followed her in is now her husband. She was the most accom-
modating salesgirl I've ever known. She would have whimper-
ing matrons pouring out all their troubles, and at the end of
each sentence she'd sell them another hat. We could hardly
make the hats fast enough for her, but we had the financial
problem of not being able to make hats cheap enough for the
street trade, so we closed the shop and concentrated on the
hidden private salon in Carnegie Hall. I've always felt if you
really had anything good, women would find your door, no
matter where it was—it's only important to have a convenient,
central location.

By 1960, I knew the millinery business was finished as a
fashion force. I still could make a living with the older women
who wore hats, but I felt that was no life for my ambitious spirit.
Besides, the matrons and I were in constant conflict—they
wanted dull, uninteresting hats, and I was continually creating
new shapes. We were like fire and water.

Selling fashion with flair and excitement to women in the
east had just about worn out my resistance. I was fighting for
something much deeper than original design. You'd be ashamed
at how much of this high-fashion business revolves around
"looking like this or that," especially in café society life, where
everyone is desperately climbing. Sometimes all the anti-
Semitic talk that filled my salon made me wonder if another
Hitler could rise. Since my earliest days in fashion, all this
damned side-of-the-mouth talk has made me ashamed of what
high fashion is used for. Poor fashion is the innocent victim of

deep-rooted hatreds. My shop was always open to everyone. *Jet* and *Ebony*, in particular, were so generous to my work, turning over lots of valuable space. For many years, I gave hat shows in Harlem, and they were some of the most exciting ever given; the audience truly appreciated creative ideas. If I were to open a shop again, I'd sure as hell consider Harlem. Those ladies know how to wear a hat like you've never seen, and the more exciting it is, the better they appreciate it. I guess the café society crowd are just envious and jealous of the great wealth amassed by the newly rich Seventh Avenue community. Of course, the most aggressive social climbers often appear to be the wives of the newly rich, who often wear the most original fashions. At any rate, it's a hot subject and has plagued the high-fashion salons, and I think it's about time women stopped all this ridiculous nonsense and wore their clothes for the sheer pleasure that they receive from something beautiful.

I CLOSED THE DOORS of William J., and it was really quite sad, all rather like a divorce. My childhood love affair didn't die, it just vanished. Women had stopped wearing hats.

Fashion Punch

While I was closing my shop, a call came from a fashion editor of *Women's Wear Daily*. She invited me to lunch to meet her boss, John Fairchild Jr. In the last three years, he had taken over this excellent but dull to read fashion trade paper and turned it into the most controversial publication in the field. It used to be called "the bible of the trade"; now it was being renamed "the New Testament."

First thing each day, buyers and designers would grab the paper to see who was being scrapped and who the new stars of the day were. John had done a fabulous job, and I was aware of every detail of his revolution. When I was asked to join them at lunch, I immediately said no, as I could read between the lines and didn't want to be maneuvered—Mr. Fairchild was tossing designers around to suit the mood of his front page. The editor said I was being ridiculous and that I would enjoy meeting him. We had the luncheon, and of course I was full of the same

revolutionary spirit as he. I had forgotten about all the unfair things I had recently read in his paper. On the spot, he asked me to write a column. I said definitely not—"I'm no writer and can hardly spell my own name." During luncheon, I told him about a party I had observed the night before, and how vivid I had felt was the revolution taking place in fashion. John got so excited he called the paper and canceled the existing front page, and right there in the Oak Room of the St. Regis I wrote my first story and made funny little drawings of the women I was describing, which a *Women's Wear* artist then turned into ravishing sketches. I went back to the paper's office after lunch, where the fashion editors were a little bit mad and asked why I had opened my big mouth. The art department was also little put out, and I got a couple of dirty glances. By the end of an hour spent in the office, I felt like a culprit—although, the people in the office weren't really mad at me, they were exasperated with John. He would very often come back from his luncheon date with some exciting fashion personality and then order his office to ditch the front page that everyone had been working on. The staff would have to stay late, developing another idea. Of course, this was the very thing that made the new *Women's Wear* the brilliant success it is today. John's mind was completely open to new thoughts, and there's no question that he was one of the great individual publishers of our day.

After closing the shop, I took a two-month Greyhound bus trip all over America, stopping at every city just to observe and see how people really lived. It was a great experience, and a very sobering one, as I had never traveled around America

before. The trip was a revelation. The Deep South, the Southwest, the West Coast, and the great wheat fields of the Midwest. I began to realize I had stayed too long hidden behind the potted palms of New York's Plaza Hotel. Very few women live that kind of la-di-da life, where they get all dressed up like the slick fashion magazines advise.

Whether I was in Kansas City, New Orleans, or Cheyenne, women just didn't seem to have that burning interest in fashion. A new house, a sleek car, or a fabulous interior design were much more realistic and exciting to the average woman. All the conquering fashion climbing is done in Paris, New York, London, and Rome. Of course, I saw nicely dressed women at luncheons and dinners, but there was never that obvious hysterical fashion climbing that I frankly enjoyed. At all the exquisite small specialty stores where top designers' clothes were sold, I got the same answer: women do buy the exciting clothes, but they seem to take them on trips to New York and Paris to wear them. This strikes a very interesting note on American society. Why is everyone afraid to be themselves in their home cities? It's always the visitors in New York who strut around in daring clothes. They don't seem to feel secure in their own city. The same could be said for the New Yorkers. Customers were always telling me they'd wear my wild hats in Europe, but not in New York. It seems to me American women are suffering from a bad case of "what will the neighbors say?" Or is it just that getting to a strange place where no one knows who you really are gives you that feeling of liberation?

Although I did observe that the midwestern ladies, strangely

enough, were the ones to buy marvelous hats, coats, and dresses simply because they loved them. In Chicago, I saw more exciting fashion than anywhere else in the country, and definitely more free-spirited fashion than you'd ever see in New York. No one in Chicago seemed to be worried about status. They didn't stop to think whether some snooty New York society woman had recognized it.

Designers should get out of their cultivated city living every three years and just travel around the country observing.

AFTER MY TWO-MONTH TRIP, I came back to New York and immediately started designing a collection of exotic bird masks that were used as window displays at Bonwit's. Birds and masks allowed me the freedom to express my imagination without worrying about the needs of a customer. The seven-room Carnegie Hall studio became too expensive to run, and I didn't need all the room, so I put an ad in the *Times* and rented half of it to a charming English writer, Jeanne Campbell, who I later learned was from an illustrious Scottish background. She and her new husband, Norman Mailer, moved in, and we all shared the place, until one morning when Mrs. Nielsen—who always arrived at work at eight o'clock—was helping me sew the masks for Bonwit's. I had gone out to walk the dog, when Mr. Mailer trotted down the stairs, through the workroom, into the bathroom, wearing only his BVDs. Well, Mrs. Nielsen, who is Victorian mannered, nearly fainted. I guess she didn't realize that Miss Campbell's new husband was living there with us.

And the funny part was, Mr. Mailer never even noticed her to say, "Excuse me." So, to keep peace in the family, I moved into a small studio, high in the tower of Carnegie Hall, with a sensational view overlooking the Hudson, and to the north, Central Park. The studio had two walls completely covered with windows, from the floor to the sixteen-foot-tall ceilings. It was a wonderful-feeling place, rather like living in a treetop. (I must be a reincarnation of a bird, for I really felt at home in this nest.)

By the end of September, I had a call from John Fairchild asking why I hadn't called him. By this time I was in my blunt period, so I told him I rarely call people in New York because they immediately think you want something. He laughed and said he wanted to have lunch again. At our second meeting, I was absolutely fascinated by this man. He had the same fashion philosophy as I did. By the time lunch was over, he had convinced me to write a couple of stories and send them to the paper. That night I got cold feet, but I went to a party at the Plaza, and the minute I got involved with looking at the guests and what they were wearing, I became so excited over the clothes that I wrote three columns and sent them to him. These he immediately printed, and I was in business, at one of the best salaries in town: $275 a week for three columns. When I told other fashion editors of leading papers, they couldn't believe it. Newspapers are notorious for paying small wages.

When my column started in *Women's Wear*, I vowed to myself never to lie about or soft-soap a designer and his collection. The only inflexible rule was that I had to preserve total

honesty and integrity when I was reporting. Many a night I went to bed sick from having written articles that were perhaps too blunt, and against popular opinion, but I couldn't allow myself to sink into the phoniness that covers 90 percent of the fashion press. John began to tell me to say things a different way. To coat everything with sugar, and hide what I really meant. I felt the fashion world reporting had been sweetened with enough self-praise that it was time for down-to-earth facts. The other rule I laid down for my reporting was to talk about ladies who appeared elegantly dressed because of their true fashion, not *who* they were. I always picked a woman for her appearance first and then asked her name. I felt my job was fashion, not discovering someone's background. Needless to say, within a few months I had made an army of enemies. But the column also generated an array of readers.

For a time, it seems everyone read my column. Of course, I started writing just as the New York papers were on strike, and there wasn't much else to read but *Women's Wear.* This probably accounted for the quick popularity my column achieved, as it certainly wasn't read for its literary value—I didn't even know what a verb was. Many of my friends were shocked by the low, common language they thought I used. This was intentional on my part. How many times had I tried to read fashion reports in the past, when I couldn't make head nor tail of what they were saying? And businesspeople don't have the time to open a dictionary to discover some obscure word a frustrated writer drops into a report. I felt the readers were working people, a great many schooled in the crafts of their hands, so I thought

the language should be in the kitchen-table coffee-break style, where everyone could quickly grasp the full meaning of what I said. I never used a word I didn't know myself. Often people in the office would suggest a more scholarly substitute for my plain-Jane sentences, but I felt it was better to keep to everyday language.

On my first trip to Paris for the daily papers, I had forgotten to tell my editors that my spelling was in the phonetic style. I was covering the shows for a number of papers, beyond the work I was doing for *Women's Wear Daily*. I never could spell, and added to the challenges of navigating a new typewriter, which was being conquered by my two finger system, the editors almost dropped dead when the stories started to pour in from Europe. The conservative intellectual *Chicago Tribune* couldn't believe their eyes. Never in their wildest imagination had they seen such spelling. They couldn't imagine how I'd gone so far with so little education. Another paper, the *Boston Herald*, never said a word, until a month later a tiny package arrived in the mail. Upon opening it, there shining in my face was the *Boston Herald* Gold Medallion Spelling Bee Award for the century's worst speller. On a couple of occasions at formal parties, I have worn the ribboned medal just for kicks, and no one has ever bothered to read the inscription. They just get all impressed and think it's some kind of royal ancestry—which is typical of New York's social climbers.

When reporting for the newspapers, I never wrote about anything I didn't see with my own eyes or hear with my own ears. Consequently, I had to go everywhere. It was a

twenty-four-hour job, and I loved every minute of it. Some nights I'd cover as many as five parties, then write a frank article as to who was actually elegantly dressed that night in New York. Reviewing designers' collections was the most difficult, because I had to be honest, and to my initial shock I found that 90 percent of the Seventh Avenue designers who had been passing their work off as real creations of their own personalities had in reality just taken ideas from other designers, especially those from Paris. When I reported this shameful turn of events in one of my columns, there was a lot of hell-raising, and I was thrown out of many of the shows. Top designers invite the press to review their work just so long as they will praise it, but criticism was something the darlings of Seventh Avenue hadn't even considered accepting. *Women's Wear's* policy gave a reporter two options, either to completely ignore a bad collection or put a negative review way back in the paper where few people took the time to read it.

During my first three months at the paper, most of the famous designers' showings had been a disappointment, as they weren't really designing but instead editing Parisian ideas. The last artist to show his collection was Norman Norell, then America's most important designer. When I got the invitation, I was thrilled. I had never seen a full Norell collection before.

The night of his showing arrived, and I was a nervous wreck, remembering what Givenchy had told me about Norell buying Balenciaga and Givenchy designs. I became panic-stricken that Norell's collection might reflect Paris, and I would be forced to report in the column that everyone's hero was just another

copyist. I became so nervous that night that I walked from my Carnegie Hall studio at Fifty-Seventh Street and Seventh Avenue down to Norell's on Thirty-Ninth Street, clutching my rosary beads and saying the Hail Marys and Our Fathers, praying that I wouldn't see copies. By the time I reached Norell's salon for the black-tie nine p.m. showing, my knees were shaking, and I thought I'd have a nervous breakdown. Finally, the first dress stepped through the perfumed salon. My whole body stopped trembling, and I smiled with relief. The dresses, coats, and suits were the most beautiful I've ever seen, and not one of them had the faintest look of anything I had ever seen from Paris. It was a total and pure signature, that of a true artist. His color sense was extraordinary, and as I said before, his timing was unbeatable.

The following afternoon the press was to review the last American collection from California, that of Jimmy Galanos. Mr. Galanos's talent as a true creator was recognized all over the world. He showed about three hundred designs, and I admired them very much, realizing the inventive construction and workmanship, but something seemed to be missing. I didn't feel there was a joyful look to the clothes. The models' faces were like a funeral parlor death march. I guess I had just never thought about those super-elegant women who never smile— they seem to take themselves too seriously. After the show I wrote my review, which I changed five times before I passed it to the paper. I understood his superb talent, yet something didn't come across to me in the showing. How could I give it the same high praise as Norell? Yet it was far superior to any

collection seen on Seventh Avenue. But I had that nagging feeling that a certain pleasure was missing, and, even worse, after reading the Norell review, everyone was waiting to see what I'd say. At first my copy had said he had "given the fashion world a golden apple." Then I changed it to "he has not given us a golden apple." Well, I turned that apple around in my mind for so long that I finally decided the collection was a shiny red apple, not golden. At any rate, to make a long story short, Mr. Galanos tossed me out of his future showings. His clothes take time to understand; their message is deep and much more sincere than the surface collections you see every day. I must honestly say now that his clothes were without contradiction the most creative and the most beautifully made in America for a time.

I left for Europe a few days later to see the collections there. The paper wouldn't send me, so I paid my own way. I sent a column back to the paper each day, always being very direct and saying just what I thought. Many of the buyers and press people told me I'd never get back in to see the collections another time if I kept up this approach. Everything went well until the day Dior opened, and I wrote a very uncomplimentary review of how the designs were mostly a rehash of past years', and what a disappointment to find the House of Dior was not the leader it had been publicized as. At any rate, John Fairchild wouldn't let me print the story. I was mad, and threatened to quit. I didn't care about the story not being published; all I could think of was the total unfairness to the other designers about whom I had been given the freedom to write so

openly. And here I was covering the most important house of fashion, the renowned Christian Dior, and John wouldn't let me say what I believed. It was all right for me to discuss the other designers, but when it came to the big boys, it seems you just had to flatter their egos. To me, this was unthinkable dishonesty to all my readers, so I wrote a column for the next day, saying the previous column had been banned in Paris, and apologizing to Jimmy Galanos for the harsh review I had given his showing in New York. My column read:

> The idea of the French couture charging "caution fees" of one thousand dollars a head to professional buyers is totally antiquated. No more than a half dozen houses in Paris still show the talent to warrant such high prices. I've been in Paris four days, and you wouldn't believe the stuff they're passing off as "grand couture." It's either rank amateur or covered with provincial dressmaking details. I speak here of the smaller houses, as I haven't seen any of the big shows. As for the young talent, I've seen no individual thought in the mob. Believe me, I'm not prejudiced, just mortified at what's being labeled "Design."

THURSDAY 9 A.M. DIOR

I found the new prestige place to view the collection. It's no longer the grand stairway, but a little balcony

overlooking the salon. I was the first one there. Half
an hour later, thirty people crowded in, including
the Marquesa de Portago, in a full-length sable coat
and her little daughter, Andrea, looking starry-eyed
at the exotic model Kouka. Down in the salon, it
looked like Filene's Basement on Dollar Day. It's a
game in Paris to make you wait and feel you won't
get into the show. And when you finally do get in,
the feeling is very special. Here they left only a
twenty-four-inch passageway for eight hundred peo-
ple to enter the salon. Gilt chairs blocked the way, as
Dior director Jacques Rouet stood right beside me,
and never lifted his voice to ease the situation. Inside
the salon, wisteria vines climbed over the spring
flowers on the mantel. Danielle Darrieux must have
felt she was sitting in the middle of a football field
when five women fell right on her as they elbowed
their way into the salon. The soignée Vicomtesse
de Ribes was something to see, wearing a black-
and-white tweed suit with a matching man's fedora
hat, black net stockings, and Toulouse-Lautrec
boots. On a Louis Somebody table, all the artists of
the major magazines and newspapers were standing
to get a better look at the collection. Just as the mob
reached a frantic height, a vulture-like vendeuse
pulled Melina Mercouri to safety, all wrapped in
her chinchilla hat and coat. The collection started
amidst great silence. It was obvious from the very

beginning that the theme of the collection was somewhat like a Louella Parsons party. Balenciaga was there in lovely coats; Saint Laurent was there with cowl-back dresses. Jimmy Galanos was there with his two-year-old jodhpur sleeves. Chanel was there, with her sweater suits, coats, short hair, and gardenias. Dior 1950 was there, in horseshoe necklines. The movie *Last Year at Marienbad* was there with self-fabric feathered necklines. Colette's Gigi was there with all her big sailor Bretons and pizza-size berets on the back of the head. Lawrence of Arabia danced in and out, and occasionally Dior's present designer Marc Bohan, plus a host of others, showed their talents.

I don't like to kick someone when they're down, but couldn't the House of Dior just be themselves and forget evolution of other people's ideas? A hundred of the two hundred models shown would have given the house success. Dior designer Marc Bohan has a definite signature, when you can get through to admire individual creations. His own personality was very creative in the draped kimono-like sleeves on suits and coats, and especially on the crepe dresses. The high, set-in sleeves, which are a cross between the Gibson girl and the leg-o'-mutton, sometimes reached within an inch of the collar. But frankly, they were too Galanos to my eye. The forty or more beaded dresses held no sparkle for me. This

is why Norell is great. He knew when beaded dresses were dead, at couture level.

After the show was over, the scene looked like the rush into the subway after the Saint Patrick's Day parade. New York fire commissioner Cavanagh would have flipped his helmet as golden chairs were tossed every which way, and the elegant ladies pushed out. Papers and cigarette butts littered the carpeted floors. Babs Simpson of *Vogue* was seen tossing a chair into a corner. *Vogue's* editor-in-chief, Mrs. Vreeland, looked like a stone-faced chief being shoved down the stairway. The Vicomtesse de Ribes was busy passing the glad hand right in the middle of the foyer. Butlers with trays of champagne were struggling up the grand stairway against the tide.

I told John if he wouldn't publish my apology to Galanos, I would quit, as I felt it was the only fair approach. I guess John thought I wanted a confessional set up in the office, but from that time on he and I never really saw eye to eye. As far as I was concerned, he appeared to be involved in outrageously dishonest favoritism, that pet game of the press. Of course, this is nothing new. You'd just die if you saw the press after a big show in Paris. Many of them gather together and discuss what they've just seen, and then write their reviews. It's no wonder the following day even the professionals can't make head nor tail of what they really are saying. How could the public possibly understand?

ONE INCIDENT THAT stands out in my mind from my days at *Women's Wear* was the Bonwit Teller affair. I was covering the fashion collection of Pierre Cardin's reproductions, which Bonwit had copied for their junior department. The clothes were heralded as the latest models out of Cardin's Paris workroom, but after seeing the collection, the truth of the matter was they were all two- and three-year-old rehashed designs. The show was embarrassingly awful, and Cardin, who was in the audience, was so upset by the degrading spectacle of his talent that he walked out saying he would never deal with Bonwit's again. I remember writing a rather critical story on the showing, and a lot of people thought there would be a reaction.

Two days later, another invitation from Bonwit's arrived, inviting me to review their fur collection. I must say I was slightly surprised that they'd send an invitation after my critical report. I put the invitation into my pocket and sashayed off to the third-floor fur salon, where a couple of hundred customers and press were eagerly awaiting the newest styles in furs. I took a seat on one of the gray sofas along with other members of the press. When presto! up came the president of the store, Mr. Smith, and grabbed me by the collar. He gave me a couple of quick pokes in the face, and with the third punch, a very elegant black eye. And before I knew it I was tossed out on the street! I didn't fight back, thinking I was a representative of the press and that this might get a little bit sticky. So, after picking myself up from the Fifty-Sixth Street sidewalk, I called our

publisher and related the dramatic story. He said to forget it, and added that he thought I deserved the whole incident—he thought Smith was totally in the right. Well, the staff of *Women's Wear* didn't buy John's thinking. The fur editor had been sitting next to me and saw the whole incident, which she related in detail to the staff of the paper. The editorial people held a meeting and demanded that Fairchild put a notice of the incident in the next day's paper, if only to protect all his other writers.

After all, it was John who wanted everyone to write very opinionated reports on the collections, and now when fists were flying, he was hiding from the brickbats. The other New York newspapers were on strike at the time, and the incident was forgotten. I wrote what I thought was a perfect column about the incident, but John would not print it. Here it is:

FASHION PUNCH

There is nothing like fashion for exciting change. You never know what is going to be in vogue next. I always want to be up to the last minute. At Bonwit's Tuesday afternoon fur show, Mr. William Smith, the distinguished president, oozing brotherly love from every pore, oiled his way across the floor and demanded that I get out. When I showed my genuine invitation, he grabbed me by the back of the neck and dragged me out—what an exit! There hasn't

been as much beaded drama on Broadway all season. There is nothing like a refined, elegant exit when you've been invited. Unfortunately, I didn't see the soft beautiful furs I was promised. Instead I saw Mr. Smith's fist, with three quick blows in the face. You can't tell what kind of a fashion punch is lurking behind all those satins and laces!

Of course, I really should thank Mr. Smith for putting me right at the height of fashion. Blackened eyes are the only way to look, if you follow all the advice of Bonwit's beauty department. I guess I'm extra special; my black eyes came from the president himself. None of the fashionable society leaders can match that—I hope.

The most thrilling part of the fashion business is the quick change from feathers to bricks, from extraordinary tempers to "O, darlings." I wouldn't want it any other way, so long as we make women beautiful, through the enjoyment of creative clothes.

I haven't heard from President Smith, and I doubt there will be a rematch, as we are both too busy wondering what will be the success of spring selling.

I hope Bonwit's has more exciting clothes from Pierre Cardin next season, and I hope Mrs. Smith remains the enthusiastically interested fashion lady she is, and enjoys wearing the lovely daisy-lined raincoat. Fashion shows should excite women to buy

right after the show—that's a healthy business. I'll be looking forward to seeing more of Bonwit's shows as soon as I lose my black eyes.

EVERYONE WAS YELLING at me to sue Bonwit's, but I decided it wasn't the thing to do, and I called the president of Bonwit's two hours after the incident. He wouldn't talk to me on the phone—I guess he was off with his lawyers, deciding what to do, and I wanted to settle the matter like gentlemen.

Two days after the incident, Mr. Smith called me and said he didn't feel there was any reason for him to apologize, as he thought we were even. I dropped the whole thing, but a year later rumors were spreading around Seventh Avenue that Mr. Smith was denying the whole incident, and that I had made up the story. Many people, noticing I hadn't sued, thought he was right. So in order to save face, a year later we filed suit, which was settled out of court with Bonwit's paying the award for one black eye: three hundred bucks. As you can see, it wasn't the money involved, it was more setting my record straight for the future.

I stayed on with *Women's Wear* through spring of '62, but they started limiting the areas in which I was free to write, and toward the end, five people in the office were editing the column, each taking out what didn't suit him or her. In the meantime, John held a staff meeting to which I wasn't invited, and he told of the *Herald Tribune*'s Eugenia Sheppard calling him at home to tell him that I was saying all sorts of terrible things about the paper and the people who worked there. When I

finally heard the stories, I knew I had never said them, as they weren't my kind of language.

First of all, I enjoyed working at the paper, and everyone on the staff was a longtime friend. Any disagreements I had with John were personal, and certainly wouldn't have caused me to belittle my friends. At any rate, John succeeded in turning the staff against me, but several intelligent people in the office told me not to pay any attention, as this was just another one of his tricks to get everyone fighting against each other, creating jealousies in the hope that everyone would work harder.

I immediately called Eugenia on the phone and confronted her with the story, which she denied having any part of, but John stuck to his story. One of Eugenia's assistants at the *Trib* confronted her, demanding an explanation. But Eugenia denied it all, with a rather guilty look all over her face. Realizing I was the victim of typical fashion-world behavior, I asked for a meeting between John and Eugenia and the staff, but all John said was, "Forget it, William, in a couple of years you'll never remember it." I suppose this was his admission of guilt. After all this, I could feel very little respect for a boss who would stoop so low. I feel that beautiful success can be had without being a schemer. I would never accept a belief that only the players who throw the foul balls succeed. I feel no matter what the odds appear to be in favor of the material world, good will win out in the long run. Plus, I'll be able to look God straight in the eye on Judgment Day and not be ashamed of deceitful deeds and people stomped on while climbing the fashion ladder.

The Top of the Ladder

Covering the European openings for a newspaper is the fashion experience of a lifetime, especially if you survive for a return engagement. The trip, which many people think is a plum reporting job, is not the luxury vacation many might imagine. The showings started in Italy, with a few minor offerings in Rome, but what really counted in Rome was the number of parties you're invited to, as most of the leading Italian designers were located in Rome and claimed some kind of aristocratic title. You never heard so many fancy pedigrees. It always surprises me that one family could have five princes and princesses, and all of the kids in the family traded on the title, with the American fashion press falling over their rhinestone tiaras, rushing to each party in the hope of being introduced to some ex-royalty. The Italians, being no dopes, make the most of it, inviting all their royal friends. It can honestly be said that the important pages of the slick fashion magazines were decided

upon during these parties, before anyone got to Florence, where the showings supposedly were unveiled for the first time. All the politicking was done days before the openings, as each year the magazines showed pages of designs from some princess who copies Balenciaga. And the poor nobody designer, who really had ideas in his head, often went unnoticed. Then, all the super-glamorous fashion press and buyers left Rome on the same luxury train to Florence, with all their furs and affected mannerisms—it was one of the best shows.

On my first trip in January of 1963, after my departure from *Women's Wear*, this deluxe train was delayed in the mountains of central Italy for seven hours while a blizzard raged outside. The ladies started to fall apart, as they're not accustomed to delays. Finally, they were thrown off the luxury train into an isolated train station in a small village. The temperature was zero, and the local farmers were standing around gaping at the strange fashion people, wearing two fur coats at a time, hats and boots, and, naturally, their sunglasses. It was a scene out of a Marx Brothers movie, with the Italian trainmen moving the swells on and off little country trains, trying to decide how to get the important press to Florence. I vividly remember the Rome editor of *Harper's Bazaar* all out of sorts over the delay. There she was, leaning out the train window, hollering back and forth at the little Italian trainmen, her body wrapped in a black alligator coat lined in thick white Mongolian lamb, a foot-tall black chiffon turban towering on her head. She was passing her case of jewels out the window to the porter as her train unexpectedly pulled away from the station. I'll never

forget this stylish lady screaming her head off and frantically waving as the train left for parts unknown. It always makes me think that these fashion magazine ladies tell the public how to be chic, even in the worst crises; meanwhile, they looked pretty disheveled themselves in a jam. All the advice they hand out doesn't work when you're outside the comfort of your plush office.

In Florence, the showings opened with great flair. The setting was the splendiferous white Pitti Palace ballroom, where the kings of Italy entertained, until central heating came into use and they moved to less grand surroundings with more comfort. The press didn't seem to have to worry about the cold, as they let off enough hot air to heat the whole palace. Huge ramps lined the sides of the room, where twelve rows of canvas folding chairs supported the rich buyers. A long T-shaped runway went down the center, past the eagle-eyed buyers, to the end of the ramp where it turned horizontal and faced the three hundred seated members of the press. I always got there early on opening day—part of the fun was to see the prima donnas arriving. The conniving and jostling for front-row seats was beyond description; with the buyers it was a cut-and-dried proposition: those with the most money got the best seats. Naturally, the rich Americans lined the front row. Next, the English and Germans fought it out over the next four rows, leaving the back rows to the French, Belgians, and Japanese.

Down at the press section, it was a prestige affair that could make or break editors, turning them into hysterical rages. Many a top editor had been known to send spies into the room

an hour beforehand just to be sure of a proper seating. The press ladies, especially the magazine girls, made fabulous calculated entrances, with their wardrobes planned out for three and four changes a day. In the front row were the top Americans, with the Italians on the side, bitching up a storm because they were not in the center; and the Germans were on the other side and really didn't mind, as they were near the entrance and could sneak out during the dull shows.

At the opening blast, everyone would "darlings" and "dearies" each other, with much hand kissing, but it didn't last long after the showing started, and the controversy over the collections put an end to the lovey-dovey atmosphere.

There were two showings in the morning, with a fifteen-minute intermission while everyone downed pitch-black coffee to glue their eyelids up, as the evenings before were always filled with parties. Also at this time the press sharpened their hatchets, and friends of the designer spread complimentary rumors. Editors making deadlines dashed out to the telegraph office to file immediate stories. These were usually the wire services, and it was amazing how little they knew about fashion. Oftentimes, I sat by them and they were forever asking the dumbest questions. It seems their only interest was in finding a sensational headline, and if there wasn't a drastic change in the clothes, then they would invent one. Many a time I read their headlines of the hemline falling, when the truth of the matter was that there wasn't one lowered hem.

For me, intermissions were the most fun, as the designers allowed the press who were interested backstage, and you

could get a real close-up of the clothes. They allowed you to take them off the rack and turn them inside out, to see how they were made and study the materials. Backstage was quite a production, especially with the Italians. They did everything in such a grand manner. Each designer brought his special hairdresser, makeup artist, milliners, and dozens of helpers to assist in getting the fifteen models in and out of the 150 designs shown in the hour allowed.

The tensions were unbelievable, what with the admiring audience rushing backstage to smother the panic-stricken designer with sometimes-real kisses, with the word "genius" flying through the air with the greatest of ease. After successful collections, the climbers elbowed their way back with such force you'd think some movie queen was doing a striptease. After an awful collection, it was really very funny to watch the press sneak out the back doors so they didn't have to write about the showing.

Bikinis sashaying down the runway were a big event in the Italian shows, and designers competed with each other with fresh ways to get news coverage, with the tiniest bikini bathing suits. There were a clatter of camera shutters as the models of Pitti Palace danced through their striptease on Sunday mornings, while the church bells of Florence were ringing their message of God. The buyers were a ravenous bunch, sitting there just waiting to gobble up a success. You could tell their nationality by their applause. When the simple-as-sin designs came parading out, the ones that looked like a reheated version of last season's bestseller, the Americans went wild with praise.

When all the fuss and feathers came strutting down the runway, you could see the faces of the Germans light up. The English granted their rather reserved applause for whatever looked expensive. But they could also be deceptive; they often applauded like crazy during the dullest shows. At first, I couldn't figure them out, until I realized they do that just to keep awake. I pity the poor designer who thinks he has a success on his hands. When the buyers really like a collection, they sit there deadpan, not moving a muscle on their face, at times tossing candies across the runway to their friends. All this hocus-pocus is merely to throw their competitors off from what they really like.

The evening shows were the same procedure, only the audience came dressed in their best clothes, each eyeing the other like jealous birds of paradise. Often the shows onstage were dull compared to the audience. The showings ended around midnight, and that's when the big rich fabric houses gave their fabulous parties, or the titled aristocrats of Florence often opened their palaces with private parties for their favorite designers. The palace hopping was the most fun. I always managed to lose myself and go snooping through all the rooms to see how the royals lived. Often I have wondered who wears all these extravagant clothes, as nobody I know lives that kind of life in America. But you'd be amazed at how many rich Italians still live in superb style. All that crying of poverty in Europe seems to stop at the palace doors, for inside the walls of what appear to be broken-down old houses, a staggering life of luxury continues. As for the press, we have to write our stories

before we can indulge in the parties. Frankly, I didn't know how most of the press stayed out all night and then struggled into the showings the following morning.

This delightful orgy of fashion continued for five days. Like the emotion-packed melodramatic Italian opera prima donnas, each Italian designer brought along his own claque to encourage his talent at the Pitti Palace. They could be heard standing along the side walls of the great ballroom, and when the press put on their sour pusses, and the faces of the German buyers took on that "I'm waiting to see something new" attitude, and when the American buyers started crinkling their candy wrappers, the claque, being paid off by the Italian designer, came to life, making their hands blister. It was all very embarrassing for the designer, as the pros knew only too well that the house was stuffed.

The first time I was allowed into the showroom while the big-money buyers were spending, I hid myself behind a rack of reversible coats, so as not to cramp the buyers' style—they don't like having the nosy press around when they're spending money. And it's no wonder, after the performance I witnessed.

Three hawk-eyed Seventh Avenue women designers, wearing the chicest boots and lace stockings, were pulling everything off the racks, where the two Italian owners and a salesgirl, plus one model, were desperately trying to keep the white clothes neatly placed. While these shrewd businesswomen were turning everything upside down, trying to discover the hidden seams, two overweight cigar-smoking Seventh Avenue manufacturers were haggling over prices, in an attempt to

distract the owners, so their soft-spoken demure little boy de-signer could make quick notes on all the styles worth stealing. Over in another corner, a California store represented by two buyers had the model jumping in and out of the clothes so fast I could hardly keep track. This was also a distraction, as they were in cahoots with the manufacturers, puffing up clouds of choking cigar smoke, causing at times a dense fog excellent for quick copying. The pathetic Italians almost went off their rock-ers trying to keep their eyes glued to this den of thieves, who would pluck your eye out and eat it for a grape. In the midst of all this, two photographers from the Italian version of *Confiden-tial* stuck their heads into the room and snapped pictures be-fore the door was slammed in the camera's eye. It happened so fast I thought it was a police raid, but I noticed one of the Seventh Avenue ladies flash a quick smile for the camera and then continue her copying. Outside the door, there started an awful row, as the English and German buyers began to bitch up a storm about the long delay by the Americans, who had been in there turning the place upside down. After all this ruckus, I could scarcely believe this crowd of thieves only bought one dress between them. The exhausted Italians col-lapsed into chairs as the Germans and English invaded for more of the same.

Italian fashion showings ended each year with a big party given by Mr. G. B. Giorgini, organizer of the showings. Gener-ally, one of the government-owned historical palaces is opened for the occasion. On rare occasions a private palace, still in use, dropped its gates of privacy to the visiting press, all for the

cause of Italian fashion, which often needs that extra padding to captivate the professionals. This particular year, each of the press and buyers received an engraved invitation to a ball being kindly given by Countess Sofia Pucci at her home, Serristori Palace. Most Americans immediately threw their invitations away, thinking it would be just another one of those damp, drafty empty palaces.

I had nothing else to do, so I saved my invitation and went to the ball, which started promptly at ten o'clock. On arrival I could feel in the surroundings that this was a place someone really lived in, and an invite was a real treat. Strains of Viennese waltzes greeted the guests as they ascended the grand stairway to one of the most sumptuous private homes in Italy. Footmen and maids, all starched in perky white uniforms, darted everywhere. Rooms filled with carved gilt furniture, red damask walls, huge crystal chandeliers, five-foot-high vases of fresh tea roses; ceilings of sculpted life-size mythological gods; wood-burning fires in white marble fireplaces; tables filled with rare porcelains and an abundance of family photographs. There were five of these salons, all decorated in similar effect. Each opened out into a monumentally huge ballroom, where you could possibly have fitted the East Wing of our White House. Six gigantic Venetian glass chandeliers of roses and feather-like branches held hundreds of candles, which bathed the frescoed walls and ceilings; gabled windows edged the forty-five-foot ceilings, from which servant girls could be seen peeking down on the dancers. The countess, who looked like someone's kind grandmother, wore a red damask

gown that seemed to match the walls, and was definitely pre-war vintage. Around her neck hung a remarkably beautiful strand of canary diamonds the size of pennies. Her hair was pulled back and held in place with a bow. There was lots of hand kissing, and lorgnettes were in full play by the local aristocracy, who seemed to enjoy observing the strange foreigners. It wasn't every day the Italian aristocracy liked to share their parties with the local press. The titled guests wore full-skirted strapless ball gowns in the grand manner, and they seemed comfortably at home sweeping through the ten-foot-wide marble arched doors. So often when I'd seen those fabulous creations in the designers' shows, I wondered just who wore them. Now I know. As for the fashion people who came to the party, they really took the cake, if cake is given out for looking like a bunch of people who didn't have the faintest idea about fashion. Eighty percent looked like they'd just come in off of Forty-Second Street, in their mismatched outfits. And to think these were the same people who spent their lives dictating to everyone else what to wear.

A lavish and tasty buffet was served at midnight. It's amazing how many people in Italy and Spain lived this almost make-believe life—or were they just saddled with family tradition and a white elephant that they couldn't unload? During the party, I made an excuse to get to the men's room so I could see what lay behind the gilt doorways. I heard gossip that the countess took in boarders on the qt, and wouldn't you know it—the maid with her hand outstretched, outside the men's room, was most eager to tell me that Chicago's Mrs. Sherwin-

Williams, of the paint company, was for many years renting an apartment in the palace. One of the buyers from a Pennsylvania department store had remembered visiting Mrs. Williams eight years before, and he claims that she had the bedroom that belonged to the countess's in-law, Napoleon's brother, the king of Spain. Incidentally, the countess's background was loaded with imperial ancestors, including one czar of Russia.

AFTER ITALY, the ambitious press invaded Olde England, which had flipped its bowler hat and thrown the wrapped umbrella out the window. The English had gone stark, raving fashion happy. The most stylish girls in Europe were to be seen crowding the colorful little shops all over London. The Establishment of England could hardly believe the rejuvenation that had taken place. Even the queen had ditched the white foxes that were emblematic of royal glamour.

Tucked away in parlor-floor apartments of lovely old Georgian houses were nearly fifty new designers, all in their twenties, and all designing clothes for the new England. When I visited each of them, I found they were mostly graduates of the same school—the Royal College of Art. I immediately hurried over to see what the school was all about that could produce so many talented people. Well, it's a nonpaying affair, where you must first pass the entrance exam, and if the school finds you worth teaching, a royal scholarship is yours for three years of happy, intensified hard work. The school only took forty-five students, including all three grades. This accounted for the

personal attention the design students must have received, as the wholesale teaching at most of our American fashion schools produced only a lot of carbon copycats. Secondly, teaching at the Royal College of Art was not a five-day-a-week job; rather, the teachers were top designers, tailors, and dressmakers working in the field who donated one day a week to teaching. This kept the students studying in a realistic world. As I toured the eight-story ultramodern building, I could feel the healthiest freedom for learning. Although there were lots of casualties among the new designers setting up their businesses, a surprisingly large number had held on, and made money. After observing them for two years, I saw where they were really developing, and their clothes later matured into well-constructed designs that normal people would enjoy wearing without feeling like freaks.

One of the most interesting aspects of this English fashion boom was the number of young girl designers. Girls had been rare on the fashion scene since the 1930s. Two of the biggest successes in London had been young girls. They were admired for the comfort of their clothes and the total understanding the designers had of a woman's body, whereas in Paris most all the designers were men who too often didn't understand the female body. Many professionals felt the next trendsetting designer would be a woman, and perhaps for the first time an Englishwoman. The two leaders, Mary Quant and Jean Muir, were then both in their late twenties. Mary said that her generation no longer had to prove their sex; they could strip themselves of all the phony outfits and wear comfortable clothes. As

for the two sexes looking more alike, Mary said it didn't matter, as they know which sex they are and don't need clothes to prove it. Jean Muir believed that clothes could now be effortless and serve a comfortable life for the wearer. None of this tripping over train as Paris tried to push. Her clothes slid over the body, but never glued to it. The big-bosom and bleached-hair female symbols of the past just didn't work for their realistic world. Certainly, England had become the number one challenger of Paris for design leadership. Fifteen years earlier, it was the Italians who almost stole the crown from Paris, but they slipped into the bad habit of copying. Now the English had a better chance because they invented their own look, which swept in with the Beatles, and a whole new generation all over the world was finding the British style the most exciting thing to wear.

After England, the fashion press who hadn't run out of breath or ink rushed down to Spain, where the big-spending-money buyers placed some of their largest orders, as the clothes were good-looking and terrifically inexpensive compared with Paris. The leader of Spanish designers was a Mr. Pertegaz in Barcelona. His clothes had the same sophisticated elegance that you would see in the best Paris salons.

After a few free days in London and Spain's couture houses, it was time for the Paris shows. Arriving in Paris, I would always go immediately to the famous flower market and buy armloads of fresh flowers to brighten up the ugly, cheap hotel

room where I'd stay. A reporter's budget is very small, and flowers brightened the place up and put me in the mood to write about gay Paris, and the thirty-five collections I would cover in ten days. My hotel was a real flea trap, but what can you expect for a couple of dollars a night? I was always brushing the cockroaches off the bed, and when I started to type those elegant reports on world fashion, those damned cockroaches came jumping out of my typewriter. Of course, I could have moved to a cleaner hotel farther away, but the saving grace of this place was its location—right in the heart of the fashion district. I could look out the bedroom window into the workrooms of Castillo, and out of the hall toilet into the salon of Pierre Cardin. The hotel had the usual community bathtub, where the maid was always complaining because I take more baths than anyone else, and they charged me double: sixty cents for each bath, because I ran the water over the six-inch mark. One evening I was luxuriating in the tub, when the maid accidentally looked in and saw it filled to the top. She nearly fell in and drowned over the shock of such a huge amount of water, but didn't seem the least bit disturbed by my immodesty.

The second thing you do when you arrive in Paris is go over the bundles of invitations, sorting them out according to their importance. There are five parties a night sandwiched between five shows a day. But it's the show invitations that cause even the most jaded old-time press to ruffle their feathers. Unlike the Italians, who show in a huge ballroom where everyone has a seat, in Paris each French house shows individually, at their own time, which is often overlapping that of their competitors.

The tiny salons are airtight; they would be jam crowded with two hundred press, but in Paris there were eight hundred magazine, newspaper, radio, and TV journalists all wanting to get into the first showing. What a mess! Usually all my invitations for the best houses were second and third showings. Being with a newspaper, it was crucial to be at the first show so you could wire your story at the same time as your competitors. For the first day, I would be running all through the streets of Paris, in and out of each couture house, talking my head off over how important it was to get into the first showing. When I found real stiff opposition, I immediately told them that the paper won't print a story if it arrives after those of the other newspapers. This usually worked, and I'd be squeezed into a corner with fifty other people who had pulled the same story. It was really hell, getting into these showings, no matter how important the newspaper you represent. And those salesladies, who lined the grand stairway of every couture house, dressed in their vulture-black dresses, defied you to get in without the proper credentials. These women were certainly the hellions of the couture, who delighted in torturing the press. I suppose it's their only defense against the fickle press who, after huffing and puffing their way into the shows and eyeing the collection, walk out arrogantly and whisper in a loud scream how it wasn't worth it. But if any of the press weren't let in to begin with, they'd probably kill themselves at the loss of face, as rival publications were quick to notice who was and who wasn't there. I've known some editors to go to parties and collections just so their competitors wouldn't say they weren't invited. Of course,

the American press didn't have half the trouble the Europeans suffer, as we rode on the coattails of our big-spending buyers. God help us when our buyers stop buying! In the meantime, it's rather enjoyable to sit back and watch the squabbling between the English and German press—you'd think the Second World War was still on.

The Dior show was the pinnacle of fashion; every newspaper in the world could count on the magical name of Dior to make headlines. Certainly, the biggest fights for seats took place in its fancy salon. You'd think we were getting into heaven, the way everyone carried on. And the name-calling over seats was enough to make a truck driver blush. I never had to worry, as I never got any further than the stairway, where a pair of opera glasses were needed to see the clothes.

The salons were always stuffed with famous and infamous private customers, movie queens, and a few duchesses for a bit of good taste. Of course, all of this provided good copy for the press in case the collection stank. I remember one year the German press ladies were sitting on the steps behind me, at the House of Dior; their noses were out of joint because they didn't get chairs, and the show was a half hour late in starting. The two gray sofas in the main salon were still empty, always saved for the most important personages. Meanwhile, three hundred other viewers sat cramped on those torturous little gold chairs, with seats too small for the derriere. Add to this, those vulture salesladies never allowed a window to be opened, for fear someone would peek in from outside and steal ideas. In summer, it was unbelievable, as no one had air-conditioning.

At any rate, on this particular day tempers were getting hotter, and still the two sofas remained empty. The German press ladies were speculating over who could be so important as to hold up the whole show. I thought surely they'd lynch the VIPs—whoever they were—when they did arrive. Finally, the most powerful American buyers arrived and plunked their torsos into the satin sofas, and there was a chorus of "Wouldn't you know it's the Americans!"

As the show began, my legs had already grown numb from their cramped position, and I couldn't move without kicking the already cranky Germans. All during the showing of eighty-two coats and suits, I was in severe pain, trying to write the important facts, my elbows pinned flat against my sides by an Italian journalist who wasn't a shade under two hundred pounds, who kept shaking her head and asking God to get her out of there alive. On the other side a Swedish woman dressed like a man smoked a pack of those smelly French cigarettes, puffing up a smoke cloud that almost obscured my view of the cocktail gowns.

The rich private customers never got their refined noses into the main salon. They had to be contented with being seated in the entrance foyer. The ex–Mrs. Henry Ford and her daughter Charlotte were flagging numbers throughout the collection, like the clothes were a dollar apiece. Charlotte circled sixty-eight numbers, while Mummy was holding on to the Ford dollars by only checking fourteen. I didn't mean to be nosy, but my seat on the grand stairway, with the rest of the undesirables, allowed me a perfect view of every mark their crayons left. Together, the two Fords just drooled over eighty-two new coats

and suits. The total would set the Fords back at least $82,000, at a conservative average of one thousand dollars an outfit. I doubt they ordered nearly that, but Barbara Hutton once ordered everything shown at the House of Lanvin, at a cost of a million dollars.

Halfway through the Dior collection, Dior's directress, Madame Bricard, entered. One of the three ladies who started with Dior sixteen years earlier and was now considered the dowager duchess of fashion, she was a raving beauty at the turn of the century, a very grand demimondaine whom kings, princes, and dukes showered with jewels. Madame made her appearance at the top of the grand stairway and magnetized my eyes for the rest of the collection, as this extraordinary woman, sparkling with every conceivable device that forms the mystery of fashion, stood like a vision from one of the great French novels, the Madame Bovary of the 1960s. A tall baby-blue felt cone hat wrapped in yards of spidery black veil exposed marcelled black curls over each ear, which were hung with pearls and bloodred rubies; from the hat edge over the right eye dangled a brooch with a pearl the size of a nightingale's egg. A pearl hatpin anchored the seductive veiling, which shadowed a face so preserved by the art of cosmetics, the eyes, lacquered and painted in silver fish streaks of green, drooped under the weight of inch-long lashes that served to shade the mystic sapphire blue of her eyes. Everyone in the room was riveted to this fascinating woman, whose delicate mouth darted out like a lovebird. Her swan-like neck was circled with sixteen

strands of pearls, all of matchless quality, and two badge-size cabochon rubies. As the now-historic Madame Bricard sat on one of the filigree-like gold salon chairs, the dancing lights from the crystal chandelier seemed to scorch her eyes. Instantly, a many-ruby-fingered hand flashed open a black lace fan that madame used as a shield.

By this time the audience was in a trance over the appearance of this lady, who was drenched and preserved in the artifice of fashion to a point where men were her slaves. Certainly, there wasn't another ruby left in all of France, as Madame Bricard was wearing them all!

For the finale, the ravishing ball gowns were shown, and my circulation had completely stopped. When the show was over and everyone jumped up to rush out, throwing their gold chairs into corners, the designer appeared and hysterical women went into the act of crying and kissing each other. As the mob swept down the stairway, six butlers loaded with trays of champagne held high over their heads pushed their way upstairs. It was like trying to conquer Mount Everest in a hurricane. I was fully paralyzed there on the steps, and nearly trampled to death trying to straighten out my twisted body. I managed to get to the street, and a half hour later the same scene was played at another collection. I'm glad to report that after many seasons my body has become totally immune to these tortures. As a matter of fact, I don't think I'd enjoy it half as much if I were able to just walk in and sit down. The battle seems to make it all that much more important.

THE TRIP THROUGH THE DESIGN salons of Paris often set my imagination flying, especially when I arrived at chez Chanel and saw that delicious eighty-year-plus Witch of the West, Coco herself, darting around the top of the mirrored stairway, ordering the last-minute stitches into the clothes. The following is what I witnessed in her salon as I watched the spring 1965 collection.

The fashion gates to heaven were thrown open by the goddess of fashion, the grand Mademoiselle Coco Chanel, and to my eye they looked a bit tarnished and seemed to squeak for the need of new oil. Twice a year, Chanel opened those mythical pearly doors, and the multitudes of the fashion press took their allotted places. Several dozen people, including one *Harper's Bazaar* editor, could not persuade the house's Saint Peter to let them in. Upstairs in this paradise of high fashion, where every inch of wall was mirrored to reflect any false movements of the guests or camera clicking, huge green-shaded lights exactly like the ones used over the prize-fight ring illuminated the path of the models to show the clothes, like disciples. The opening day audience had a fetish about wearing original Chanel suits. There were so many seen I wondered if they would be the eternal robe for the hereafter. As each woman sat and crossed her legs, there appeared dozens upon dozens of those sling-back shoes, in beige with black tips. *Vogue* magazine, as usual, sat on the huge beige velvet Jacobean sofa. Three out of the four were wearing the day's uniform, last

season's successful suit, with yards of tiny gold chains hanging over the flat bosoms, which is Chanel's trademark. The salon was set up very much how I expect the Judgment Day council to look, with *Vogue* as the judge. You see, they were the first to support Chanel when she made her comeback eleven years earlier. Sitting on the right hand was the *New York Times*, and the French magazine *Elle*, and on the left, *Harper's Bazaar*, who were banished to purgatory for not supporting the designer when she reopened. The famous mirror-lined stairway was the Road to Eternal Life for those who have sat on the steps at the feet of the great fashion goddess, who watches from the top step, hidden from the curious human eyes in the salon below. That year, as usual, it was all men (quite handsome) who sat on the stairs, but there was one casualty, a sort of fallen angel—the publisher of the New York trade paper, who usually sat only one step below the great Chanel and held her hand during the show. This time he sat smack at the bottom of the stairs, and never once climbed to greet his former goddess. Just below the stairs, three dozen gold chairs held the worshipping private customers. Seconds before the show began, the top English fashion writer who was sitting next to me jumped up and threw an audible curse on Chanel. Seems the high-powered English lady was tossed into purgatory for using unkind words. The show was three-quarters of an hour late in starting as white-smocked sewers were seen dashing up and down the stairs, with the clothes hidden under sheets. A few brave souls in the audience started to clap, like they do when the movies are late in starting. It was a feeble attempt, as most people are afraid to move

so much as an eyeball in fear of Chanel's wrath, which was already roaring due to the delay. She could be a hellion on wheels and would think nothing of dumping the whole chic crowd out on the street. As the first model appeared, a dead, frightening silence fell over the room, such a silence as only occurs when the pope himself enters an audience chamber. The collection moved on at a funereal pace, each new tweed suit eagerly eyed for any new detail.

Her suits all looked very familiar, and the press didn't show any enthusiasm until the dresses appeared. And even then the press never applauded, although the private customers applauded twenty times during the show. It was all too much of something out of the attic trunk, and by the end of the long, hot show, it was quite evident that the great Chanel had thrown us the same old bone, which fashionable women had eaten clean for the prior eleven years. Too bad there wasn't the usual hunk of newsy meat on the bone. That night in Paris everyone was wondering out loud whether those heavenly Chanel gates would ever open as wide, or if the winds of Molyneux, whose show opened the next day, were pushing them closed, as they had once before in the middle 1930s.

All through the night, behind the satin and velvet draperies of the elegant fashion houses, the lights burnt to the wee hours of the morning, showering rays of hope on the 650 magazine, newspaper, and advertising editors from all over the world, each demanding to photograph the most successful dress, all at the same time. As the big doors of the Paris fashion houses swung closed each night at seven and the last rich buyer had climbed into her

chauffeured limousine, a near-frantic line of waiting messengers and editors invaded the office of the four or five girls who managed the publicity department at each house. At successful houses like Cardin and Dior, the line to borrow the clothes ran long, and much excited yelling could be heard as prestige magazines got first choice. It matters little how early you place your order. If *Vogue* wants the same design as you, you're out of luck; even though each collection shows 175 designs, there's always that one dress that everyone decides is "it," and it drives the publicity girls frantic to keep peace and good relations with the demanding press, who are all too often consumed by their self-importance. The publicity girls worked from 7:30 a.m. to 3:00 a.m. the next day, with only an hour for lunch and dinner. The girls at Dior told me they didn't make as much money as their maids at home. These jobs were prestige affairs, where young debutantes could feel the pulse of the elegant business world, and escape back to their social whirls before the job lost its novelty.

All through this three-week siege, every press person has only one fear: sickness. Good health is the most important asset. Frankly, I live on tea and sandwiches during the ordeal. Of course, I love the perfume of French cooking, but I haven't got the stomach that would put up with it during the nerve-wracking showings.

Another top attraction during these showings was the swanky hotel lobbies, where big crowds of buyers and press held their secret meetings, scheming ways to get into the collections without paying, passing photographs and sketches of the clothes. After the collections of the two most important

designers, Balenciaga and Givenchy, who ban the press for a month, each journalist put on his dark glasses and fake moustache and hid behind one of the chestnut trees on the Avenue George V, where he darted out and hustled his source off to a hidden location when they came out after the showing. Here all the latest news is told in detail, while someone's undisclosed flunky sketches from memory everything that's just been seen. The Ritz Bar was the most famous hideout for buyers and press; at any hour of the day or night you could just quietly sneak in and sit down. You were sure to hear the whole inside story of Paris fashion. After an important show, you saw all kinds of people prowling like cats through the corridors of the Ritz.

All the press automatically received invitations to the third- and fourth-rate collections, but when it came to the best collections, like André Courrèges, who was the most daring and creative designer at this time and had the smallest salon in Paris with seats for only forty lookers, it was a near miracle if you got in the first day. Having been an active admirer of his work from the beginning, I usually got in to the second show of the first day. The rooms were all hospital white: rugs, lamps, chairs, drapes, etc. Even the sewing girls wore white hospital smocks, like Mr. Courrèges. When you got out of the coffin-size elevator, which is standard equipment in Paris, you rang the doorbell and waited what seemed a hundred hours for one of the hawk-eyed salesgirls to open that damned door. There you stood, with that sickening white invitation in your sweaty hand, as the door opened a few inches and you got a thorough looking over. Then a stern, totally unsympathetic voice

demanded to know what you wanted as you waved the invite for the showing. The pair of frosty cold eyes seemed to say, "What show?" And just as you were about to drop dead from fright, thinking you'd come on the wrong day, the door opened twelve inches and you squeezed in sideways. (Thank God I'm skinny!) Inside, the pure white carpet seemed to scream, "Take your dirty feet off me!" and the white-draped walls silently glared no welcome. The leader of Mr. Courrèges's salon, Mademoiselle Brener, appeared with a long white paper that re minded me of a jail roster. She slyly smiled like the Mona Lisa, enjoying every minute of your discomfort, and promptly took you to one of the white cushioned chairs, edged in white ball fringe. Each time I sank my fanny onto the wretchedly uncomfortable chair, I sighed as if I'd been let in to the first spaceship. This same routine was followed as the forty guests arrive, and frankly it was a riot to watch the others, especially those high-and-mighty fashion editors, as they shrink to pint size. These same editors are the ones who are consumed by their own verbosity and cause near riots at other houses when their chairs aren't in the front row. Here they don't dare move a false eyelash, let alone change their chair. While all this hocus-pocus was going on, one big brown porcelainlike eye, framed by a hole in the white curtain closing off the models' entrance, watched every move of the audience. It was the creepiest feeling to sit through the show with that big searching eye never resting its glance. But this was nothing compared to other houses, where five peepholes at a time watched the crowd.

The funeral-parlor silence of the salon was shattered by the

screaming electronic music switched on without notice at the beginning of the show, and causing half those old battle-ax editors to faint from fright. Mr. Courrèges was pure twentieth century, and his models blasted out into the showroom and streaked through the salon, all in step to the cold, bloodcurdling music. They moved just like robots while Mr. Courrèges himself, hiding behind the curtain, adjusted the volume to accent the models' turns. The models walked so fast the editors' pens flew over their pads, desperately trying to keep up with the revolutionary clothes. Nowhere in all Paris did you feel the rejuvenating spirit of modern clothes as at this house. The white drum-major boots of the models stepping through the rooms, the skirts three inches above the knee, the silhouette always in abstract squares. When the final blast of music dropped dead and the cold, clinical white of the salon chilled your romantic nineteenth-century flesh with goose pimples, your pen just collapsed from exhaustion as your body felt as if it had been squeezed through a wringer.

If you get the fashion message, you bolt out of your seat applauding. The old-time fuddy-duddies just leaned back and gasped for another breath. There was no soupy emotional kissing the designer after this show, as Mr. Courrèges never appeared, not even to the demanding command of *Vogue* and *Harper's*, who wished to be presented to Courrèges. Instead, everyone was quietly and quickly hustled out of the salon. Frankly, I felt it was cruel to shove us out into the dirty sooty air of Paris, with no time to daydream, as the showings there took place one after the other. Out on the street, there was a mad scene while everyone screamed for taxis.

The next showing was the revival of Molyneux, who had been the great leader of the 1930s. After many years of retirement, and at the age of seventy, Mr. Molyneux, an elegant, refined gentleman, was staging a comeback. Everyone wanted to be present for his moment of triumph. There wasn't an inch of space in his newly decorated brown-and-beige salon. The air was filled with expectation, and old ladies overflowed with the memories of beautiful gowns monsieur had designed for them in his heyday. They could hardly restrain a flood of tears at the thought of once again recapturing their past beauty. I was allotted standing room; hopefully, I snuck into the grand salon and squeezed into eight inches of space behind a vase of pink apple blossoms that I thought would camouflage me from the sharp-eyed salesgirls who sat each jealous guest according to his importance. Just as I was shifting from one foot, a hollering voice ordered me out from behind the fragile blossoms. I was relegated to the entrance foyer, where all the third-rate outcast press were causing a riot over space. I climbed over three rows of chairs, then crawled over the top of the howling head salesgirl's desk, and finally rested my worn-out feet on a patch of the brown carpet. A huge plant of white hyacinths blocked my view and nearly suffocated me with its drenching perfume. I quickly moved the potted plant under the desk, where I discovered a famous American fashion artist was hiding for safety. Unlike the other salons, where peepholes in the curtains allow the designers to watch the press, Mr. Molyneux did something no one has ever done before: he walked out into the salon just before the show started and sat in the center of the

chocolate-brown sofa. Everyone nearly died, but recovered themselves to rock the salon with their applause.

The show began with the first dress, which was a side-wrapped sarong worn three inches below the knee, in a beige-and-black abstract print, all very 1940. Many knowing people in the audience can tell whether the showing will be any good from the first gown out, as it usually represents the designer's theme. The artist hiding under the desk poked his head up from beside the hyacinths, took a piercing look at the dress, and in an all-too-clear voice, boomed out, "It's going to be a bomb!" and then crawled back under the desk to catch up on his lost sleep.

The electrifying air of expectancy seemed to vanish, and just then an actual electrical fuse blew, leaving only the gray Paris light coming through the French windows that faced the Place de la Concorde, where Marie Antoinette and her gang cavorted before they lost their heads, and many of the sharp-tongued press were sitting just inside, ready to cut off the head of the designer.

The next few dresses were more of the same: old looking, because of the long length. The audience started to fidget, and give each other deadpan glances. They couldn't whisper, as Molyneux was sitting right in front of them. The feeling in the salon was like that of a trial. The next design was a lovely three-piece suit. The audience applauded, even though they would have ignored it at another designer's. Under the circumstances, most people wanted Mr. Molyneux to succeed. Several times during the showing, the air of expectation tried desperately to pull itself back into the room, but never quite made it.

The know-it-all press thought he was going to revive the 1930 softness from his heyday of stardom and that is now the overall theme of every Paris designer. But he did not. Instead, Molyneux picked up where he left off in 1950. Over at the Paris fashion library, the fashion magazines of the 1930s period have been practically worn out, as almost every designer in Paris has been flipping through the pages in hopes of recapturing the spirit of Molyneux in that era. Of course, they wasted their time, as it was his designing for the present, not the past, that made him a star. And this is why this collection should not be judged as a failure. Like Chanel when she first made her revival, everyone laughed and said to put it back in the trunk. But Chanel, with the enthusiasm and encouragement of *Vogue*'s editors, who believed in her basic philosophy, put her suits into the spirit of the time. Now Molyneux, who showed some wonderful ideas, and particularly oriental-inspired gowns that could be the straw in the wind, needed this same readjustment. When the show was over, crowds surged forward to greet him, gushing praises. He wasn't fooled. As the dozens of cameras recorded these tense emotional moments, I carefully watched his face, and I could tell he knew all too well what they really thought of the collection. That same evening, Molyneux gave a huge party downstairs at Maxim's famous restaurant. Everyone chic in Paris was invited. Lots of people got weak stomachs at the thought of celebrating his return—which by any standards couldn't be called even a mild success. But everyone loved him, so they showed up by the hundreds, and he made them feel at ease with his gentlemanly manner.

After the ten days of five showings a day, most of the buyers and press left Paris. The spring showings were over, except for the three most important designers who don't show to the press until a month later. The salesgirls were so exhausted from the hysteria of those three weeks that they could hardly get their aching bones out of the Louis XIV chairs to greet the complaining leftover buyers. There was a lot of excitement the last couple of days. It seems the American buyers had, without knowing it, bought a lot of designs and materials that turned out to be imported from China, courtesy of Le Grand General de Gaulle, who wanted all our gold so he could trade with the Red Chinese. At any rate, it was all discovered as the Americans started to go through customs and were told that the clothes they had bought wouldn't be allowed into the United States because of the Chinese materials. Immediately, there was a monumental pile of canceled orders with designers like Dior, who had to switch to European fabrics.

While I waited in Paris for the last shows, I had three weeks to ransack all the fabric and accessory houses. It was an inspiration to see and feel the construction of the cloth that had shaped the thousands of designs I had written about. The second you feel the material, you realize why the coat, suit, or dress was cut that certain way. Everything depends on the drape and weight of the fabric. Each fabric house has what it calls a book of the models. This is a sample book showing all the materials each designer used from the firm. The button and belt houses show why Paris is the center of fashion. Here, in one city, are hundreds of artisans, all creating accessories for

fashion. New York, Rome, London, and California cannot be tops as long as they don't have the artisans to dye each sample material, create the special button, design the right flower. In New York, you had to order buttons by the gross or cloth by the bolt, whereas in Paris, designers could have just the amount to make an original. It was still an individual business in Paris, while in New York it was huge volume, with no shelter for experimentation. In Rome, the generations of fine Italian tailors were the backbone of their fashion industry. But European designers began to gear their workrooms to mass-produced ready-to-wear. The final nail in the coffin was poised to strike custom-made clothing, and a tradition started by the first couture house, Worth, in the 1800s, seemed headed for its grave.

Fashion must be instantaneous, ready to be worn out the door of the shop, the day you want it—not four weeks later. Of course, wonderful imaginative clothes will disappear, but frankly it seems that no one really wants them. The practical way of life, with all its harsh realities, has taken a firm hold on women's fashion. But, like the horse and buggy, life must move on, on to a rocket.

After a few weeks, the first of the three top designers who slammed the doors on the press arrogantly opened them. I was one of the few American newspaper reporters to still be on the scene. Designer Yves Saint Laurent usually had bulging crowds of eager press people who publicized his work to the top. But then he turned on them when they failed to write kindly about one of his collections. At that day's showing, only seventy-two people appeared, where three hundred and fifty had sat during

previous seasons. Only one salon was used, and the winding stairway that usually held one hundred souls was lonely and empty. The two brown satin sofas that were accustomed to the most important press fannies were taken over by less august persons. An air of arrogant "we don't need the press" greeted

each arrival. The warm, friendly feeling of the past was now frozen-faced and formal. The designs were filled with charm, and most women would have sat hypnotized by the many creative ideas. The bride ended the show wearing, instead of the traditional veil, a big eight-inch-brimmed white sailor hat with a trellis-like veil to the floor, all dotted with white spring flowers. It's a shame the house insisted on putting on such airs. They didn't need to; the beautiful clothes spoke so loudly we shouldn't have had to hear the internal feuding.

The second designer to ban the press, Givenchy, showed after Saint Laurent. His house was one of the most imposing mansions in Paris, at least from the outside. The street-floor boutique was very elegant, with huge Persian vases and cocoa-brown leather floor-touching tablecloths holding displays of scarves and jewels. A pastel array of gloves rested fan-shaped on a cocoa-brown hand-tooled-in-gold-leather pillow. In the middle of the room, a gold Louis XVI urn sprouted spring flowers. All the anxious ticket holders climbed the grand stairway to the big, airy salon, which looked rather dull in its mousy off-white paint. The salon is obviously for showing clothes, not impressing customers.

In the audience was America's top *Vogue* editor, Mrs. Vreeland, who had flown to Paris just for this show. Seconds before the parade of models, she dashed down to the opposite end of the room, where her competitor, *Harper's Bazaar*, was sitting on the gray sofa. Mrs. Vreeland gave the grand dowager editor, Marie-Louise Bousquet, an affectionate kiss. Then the show started.

To my eyes, it was rather like an old familiar symphony that

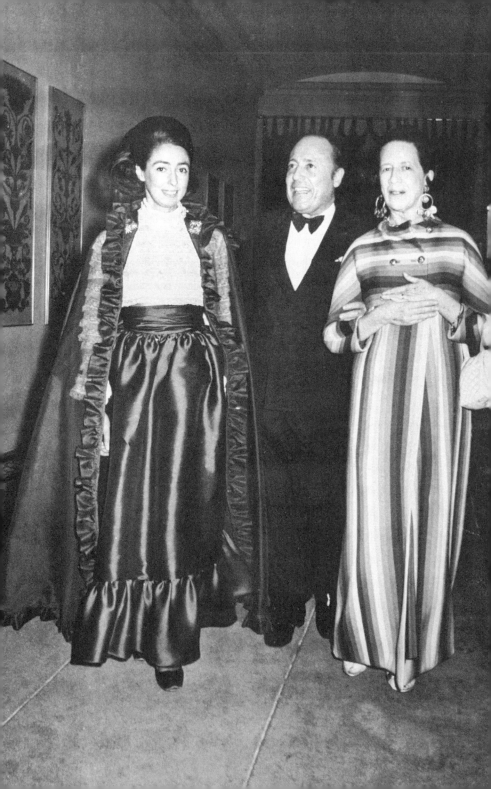

you didn't mind hearing again. But it didn't inspire you to actively debate. The Givenchy fashion concept, so well balanced with exquisite taste, was almost extinct in that day of flamboyant coloring. The two-hour show certainly wasn't as fresh as it had been when the designer's message was thrilling the world. But let's face it, there was enough cool, calculated dynamite in his great new dresses to keep the whole fashion dress market sizzling with sales for the next two years. Everything in his collection looked 100 percent Audrey Hepburn, the designer's favorite customer. Mr. Givenchy watched the showing from a giant-size peephole in the wall of the main salon. He didn't see the fashion editors spilling much ink over his newest designs, but then he never did seem to care a hoot about the press, let alone entertaining them.

The buyers tell a story of one of his early shows, when Givenchy stood behind a Chinese lacquered screen with a peephole cut out of it. Halfway through the showing, the screen fell over, exposing "le grand" Givenchy himself! It's no wonder designers have little respect for the fickle press. If you could just see the rogues' gallery of hideously dressed people who call themselves fashion experts and dictate to the world. Why, 90 percent of them look like they never had a mouthful of taste. Sitting next to me at Givenchy was a real lulu representing one of the top German papers. Five foot tall, bow-legged, with a face of wrinkled leather framed by bleached-blond hair and a tweed beret that didn't match or blend with her yellow-gold suit and sequin blouse. She was chewing a wad of gum while smacking her messily painted red lips. A pair of chandelier-length

diamond earrings swayed back and forth as her short and dumpy many-ringed fingers spelled out the elegant fashion news. Her skirt was seven inches above her knees when sitting, and her white boots reached the kneecap. All I could think was that this lady was telling others what to wear.

Next came the most important show of all, the world-famous Balenciaga. My invitation to his showing hadn't arrived. Knowing the house would be difficult about handing out invites, I was worried to death. I had already suffered a couple of sleepless nights wondering whether I'd get in. I gathered my courage and called the house, two days before his show, and was brusquely told there would be no ticket, as I was with *Women's Wear*, the American fashion trade paper that spies on every move Balenciaga makes. Madame Vera, the press attaché for the house, who looked like a kind, motherly gray-haired woman with a memory like an elephant's, set the rules as to how the show would be run, and just who will see it. We talked for twenty minutes on the phone, while I explained that I had left *Women's Wear* two years ago. There was a lot of cross-examination, and finally I was invited to come right over to meet Madame Vera. I always felt this was so she could give me the once-over.

When I arrived at the boutique, it was neatly arranged with tables of scarves and gloves. Two very large mink blankets were thrown over the emerald-green sofa, and a bronze deer and a few Louis XVI mirrors set the mood. The elevator that took you up to the inner sanctum was completely lined with wine-colored leather. Once inside the sacred stomping ground of the

world's most elegant women, I was surprised to see a great deal of action. Customers and salesgirls were scurrying around in an unusual rush of business. As a matter of fact, it was the most businesslike salon I had ever seen in Paris. The desks were scattered with fabric samples, and the usual too-elegant atmosphere that frightens most customers away in all other designers' salons was absent. Instead, Mesdames Vera and Renée, the two most feared salesladies in Paris—even by the brashest buyers—watched everyone entering the room. Many a rich and famous lady had been coldly turned away. It mattered little whom you were with; once the Baroness Rothschild, one of the biggest private buyers, brought along an equally rich American friend, but was refused service. The House of Balenciaga had the upper hand. They had the biggest business in Paris, and rejected what would be considered star customers for other dressmakers.

I must say that my cross-examination turned out to be an enjoyable half hour spent with Madame Vera. We exchanged ideas and philosophies. The house did away with all the phonies trying to get in by the use of some obscure news medium. You only got in if you represented a substantial paper or magazine. And then only one person from each journal could attend—unlike other designers who let in as many as six from one big paper. And you didn't get back in the next season unless you sent the house a clipping of what you'd written. Luckily, it's the most creative fashion house in Paris, so you can almost be certain to write a favorable report. In this salon, the place was ruled by an iron fist (where's the freedom of the press?) but it's their salon,

and if you wanted to see, you played the game their way or not at all. When Madame Vera finally handed me my invitation, I had the feeling I was being presented with the key to heaven.

At last, the day of my seeing his collection in the flesh arrived. It was a typical cold, gray, end-of-February day. The night before the show, I tossed and turned in my $1.65 per night hotel. All sorts of nightmare disasters kept racing through my head. I must have thought of every conceivable casualty that could stop me from seeing the show.

When I finally fell asleep, around two a.m., I was awakened by a huffing and puffing and terrific pounding in the tiny radiator, causing such a noise. Usually you could sit on the radiator all day and never even feel lukewarm. The steam was blasting off, and my instincts told me something was wrong. Here I was tucked away in a sixth-floor attic room, and of course the French never heard of anything like a fire escape. I leaped out of bed and opened the door. People were hollering and running up and down the stairs. The water heater had blown up, and the landlord was near hysterics. I was about to crawl out the alcove window onto the roof, when I was reassured everything was safe. Needless to say, I never slept the rest of the night. I would have been happy just going and sitting on the stoop at chez Balenciaga to wait.

I arrived outside his shop two hours before the show. I was the first press person into the house, and when the gendarme-like Madame Renée showed me my seat, which was an excellent one right in the middle of the grand salon, my whole body seemed to sigh with relief. I had made it!

As the audience arrived, I had a last horrifying thought: suppose I should fall asleep during the show! The rooms don't have a breath of air, with all the locked windows and tightly drawn drapes to keep out the eyes of unwanted Peeping Toms. Mrs. Gloria Guinness, one of the world's chicest women, sat four seats away from me, and when the show started, I never dropped an eyelash. For two hours the designs paraded by, in one of the most thrilling experiences. The effect was that of peace, repose, or a dream—rather like opium.

Unlike other designers' salons, where the press are always carrying on with side remarks, everyone here was fully alert, from the first suit out, which was the trend maker, with a new long wrist-length jacket and half-dollar-size gold buttons fitting it gently over the feminine figure. The dresses were the biggest thrill of all. Balenciaga had invented a new kind of slithery, seductive, sensuous sex with his bias-cut satin crepe gowns that clung to the body as if the wearer had just come out from under a shower. They revealed the torso and thighs with new enthusiasm; the garter line showed ever so slightly as his models slinked through the gray salon, which didn't need any crystal chandeliers to light up the room. Magnificent floor-length evening coats were made of rippled taffeta pink ribbon and lilac buds, and there were sumptuously beaded sari gowns, worn with huge diamond necklaces. The accessories were fantastically different and creative. Every hat was a dream, from the rooster-red feathered cone reaching a foot high, to the yard-wide Mae West black taffeta brim. Seeing the fashion collection of Balenciaga was like bathing in a fountain of new

faith. All my life I had believed in designers being themselves and making a strong personal statement, never giving a damn what their friends had to say, or the press critics, who know only how to push status symbols. Ninety-five percent of the time, the press are trying to influence designers. Since my earliest days, I can remember the affected accents from the editors of the slick fashion magazines. Their favorite phrase was: "If we could only corral your talent!" Well, Balenciaga's collection was a real kick in the pants to all the status snobs. His designs were purely his own ideas, with no outside influence. He broke every rule in the fashion book, with new shapes and construction, then thumbed his nose at the phonies by throwing ropes of rubies over tweed suit jackets, adding two diamond necklaces at a time to an evening gown. And the final scream of freedom was when he added two big diamond bracelets, worn on the outside of long white gloves. The snobs had been telling their readers for generations that only prostitutes wore their jewels over their gloves.

For the first time at any fashion show, I came away with something really worth dreaming about. This man believed in everything I had hoped for. My spirit was renewed; the long, hard fashion climb had been filled with constant disappointments. But when I finally reached the top of the fashion ladder, I found the rainbow pot of gold. No one will ever again be able to influence my fashion thinking, for I have seen the proof of creative design, and it's worth every drop of hardship to climb to the top.

On Society

I n the 1930s and '40s, fashion revolved around the movies. In the 1950s and '60s, fashion was inspired by society. Fashion climbing replaced social climbing with the birth of Christian Dior's New Look of 1947. An enormous change of fortune took place during the war, leaving half the names in the Social Register impoverished. Once-swanky resorts and private clubs had sprung leaky roofs and were now in search of new fortunes to embellish their stomping grounds. The white ermine that cuddled the elegant snobs of the 1930s had turned yellow, or were being cut up to make collars and cuffs in a last desperate hold on the ladder of affluence. The Protestant-dominated social playground of Park Avenue was the scene of bitter battles. Regiments of Seventh Avenue manufacturers and Texans turned into superb fashion climbers, using the ballrooms of the Waldorf, Plaza, and Astor hotels as the most voluptuous battlefields since the days of medieval splendor, when knights in shining

armor fought for the titles of Europe. The weapons of this historic battle were to be fashion. The invading army advanced in shimmering splendor, while the old guard threw up its first barricade of moth-eaten chinchilla, and tarnished brocades and sapphires. As in the days of old, the French came to the aid of the revolutionary forces, led by a Monsieur Christian Dior. He brought with him a new miracle weapon, the atom bomb of fashion, his New Look. The bomb scored a direct hit in New York City: total destruction of existing armor. The Social Register mortgaged its Newport and Southampton summer cottages, along with its mighty palaces lining the gold coast of Fifth Avenue. The invading army was sweeping across Central Park's green lawns, and the baronial castles of Fifth Avenue couldn't stand the barrage of new ammunition: fashion. The pedigreed family label was totally eclipsed by those of Paris designers sewn into the collars of the advancing army. The news media of the world headlined the names of Dior, Fath, and Balenciaga. At each charity ball skirmish, the big scream was, "Whose dress is it?" as reporters bolted from behind potted palms. The gossip columns were filled with the names of fashion designers. The press cared little about the wearers, so long as their gowns had a label. The old guard indulged in the new ammunition, and each party became a rivalry of fashion. It was like a superb game of chess, with all the pawns gowned by Paris.

Lurking in the background were the newly christened American designers. Their playing field was a checkerboard, slipcovered in less imposing fashions; the game was fought each

day at the luncheon tables of the Colony and Le Pavillon restaurants, where the best-looking coats and suits elbowed each other for front tables. Every night a new charity ball was formed by the old guard, as the night-before party had been conquered by the invaders. The hysterical pace of thinking up new diseases to benefit from these charity balls staggered the imagination. Some people invented diseases no one had ever heard of; so long as it sounded sickening and deadly, it could have its charity ball and allow the opposing forces to don their new finery. The biggest battles that will go down in history were all fought at the April in Paris Ball, led by General Elsa Maxwell. Miss Maxwell encamped her battalion at the first party, like an English picnic, at twenty-five dollars a head, held high in the Starlight Roof of the Waldorf. The audience was mostly old guard while the fashion climbers were onstage, performing a tableau. Mr. John, the milliner, portrayed Napoleon. Each year the battlefield enlarged, with the invaders being seated next to kitchen doors and in Siberian corners. The price of tickets steadily climbed. The arrival of the invaders' fashion armor eclipsed the badly wounded old guard's satins and laces. The newcomers were being splashed over the photo pages of the next day's papers.

Each succeeding year the invaders advanced on the ringside tables in more ravishing plumage. The old guard's social bigwigs counterattacked successfully in 1958. Their leader wore the first solid gold beaded gown. The invaders were shocked, and totally defeated in their tulle and brocades. Every newspaper headlined the gold-beaded socialite. The following year,

the Waldorf ballroom was dynamited by the invaders, wearing a blizzard of beaded gowns. This was the year that the fashionable women adopted the wearing of sunglasses in the evening. The trillions of sequins and beads wiggling over the fannies of the fashion-climbing warriors nearly did in the opposition, but with one last gasp, the Social Register crowd went back to its exhausted sewing machines, reappearing the following year as the understated maid. Not since the days of the Puritans had anyone seen such dull clothes. The advancing army appeared with diamonds on diamonds, and solid beaded gowns became three-dimensional, hanging like icicles all over the body. Television followed the new conquerors onto the battlefield in 1963, to record the hardest fought battle of the fashion-climbing war. The old guard just faded away. The ladies who once sat by the kitchen doors now found themselves at the ringmaster's table, with no one to crack their whips at. The invaders would now have to look at each other, as Valhalla had been destroyed in the battle.

Out of the old guard, a new young guard emerged with a strategy that was to change the fashion world. Their formula was a striptease. After years of their elders competing with the waterfall of new clothes worn by the rich invaders, young blue book society turned Park Avenue into an elegant burlesque stage, where each new fashion weapon of the invaders was removed; as the invaders came swirling up the avenue in tent coats, the new guard marched swiftly down in the skinniest, hungriest coats you've ever seen. The invaders wore their status mink coats as long as they could—the more the better, was

the motto. The new guard shortened theirs to three inches above the knees, and many a climber nearly died having her mink coat shortened. This was the most genteel striptease act the fashion world had seen, reaching alarming proportions by late 1963, in the form of slip dresses and topless bathing suits, which finally drove the fashion-climbing weapons off the world's stage.

American designers were used as effective new weapons for a short time. The names of Norell, Sarmi, Chez Ninon, Mainbocher, and Ben Zuckerman were a surprise, and this attack by the invaders flourished. But it didn't last long, as the designers climbed too fast themselves and were soon sitting at the best tables for lunch and dinner, thus putting them in the firing line of the invaders: Seventh Avenue, which marched on the coattails of the women they dressed. The designers got caught wearing the customers' coats too often, and no general likes to be seen in the same uniform the buck private is wearing. The opera and the Easter parade were other colorful fields of battle, but these were destroyed by a bomb more powerful than fashion: television, which has never been kind to fashion. Since its orbit into life, TV has wounded fashion climbers in each combat.

Indulging in fashionable society is quite a deadly game. The sidewalks of the fashionable East Side are covered with the footprints of slain invaders. The party pace is faster than a squadron of jet bombers, and equally as devastating. You're only wanted while you're news or new; once the social leaders have raped the message or news you represent, you're a dead

duck. The only way to last is never to let anyone really know you, for society is only friendly to new faces, out of fear that you're better than they. It's that old insecurity of American climbers. At all those fabulous parties you read about, 85 percent of the guests don't go to enjoy themselves, but to rub

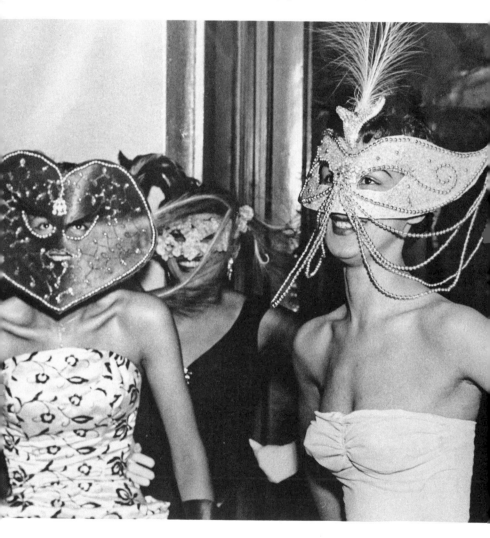

shoulders and climb, and show off their wealth. These poor devils go out on the town not for relaxation and fun, but as a challenge known only to army generals in the heat of combat. When one stops to remember all the glamorous fashion climbing that was achieved under the banner of humble, poor charity—the sole cry of each of the thousands of luncheons, balls, and theater parties that set the battlefield—oh, how I yearn for my youthful days, when women wore lovely clothes for the sheer pleasure and joy of pleasing their friends.

On Taste

Taste is something very few people have in large quantities, although Madison Avenue advertising would have you believe each time you buy one of their products, you automatically get an overdose of taste. Now, enough of that nonsense. No one is ever going to bottle taste. It's a sense you are born with, and if you're smart, cultivate like a rare flower all through life. Taste comes from both sides of the tracks: the environment during the growing years, and parents who know when to expose a child to fine music, books, art, and the association of friends. And God's graces are just as abundant to the poor. Many of the world's greatest artists and musicians came from humble surroundings. It's all very true: high fashion does gravitate around society, who claim to have taste. It's only because they have the time, money, and places to wear trendsetting creations. It's a ridiculous belief that money brings taste; it definitely doesn't. As a matter of fact, it often merely allows one to

enjoy bad taste with louder vulgarity. If a large number of soci-
ety women appear to have fine taste, it's not necessarily so, as
these groups all follow the mold established by a couple of
leaders. This crowd is scared to death to ever express its own
personality or taste, out of fear of criticism. Women outside
sleek social cliques often enjoy more freedom expressing per-
sonal taste; that's why the cities of Chicago, Dallas, and San
Francisco have larger numbers of individually fashionable
women who are not dominated by the rigid rules of a few
leaders.

The international group have no more taste than the aver-
age woman, but they do have the good sense to put themselves
in the hands of capable fashion advisors. When these ladies of
international society pay thousands of dollars for their clothes,
it's not just for the cloth and workmanship, but rather for the
quality of taste the designer has built into the clothes. Even
with these gilt-edged million-dollar advantages, you still can't
buy taste, as it's in the actual wearing; how the body moves, the
quality hidden deep inside the wearer's soul, speaks so loud
you can't see what they're wearing. That's why people often
remark, "What a ravishing lady!" but fail to realize each effect,
as the quality of the woman's personal taste is so strong it
eclipses everything being worn. Taste is never limited to just
one style. Hollywood flair can be done with great taste. A ser-
vant can have superb taste in tying her apron. Taste is constant;
style varies from season to season. It's all in how the wearer
adjusts the new style to her proportions. Most mistakes in
dressing are committed with proportion of clothes to the body,

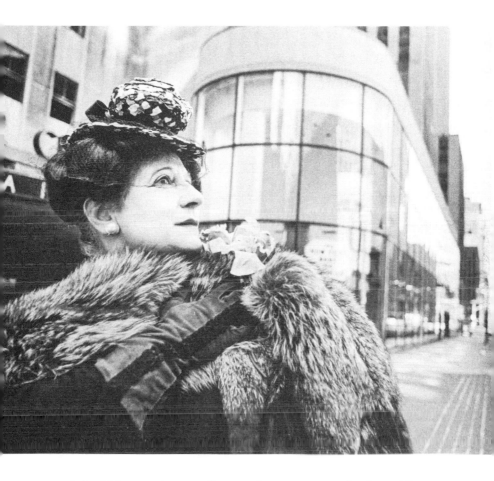

and the hideous mixture of screaming textures and colors. All this is the reason why women should never go to a designer simply because the newspapers and magazines are raving how marvelous he is. Women should stop and think, selecting the designer's work that best suits their temperament and personality. It's the same with interior decoration. You choose the designer whose taste resembles your own.

This is how chic women get themselves together. They

never run around buying odds and ends, which howl bad taste when put together. Rather, they assemble each costume individually, with the exception of sports clothes, where the mixing and blending of unusual styles form a pleasing composition. After observing hundreds of openings, restaurants, and balls, I believe there are very few people born with fine taste. Most people acquire style for status, which never truly satisfies the personal desire to be your real self. This is why really new fashions are so long in catching on, as so few women have the authority of their own beliefs to wear something before everyone else. At any time, in any city, only a few dozen women can be said to have total taste. The ten-best-dressed list is the most outrageous lie of our times. How could a few editors pick women they have never seen to be the winners? It's merely the stunt of publicity operators, promoting the egos of customers or yearly celebrities.

There's no question that different types of clothing change the personality of the wearer. A woman in sloppy, untasteful clothes is always complaining without knowing why. Her spirit takes on the same appearance as her outer armor. Just look at the glow in the eye of most women when a mink coat is slipped over her shoulders. Her mood becomes sophisticated and elegant. Give the same woman a worn-out muskrat coat, and she would sneak along all the back streets so no one would see her. How many times have I witnessed a fabulous fun party ruined because the guests are asked to wear formal clothes, which they're not accustomed to and feel over-ritzy in, all because their hostess wants to put on the dog. She should consider the

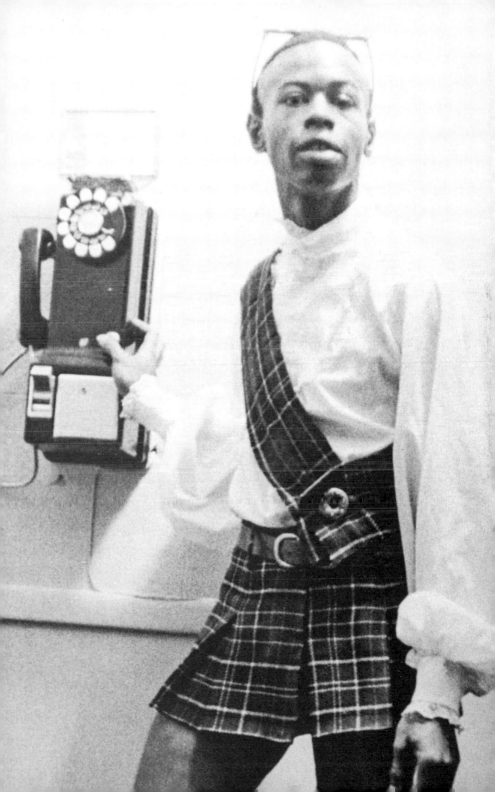

lives of her guests and not put them into a costume. One of the Vanderbilts wouldn't ask their swanky dinner guests to appear in bohemian clothes unless it were a masquerade. People definitely feel odd wearing clothes they're not accustomed to. It throws a stiff, unenjoyable atmosphere into the occasion, and the guests don't feel free to let their hair down, as they're trying too hard to be something they're not. Real sophistication takes a long time to acquire, although elegance is inside a person.

Often the well-dressed rich enjoy playing the beatnik, wearing their black stockings and turtleneck sweaters. It's rather fun, so long as they can change back to their glad rags by the next sunrise. Think of all the formal wedding parties where bridal consultants scare the fun out of the whole affair by imposing a lot of passé traditions on the unprotected family, who just want to do it right. Why, many of these affairs would turn into funeral atmospheres, if it weren't for the colorful clothes. It's only after the guests have started to lap up the champagne that they finally forget all the nonsense and relax. I think they should chloroform those damned bridal consultants, with their snobbish books of rules.

Just look what happens to men and women in the army and navy uniforms—their whole attitude changes; a feeling of superior power emerges when they don the spit and polish of uniforms.

Most women stumble over a few basic elements of fashion when it comes to choosing their own clothes. Usually they are so busy imitating a friend or celebrity that they never really see

themselves in the mirror; all they can visualize is the glamorous image they've seen in the picture. They don't seem to understand the proportion of their own body to the lines of the clothes. They allow the sleeves, neckline, tunics, and jackets to cut the figure in the wrong places. Unfortunately, the salespeople selling don't know what they're doing either, and couldn't care less, so long as they sell. Colors should be complimentary to the skin tone and change all during one's life.

The wearing of clothes at the proper place and time is so important. How many times have you seen women trotting off at nine a.m. dressed like they're going to a six p.m. cocktail party? And those luncheon parties are forever looking like an English tea party, with hats that should be kept inside their boxes for late afternoon, or Easter Sunday. And the idea of wearing classic, simple clothes to play it safe is equally in bad taste. To be seen at the opera or a concert in a tailored suit or day dress is just as awful as the wrong feathers at the wrong hour of the day. When it comes to great individual fashion, as often shown in *Vogue* and *Harper's*, the general public even if they were given the high styles free of charge—wouldn't know what to do with them, or have the slightest idea how or where to wear them. These high fashions, in their pure form, are meant for only a few women. It's only one in ten thousand who could successfully wear furs, feathers, jewels, and satins all at once and not look like a streetwalker. Incidentally, speaking of streetwalkers, prostitutes are very fashion conscious. You'd be amazed at how chic and elegant they carry themselves off. No more of those black satin dresses and the swinging beaded

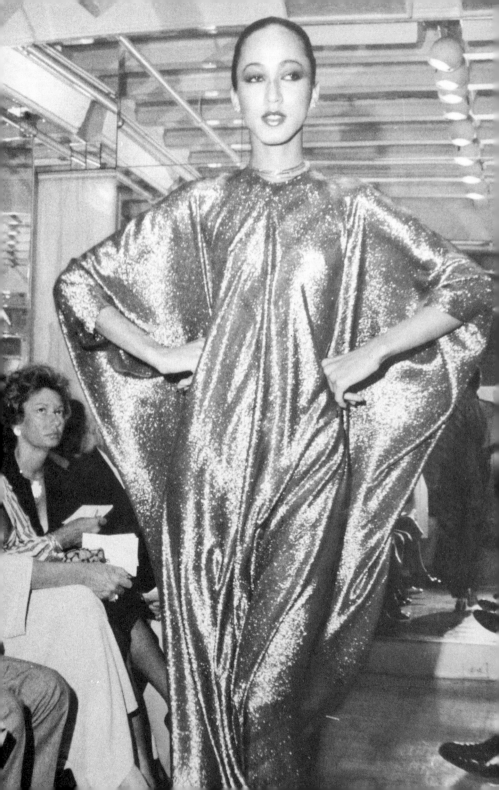

handbags. As a matter of fact, one of today's most elegant women was a lady of the night not so long ago, and now she's leading the whole western world of fashion. Did I hear the ladies of the Southampton beach club burp? It takes superb posture and carriage, plus exquisite manners and generations of good breeding, to carry off high fashion. You can't slipcover a pig and expect it not to grunt. Well, it's the same formula in high fashion—it's rarely an art, as most people don't have the taste, money, or time.

But let's hope the fashion world never stops creating for those few who stimulate the imaginations of creative designers, and on wearing their flights of fancy, bring fashion into a living art. There's only one rule in fashion that you should remember, whether you're a client or a designer: when you feel you know everything, and have captured the spirit of today's fashion, that's the very instant to stand everything you have learned upside down and discover new ways in using the old formulas for the spirit of today. Constant change is the breath of fashion.

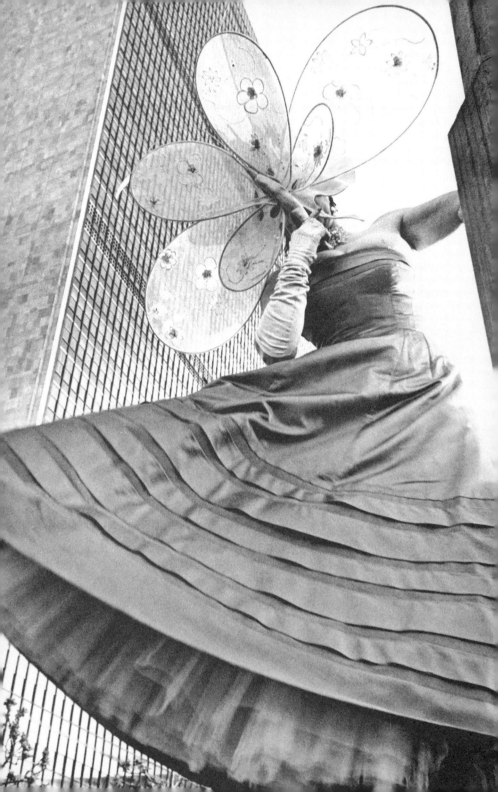

Laura Johnson's Philosophy

To anyone designing for her, her advice was: "Don't walk while designing for me; run, run, run, till you're out of breath! Then throw out all your timid thoughts, and give me emotion."